Is There Truth in Art?

ALSO BY HERMAN RAPAPORT

Milton and the Postmodern

Heidegger and Derrida: Reflections on Time and Language

Between the Sign and the Gaze

Is There Truth in Art?

HERMAN RAPAPORT

Cornell University Press

ITHACA AND LONDON

Copyright © 1997 by Cornell University

All rights reserved. Except for brief quotations in a review, this book, or parts
thereof, must not be reproduced in any form without permission in writing from
the publisher. For information, address Cornell University Press, Sage House,
512 East State Street, Ithaca, New York 14850.

First published 1997 by Cornell University Press.

Library of Congress Cataloging-in-Publication Data

Rapaport, Herman, b. 1947
 Is there truth in art? / Herman Rapaport.
 p. cm.
 Includes bibliographical references and index.
 ISBN 0-8014-3275-8 (cloth : alk. paper).—ISBN 0-8014-8353-0
(pbk. : alk. paper)
 1. Truth (Aesthetics) 2. Truth. I. Title.
BH301.T77R36 1996
111'.85—dc20 96-28088

Printed in the United States of America

This book is printed on Lyons Falls Turin Book,
a paper that is totally chlorine-free and acid-free.

Cloth printing 10 9 8 7 6 5 4 3 2 1
Paperback printing 10 9 8 7 6 5 4 3 2 1

For Aaron and Vanessa

Contents

Preface

Contrary to what the title suggests, this book does not debate whether there is or isn't truth in art. Rather, my purpose is to inquire into how the question of truth in art needs to be thought from the hither side of its having been deconstructed and discredited. Briefly stated, my position is that because the truth in art transcends any yes-or-no response to the question "Is there truth in art?" it is not something that can be invalidated or done away with in the name of opening canons, deconstructing metaphysics, or transculturation. This is because the living-on or survival of the truth in art is not reducible to a nostalgia for universals, absolute values, or a stable ground for justifying opinions and assessments of quality or longevity. Rather, the truth in art persists in the wake of its demise because it is neither an entity or content that has been put into the work nor a transcendental universalizing concept or ground that exists outside the work as a guarantor of its authenticity as art. Indeed, it would be an error to consider the truth in art as a singular formation or construction that can be represented apodictically and transmitted independently of the work or works of which it is thought to be a part. Therefore, although I believe there is truth in art, this truth is probably different from what many readers may have in mind when I invoke the term, because for me the truth in art is not an essent or essence in a traditional sense. Hence the irony, "Is there truth in art?"

In Chapter 1, I provide an overview of the theoretical considerations relevant to the chapters that follow on atonal music, environmental art, modern German and French poetry, modern French fic-

tion, experimental French film, and a photograph taken by the National Socialists during the destruction of the Warsaw ghetto. How and in which form the truth can be said to occur in these examples requires an analytic that has to be taken up anew in each case. Whereas the chapters draw from the philosophy of Martin Heidegger, Jacques Derrida, and Emmanuel Lévinas—thinkers who have radically reformulated questions about truth—I have not used the work of these thinkers to create a general theory of postmetaphysical truth. Instead, I have used their writings as clues or guides that are expanded and developed in the context of interpreting various cultural works whose philosophical implications are at least as important as those of the philosophies from which I take my bearings. In this way I have attempted to advance what one might call a thick description of truth from a postmetaphysical orientation, one that explores various dimensions, aspects, or constructions of truth in philosophical or other cultural works without necessarily providing closure. Because this view stems from a phenomenological orientation, it follows that the question of truth requires what Edmund Husserl called acts of "relational contemplation"; that is, attention to the partial coincidences and disjunctions of conceptual formations that are often abbreviated, overlooked, and hence reconciled for the sake of being reduced to general categories such as truth, being, or the good.

Fundamental to the idea of thick description in the context of my researches is that the question of truth in art ought to be considered "site specific"—dependent on the particular work in which truth is disclosed. Given the significance of the work of art as a particular rather than a general, it follows that the truth in art will not be consistent with or identical to itself even as truth persists in art as a coming back or restitution. Such restitution can be equated to Friedrich Nietzsche's conceptions of eternal return, Martin Heidegger's questioning of the persistence of truth in relation to ontological difference, or Jacques Derrida's identification of truth with *la différance*. Rather than localize the question of truth in terms of such aporetic sites for the sake of a structural postmetaphysical account of truth, I want to consider various instantiations of truth as complex site-specific articulations whose definition and performance can be seen as the consequence of specific works that are themselves extremely difficult to interpret because they push the limits of tradi-

tional aesthetic analyses. It is my assumption that for the hermeneutic of analyzing such works, one's approach to the understanding of a truth in art must differ from traditional assumptions about truth whose sources are in Ancient Greek thought.

The works I examine require one to question classical assumptions about how truth links beings to Being and how this linkage concerns the human as an ethical being-for-others under the moral gaze of the divine. This traditional construction presupposes that among the functions of truth in art is that of making ethical distinctions based on our ability to differentiate between the profane and the sacred, good and evil, the human and the inhuman. Structurally, this requires truth to be positioned at the interface of the existential (beings) and the ontological (Being). As Heidegger, Derrida, and Lévinas have suggested, this determination is possible only because truth has been subordinated to an agency that positions itself in advance as human and, as such, constitutes truth as a law defining the existential and ontological in terms of their difference. Were truth to be liberated from this structure, it might well speak from a place other than that of an agency that vows to tell the truth in the name of its own humanity.

Chapter 1 begins with an abbreviated historical account of the metaphysical tradition we usually associate with "the truth in art." Even though readers are most likely well acquainted with this tradition, I review it because the figures and works I discuss are in direct dialogue with specific aspects of this tradition that need to be defined. My necessarily selective and general survey is followed by a brief outline of what could be called a postmetaphysical moment, starting with Nietzsche and ending with Lévinas. The sections that follow this are expanded, detailed accounts of how Heidegger, Derrida, and Lévinas have inherited from Nietzsche a dis-appropriative understanding of the truth in art wherein the truth is eternally restituted on the hither side of its deconstruction. What this truth is restituted *as* each time it comes back is, however, not a foregone conclusion.

Chapter 2 focuses on Anton von Webern's "Two Rilke Songs," Op. 8, and considers the interplay between what Heidegger in a seminar on Parmenides calls *veritas* and *aletheia*. Of central importance to me is that Webern is an artist who more than anticipates Heidegger's thinking; he brings Heidegger's thinking into its later phases before Heidegger had even begun his major work. That Heidegger himself was not

receptive enough to developments in the contemporary arts is one of the criticisms this chapter is implicitly making throughout. My main theoretical argument is that the rapport between music and speech in Webern's songs is vexed because, on the one hand, it is inexistent or fleeting at best, and, on the other hand, there is direct correspondence and mutual reinforcement. Yet, how can both these claims be true at the same time? I argue that from the perspective of what Heidegger calls *aletheia* (*Un-Verborgenheit; Ent-Bergung*), Webern's music is intended to undergo a withdrawal or retreat from a human sphere in which art survives its own performance for the sake of reaching a listener. Webern's minimalism, in other words, is not fully intended for human apprehension; it withdraws from presence, that is, from music per se. The Rilke text, however, is selected by Webern to address a woman with whom he is in love. As such, it is meant to correspond to human passion and to another human as *envoi*. In this sense the songs function as *veritas*: the truthful correspondence of what is said to what is meant. But what does it mean that a double movement exists between the work's emergence for the sake of a being-for-another and the work's withdrawal into a peal of stillness that refuses human contact and the human as such? The answer is that the truth in art is divisible and that one has to see that truth in terms of an interplay between *veritas* and *aletheia* that is, in Heidegger's terms, dis-appropriative (appropriable and expropriable). This conception serves as a basis for the analyses to follow in which the destruction and recovery of truth manifest themselves quite differently.

Chapter 3 is on the site-specific performances, sculptures, and photo-documentation of the English earth artist Richard Long. What interests me about Long is that his work speaks to deconstruction in a way that none of Derrida's own artistic examples have done. As in the case of Heidegger, there seems to be a curious avoidance on the part of Derrida of nonliterary artists whose work could be considered theoretically radical by contemporary standards. In considering Richard Long, I purposely tried to find an artist whose work looks more metaphysical than it is, if not to say someone whose work cannot be easily classified. Long is and is not making sculpture, performance, photography, installations, concept art, or artists' books. For me a guiding question is how in Long's work aesthetics is restituted after the end of metaphysics and how that necessitates a dis-appropriative understanding of truth and

the Heideggerian concept of regioning in which a re-appropriative aesthetic moment is quite dominant. Whereas in Webern the work does not survive its performance, in Long the work is often but the trace of a work that is inappropriable to begin with. Not only that, but Long's installations and documentations suggest that the work belongs to a region quite alien to the human, even if traces of a human touch are to be found. This retreat from the human, literalized in Long's lonely walks in remote deserts and mountains, requires an understanding of truth that is disappropriative. His photographs, however, are vestiges that utterly contradict this understanding of truth, because they re-appropriate an aesthetic that one might have thought Long had cast off.

Chapter 4 turns to the poetry of Paul Celan and René Char. Celan translated all of Char's "Feuillets d'Hypnos" and, like Char, was very attracted to the thinking of Martin Heidegger. In taking somewhat further the materials on regioning developed in the previous chapter on land art, I investigate the correspondence between Heidegger, Char, and Celan in terms of Heidegger's idea that the neighborhood where poetizing and thinking come into proximity should be dis-appropriative in the sense of Heidegger's most radical formulations of truth. Heidegger's reading of fatherland in Hölderlin is key to such an understanding because it dismantles any metaphysical understanding of ground on which artistic notions of truth can be established. Both Celan and Char exercise a similarly dis-appropriative understanding of place in which language is "disincorporated." This is especially evident in Char's "Feuillets d'Hypnos" and Celan's poetry of the 1960s. In translating Char, Celan often provides somewhat earthier and more historically allusive language as if to resist the degree of aloofness or purity that Char's poetic language has from the everyday world. In doing this, Celan lends to Char's poems a political truth they do not have in and of themselves. This becomes clear in the examples with which I end the chapter. This is but one aspect of a rather complex interplay of problems, however, one of which is the fact that a dis-appropriative aesthetic such as Heidegger's has fascist overtones in which both Celan and Char are implicated despite their best efforts to keep their distance. This is one of the reasons why Celan's poem "Todtnauberg" is of interest: it articulates a love–hate relationship with Heidegger's conception of fatherland that is at once very far from and very near to Celan's own aesthetic.

Chapter 5 expands the concept of regioning as a dis-appropriation of truth to include lighting effects in the fiction of Julien Gracq's *Au château d'Argol* and Maurice Blanchot's "Le Dernier Mot," two fictions written in the late 1930s. Whereas the interplay of lights and darks in Western literature has overwhelmingly been tied to the truth of an ethical disclosure of good and evil, in Gracq and Blanchot the interplay of light is beyond good and evil. Setting does not truthfully link the aesthetic to the ethical but, rather, dis-appropriates that link. The fluctuation of light and dark is an unanswerable destruction in which truth as ethical correspondence falls into oblivion and violence takes its place. Yet in Gracq this violence has the effect of ultrarefined discriminations that restore the aesthetic in the very place where ethics is dis-appropriated. In Blanchot the violence of what appears to be a national revolution clears away any reliable *mot d'ordre* and forces the protagonist to acknowledge a "last word" that is orphaned from any regime of truth even while it refers back to an old order and forward to a new one. Here, too, ultrarefined discriminations occur in the wake of the destruction of place as the destruction of truth. In both Gracq and Blanchot literature dis-appropriates the symbolic by introducing a truth that is heteronomous and, as such, both violently anarchic and discriminatingly regimented. That this violence is intended to supersede even the violence of, say, fascism is a real possibility. At least, this seems to be at issue in a review Blanchot wrote of Gracq in which he faulted Gracq's use of the epithet. Taken as a whole, this chapter is on the sovereign last word whose essence is fluctuation and differentiation: radiant suspensions of light.

Chapter 6 is about the radiant suspensions of Marguerite Duras's Aurélia Steiner cycle, which I discuss by way of Derrida's very difficult essay on Lévinas, "At This Very Moment in This Work Here I Am" ("En ce moment même dans cet ouvrage me voici"). The Aurélia Steiner films and texts are appropriate because they exemplify a seriality that is very compatible with what Derrida is discussing when he talks about nonidentity within identity. This, too, challenges a mimetic notion of truth (*veritas*), something that in both Lévinas and Duras pertains rather directly to the question of ethnic identity. Aurélia Steiner is the Jewish name for a heteronomy out of which Duras constructs a number of fictions and films. She is "le dernier mot" in Blanchot's sense, a figure of truth that stands apart from any

regime of truth, including her own story as the narrative of her identity. Yet, whereas the heteronomy of the Sovereign in Gracq or even Blanchot was predicated on a demise of the ethical, in Duras it is the ethical that is restored, though not without its own divisions and contradictions, among which are Duras's own confused attitudes, some of which are very troubling, about Jews. Important, therefore, are the synchronization and asynchronization of those relations whereby Duras constructs the identity of Aurélia Steiner. Like the following chapter, this one considers the photograph of a child, in this case, Aurélia Steiner as the girl with green eyes. How this photograph suggests a coincidence analogous to the truth conditions of what Derrida and Lévinas call the "en ce moment même" is very relevant.

Chapter 7 contrasts with the Duras chapter by addressing a photograph taken by Nazi forces during the Second World War of a boy whose name we do not know and whose fate we can only imagine. In this case, the instantiation of an identity is no longer a matter of art or fiction but of a real person whose identity will never be known to us. How the image of this person exceeds the frozen condition of his immediate situation is something that from a Lévinasian perspective accedes to a truth in art that could come only from a place exterior and remote from art, the anti-aesthetic. The turn from art to life is important in that we have an image whose truth is much more ostensibly of the *veritas* variety. Its realism is unimpeachable. Yet, even here there are other understandings or constructions of truth that one could consider, for example, Lévinas's idea that the truth is the *il y a*, or "there is," of being that is experienced as horror: the burden, terror, and pain of the *Da* of *Dasein*. This is a truth that one cannot grasp by withdrawing into oneself or by retreating from the human; rather, it is the truth encountered in the face-to-face wherein is revealed the disappropriative truth of Hebraic law. That this law is not reducible to our usual notions of humanity or humanness means that we are considering a conception of truth that is heteronomous and beyond essence, what Lévinas calls, the otherwise-than-being.

PORTIONS of this book were read at the Modern Language Association, Society for Phenomenological and Existential Philosophy, the University of London, the University of Kansas, Emory University, the University of Iowa, and the University of Minnesota. I am especially

grateful to Gerald Bruns, who arranged for me to deliver three of the chapters as the Ward Philips Lectures at the University of Notre Dame in 1993. I enjoyed my visit there. Three chapters have appeared in slightly different versions: "Brushed Path, Slate Line, Stone Circle" in *Deconstruction and the Visual Arts*, ed. Peter Brunette and David Wills (Cambridge: Cambridge University Press, 1994, reprinted with the permission of Cambridge University Press); "Aurélia Steiner or Beyond Essence" in *Auschwitz and After*, ed. Larry Kritzman (New York: Routledge, 1995); and "Of the Eye and the Law" in *Unruly Examples*, ed. Alexander Gelley (Stanford: Stanford University Press, 1995).

The poems by Paul Celan are reprinted by permission of the publishers. "Was Geschah?" in *Die Niemandsrose* © S. Fischer Verlag, Frankfurt am Main, 1963; "Todtnauberg," in *Lichtzwang* © Suhrkamp Verlag, Frankfurt am Main, 1970; and the translations, "What Occurred?" and "Todtnauberg," in *Poems of Paul Celan*, translated by Michael Hamburger, copyright © 1972, 1980, 1988 by Michael Hamburger, reprinted by permission of Persea Books, Inc. The quotations from poetry by René Char are reprinted by permission of the publishers: "Feuillets d'Hypnos," "La Bibliothèque est en feu," "Sept parcelles du Lubéron," "Le Jonc ingénieux," in René Char, *Œuvres complètes* (Paris: Gallimard, 1983) © Éditions Gallimard; the German translations by Paul Celan, in *Gesammelte Werke* (Frankfurt am Main: Suhrkamp Verlag, 1986) © S. Fischer Verlag GmbH, Frankfurt am Main, 1959; and the English translations by permission of Cid Corman. Quotations from *Tales of Horror*, by Laura Mullen, are reprinted courtesy of the author. The photograph by Richard Long is reprinted courtesy of the author. The photograph of Aurélia Steiner appeared in *Cahiers du Cinéma*, 1980. The photograph of the child in the Warsaw ghetto is reprinted by permission of YIVO Institute for Jewish Research, New York. The introductory theoretical chapter, as well as the chapter on Paul Celan and René Char, were written or completed during a sabbatical leave in the fall of 1994 granted by the University of Iowa. I want to thank my past editors who not only asked that I write new work for their anthologies but also stuck by it; my pieces are layered and require some acquaintance with the materials. Fred Moten was kind enough to read and comment on a couple of the chapters, and Sabine Gölz was a good sport about letting me ply her with questions about Celan. Alex Gelley critiqued my introductory chapter; Ned Lukacher advised me on some

of the translations; and Dudley Andrew located and ordered the Duras films for study. I also am grateful to Bernhard Kendler at Cornell University Press for his continued interest in my work and for his support.

HERMAN RAPAPORT

Grosse Pointe

1 Is There Truth in Art?

Before one considers how the question of the truth in art has been attacked, subverted, or deconstructed, it is helpful to note that the history of metaphysical articulations of truth in Western art reflects an ongoing attempt throughout the different epochs to bridge what the Ancient Greeks perceived as an ontological difference between beings and Being.[1] Essentially, the traditional conception of truth, by no means naive or easily dismissed, verifies that beings are grounded in Being, a verification that, oddly enough, has been mediated by the arts. Plato was fully aware of this oddity in that he found it extremely questionable in the *Republic* to base one's understanding of the truth of Being on a mimetic relation or *illusion* whose being is difficult to establish with any certainty. What is the being of an epic like the *Iliad*, a piece of music like Claudio Monteverdi's *Vespro della Beata Vergine*, or of a painting like *Gilles* by Antoine Watteau? Do these works have being as art independent of a relationship with a beholder, let alone a community or culture? Do they simply simulate with our cooperation a being that they do not, in fact, have? Is non-being part of the es-

1. For other aspects of the selective history I tell, see Carlo Sini's excellent *Images of Truth: From Sign to Symbol*, trans. Massimo Verdicchio (Atlantic Heights: Humanities Press, 1993). Sini's main topics include the experience of truth, the uncovery of truth as social process, truth and language, truth as correspondence to reality, and truth in relation to Being. Another closely related text is John Sallis's *Double Truth* (Albany: State University of New York Press, 1994), in which he develops Heidegger's understanding of truth in art as an iteration or redoubling wherein the self-identity of truth is both affirmed and subverted. Sallis's work is a good introduction for my own project because he is analyzing aspects of a metaphysical apprehension of art that focuses largely on mainstays like origin, intention, imagination, and mimesis.

sence of the being of the work of art? Or is that non-being merely a
symptom of the sham or illusion that is the work of art? Given how
open these fairly fundamental questions are, can one responsibly even
begin to talk about something like the truth in art? For is it not a leap
to begin discussing how a work vouches for the bridging of the differ-
ence between beings and Being if we have not resolved the question of
how the work itself has being or participates in being?

Martin Heidegger, in his deliberations on the truth in art, took up
Plato's question as follows: "What sort of thing is the work of art?" To
this question Erwin Panofsky had in 1924 already provided a tradi-
tional answer in the title of his celebrated book *Idea: A Concept in Art
Theory.* Still required reading for those interested in surveying the
metaphysical underpinnings of Western conceptions of the visual arts,
Panofsky's book selectively develops aspects of a theory of art that
from Antiquity to the Renaissance depends on a notion of the Idea—
the inspired thoughtful form given to matter by the artist.

As Panofsky noted, Aristotle had theorized that in the relationship
of form to matter the truth of the work is made conspicuous to the
beholder. In taking distance from Plato's *Republic,* Aristotle argued
that art is not a counterfeit removed from the pure forms, but some-
thing that is *both* thingly and cognitive, physical and metaphysical,
substantial and insubstantial, concrete and intellectual. This meant
that one ascribed to the work a thingly character appropriate to be-
ings and a transcendental or divine character appropriate to Being. By
conferring idea on substance, the artist disclosed a relationship be-
tween Being and beings that manifested itself as the essence or truth
of the work.

Aristotle also substituted for the divine forms of Plato a notion of
excellence, both moral and intellectual, which in the *Nicomachean
Ethics* is correlated to human action. The forms of excellence are spe-
cifically determined on the existential ground of our being human, on
the basis of what it is we can actually achieve, and not on the basis of
what can be imagined or intuited in some divine realm beyond the
human. Therefore when Aristotle discusses the truth in art, it is clear
that for him the soul has access to truth through art only because it
results from a reasoned state or human capacity to make something.
"All art is concerned with coming into being, i.e., with contriving and
considering how something may come into being which is capable of

either being or not being, and whose origin is in the maker and not in the thing made."[2] Art does not concern things that *necessarily* come into being or that come into being on account of nature, but with the making of things that are *otherwise* or *different* from the things of necessity or of nature.

The *Nicomachean Ethics* suggests that if the work of art is to give the soul insight into the truth, that work has to be "excellent": reasonable, well balanced, just, and hence, good. Moreover, because this excellence necessarily brings things into proper balance, Aristotle says that it aims at the intermediate, the *formal* point between excessiveness and deficiency where neither obtains. This golden mean is where justice is to be found, and in the *Poetics* it is readily apparent that the point of just relation is to be formally or structurally located at the point in tragedy where the reversal of fortunes comes about, that is, the center of the work. For Aristotle, then, the form of the work, if it is to be good, true, and beautiful, ought to reflect mimetically the ethical principle of the intermediate, because in that way both form and idea are wedded. Key to this view is that only by way of the balanced or ethical form of existential being—that which makes us stand out as most human—does the mimetic nature of the work of art accede to the truth of beings and, ultimately, Being. In other words, for Aristotle, *existential difference* mediates ontological difference and exists in right balance with it.

The opposite, however, was maintained just as forcefully by Neoplatonic revisionists like Plotinus for whom art bridges beings and Being. Plotinus was motivated to resolve what Aristotle saw as a contradiction in Plato's doctrine of pure forms: that the pure form cannot be at once transcendent and immanent with respect to the things themselves. This is why Aristotle stressed the activity of giving form to matter and why he thought in terms of material, efficient, formal, and final causes. Plotinus, however, thought the problem was resolved if one admitted to a graduated ontological order whereby the pure forms or archetypes are embodied according to a system of levels whose difference breaks with the law of contradiction in which something cannot be at once both identical and different. Plotinus's *En-*

2. Aristotle, *Complete Works*, ed. Jonathan Barnes (Princeton: Princeton University Press, 1984), 1140a.11.

neads, which were written over a period of many years, offer various explanations. In *Ennead* V.8, we are told: "From the beginning to end all is gripped by the Forms of the Intellectual Realm: Matter itself is held by the Ideas of the elements and to these Ideas are added other Ideas and others again, so that it is hard to work down to crude Matter beneath all that sheathing of Idea. Indeed, since Matter itself is, in its degree, an Idea—the lowest—all this universe is Idea and there is nothing that is not Idea as the archetype was."[3]

In *Ennead* VI.5, Plotinus imagines a series of circles whose centers converge about a central axis of Being and whose radii represent particular beings. Each circle is identical to the All, even though each circle is, at the same time, different or particular: "Thus we may liken the Intellectual Beings in their diversity to many centers coinciding with the one center and themselves at one in it but appearing multiple on account of the radial lines—lines which do not generate the centers but merely lead to them. The radii, thus, afford a serviceable illustration for the mode of contact by which the Intellectual Unity manifests itself as multiple and multipresent."[4] Because the doctrine of Intellectual Being does not make a sharp division between beings and Being, art cannot be hopelessly debased, as its truth is reflected in how the work participates in an Idea or Ideal Form. In what is perhaps Plotinus's most influential statement about art, gathered in *Ennead* I.6, we read: "Where the Ideal-Form has entered, it has grouped and co-ordinated what from a diversity of parts was to become a unity: it has rallied confusion into cooperation: it has made the sum one harmonious coherence: for the Idea is a unity and what it molds must come to unity as far as multiplicity may." In other words, the work of art *imitates* Being insofar as Being is that unity which is also a multiplicity. Beauty, according to Plotinus, is present the moment the disparate is given Ideal-Form, symmetry, and, hence, "gracefulness." In such gracefulness the soul rejoices, is uplifted, and moves in "the realm of Truth."[5] Beauty not only is characteristic of an excellence or superiority over imperfect or earthly things, but also it is of the order of truth, the consequence of a superior intellect that "knows" Intellectual Being; as such, beauty is a reflection of the transcendent and

3. Plotinus, *The Enneads* (London: Penguin, 1992), pp. 417–18.
4. Ibid., p. 460.
5. Ibid., p. 47.

eternal. Consequently art points to the eternally beautiful Idea that is divine, true, good, and has everlasting Being.

Whereas Aristotle's understanding of art was modeled on an ethics that was existential (human), Plotinus based his understanding of art on an ethics that was ontological (not human). For Plotinus a divine truth could be disclosed in art because everything is sheathed in the divine, but for Aristotle the truth of ethics could be demonstrated through art as human moderation, temperance, and the median point between excess and deficiency—in other words, in terms of formalizing everyday human practices that constitute a way of life. Continental philosophy has inherited this division of views between the *existential* and *ontological,* an inheritance key to the interpretation of truth in the work of Nietzsche, Heidegger, Derrida, and Lévinas.

During the medieval period the question of truth was debated among Aristotelians and Neoplatonists, nominalists and realists, rhetoricians and logicians, but the Church Fathers did, with varying success, marry the views of Aristotle with those of Plotinus, largely because the teachings of Christ were predicated on the intersection of human being ("thou shalt love thy neighbor as thyself") and divine being ("in the beginning was the Word"). In short, the existential difference on which an ethics of human behavior depends mediates the ontological difference where divine law is revealed. That Christ was both man and God meant that by way of example he is the form that brings the existential and ontological into harmonious and mutually reinforcing relation. By the thirteenth century we see this metaphysical conjunction in French cathedrals where Christ is represented as both creator and redeemer. According to Émile Mâle, Hugh of St. Victor argued that the world is a thought of God realized through the Word, the Word being identified with Christ. Émile Mâle explains further:

> If this be so then in each being is hidden a divine thought; the world is a book written by the hand of God in which every creature is a word charged with meaning. The ignorant see the forms—the mysterious letters—understanding nothing of their meaning, but the wise pass from the visible to the invisible, and in reading nature read the thoughts of God. True knowledge, then, consists not in the study of things in themselves—the outward forms—but in penetrating to the inner meaning intended by God for our instruction, for in the words of Ho-

norius of Autun, "every creature is a shadow of truth and life." All being holds in its depths the reflection of the sacrifice of Christ, the image of the Church and of the virtues and vices.[6]

In this summation of thirteenth-century Christian theology, we can see the extent to which an essentially Neoplatonic view of how nature is imbued with God's intelligence is mediated by an Aristotelian view that emphasizes the existential in terms of the virtues and vices, the church, and Christ's sacrifice. Evidence of this view is widely represented in Gothic cathedrals where stained glass and statuary reflect the thinking of Hugh of St. Victor, Vincent de Beauvais, Peter Lombard, St. Bonaventure, and others.

During the Middle Ages, however, there was resistance to the exegetical model. In the thirteenth century, for example, Duns Scotus's "Concerning Human Knowledge" takes issue with passages in St. Augustine's *De Trinitate* IX. St. Augustine: "But we gaze upon the indestructible truth by reason of which we may define perfectly what the mind of man should be according to the eternal reasons." Again, "In the eternal truth from which all temporal things are made, we behold the form . . . and we have within us like a Word the knowledge of what we have conceived."[7] Duns Scotus takes this as a commonly held metaphysical ground for knowledge that curiously contradicts the New Testament. Quoting Romans, "for since the creation of the world, God's invisible attributes are clearly seen . . . being understood through the things that are made."[8] Here Duns Scotus perceives a bifurcation of truth into two exemplars. There is the "created exemplar [that] is the species of the universal caused by the thing," and there is "the uncreated exemplar [which] is the idea in the divine mind." Duns Scotus concludes that "consequently, a twofold truth and twofold conformity to an exemplar exists."[9] Where the two exemplars conform, there we have certain truth. However, Duns Scotus rejects this proposition because in his view a double notion of truth conspires against "natural knowledge" by privileging a metaphysical exemplar. In a passage that reads like a protodeconstruction of meta-

6. Émile Mâle, *The Gothic Image* (New York: Harper and Row, 1972), p. 29.
7. Duns Scotus, "Concerning Human Knowledge," in *Duns Scotus: Philosophical Writings*, trans. Allan Wolter (Indianapolis: Hackett, 1987), p. 97.
8. Ibid., p. 98.
9. Ibid., p. 100.

physics, Duns Scotus takes issue with the rhetoric of light and the idea that the visible light of our realm requires the invisible light of God's realm if anything is to be truly known:[10]

> Either the Eternal Light [*lux aeterna*], which you say is necessary in order to have unadulterated truth [*sinceram veritatem*], causes something naturally prior to the act or not. If it does, then this thing is produced either in the object or in the intellect. But it cannot be produced in the object, because the object, insofar as it exists in the intellect, has no real existence but only intentional existence. Therefore, it is incapable of any real accident. If this thing is produced in the intellect, then the Eternal Light transforms [the mind] to know pure truth only through the medium of its effect. If this be the case, then it seems that common opinion attributes knowledge to the Uncreated Light to the same extent as does this, for the common view assumes that knowledge is seen in the active intellect, which is the effect of the Uncreated Light, and indeed in a more perfect effect than this accidental created Light would be. If this Uncreated Light does not cause anything prior to the act, then either the Light alone [*sola lux*, that is, the light we actually see] causes the act [of Knowledge], or the Light with the intellect and object do so. If the Light does so alone, then the active intellect has no function whatsoever in knowing pure truth. But this seems inconsistent because the latter is the most noble function of our intellect.[11]

According to Duns Scotus, there is no correspondence or logical account that would explain the connections and interrelations between created light (what we physically perceive), uncreated light (what we know by way of divine revelation), and the intellect. Why do we need uncreated light to see with created light? Anyway, if created or uncreated light were entirely fundamental, why would we have to think at all? Does anyone seriously believe that thinking is passively created at the juncture of uncreated and created light or that its act can be shifted or displaced in such a way that it takes place *before* it takes place? Why is thinking predicated on some remote causes such as the uncreated light (for example, the revelation of truth in being) when, in fact, there is much evidence to suggest that eternal rules can be

10. Henri de Lubac traces the popularity of this notion to St. Gregory for whom light was a metaphor for the faith in Christ required to illuminate the scriptures and thereby reveal the true essence of the literal, the moral, and the spiritual. St. Gregory evidently adopted this from St. Augustine. See *Exégèse médiévale* II.1 (Paris: Aubier, 1961), pp. 537ff.

11. Duns Scotus, "Concerning Human Knowledge," pp. 121–23.

found more immediately by the intellect in the things themselves?
Such questions take us in directions that obviously do violence to a
theology that presupposes the notion of a *speculum* in whose reflec-
tion a direct correspondence between ourselves and God can be ascer-
tained. Having called this theological presupposition into question,
and with it the conjunction of the existential and the ontological,
Duns Scotus writes the following. "I say that all the intelligibles have
an intelligible being in virtue of the act of the divine intellect. In these
intelligibles all the truths that can be affirmed about them are visible
so that the intellect knowing these intelligibles and in virtue thereof
understanding the necessary truths about them, sees these truths in
them as in an object."[12] Having reformulated the thinking of the di-
vines in a way that does not appear to controvert exegetical tradition,
Duns Scotus has, in fact, taken the mirror out of theology whereby
the divine and the human were joined.

The Renaissance discovery of perspective in painting is reminiscent
of Duns Scotus in that it imagines a picture as a unique and entire
form or idea deemed objective, logical, rational, and scientific. Bru-
nelleschi's discovery of the vanishing point reinforced the totalizing
effect of perspective even as it also provided an ineffable point of
depth beyond the totality or form as its metaphysical signature. As
Panofsky argued, even though an abstract metaphysical idea, perspec-
tive was also seen as a faithful and concrete representation. Moreover,
that faithfulness or "realism" was seen as a guarantor for the validity
of the idea and the form, a notion inherent in Duns Soctus and still
dominant in Western societies. Realism was taken as evidence that the
visible, as perspective, puts us into relation with moral and meta-
physical truth, hence bridging beings with Being. Perspective, in
short, was viewed as itself the truth in painting, just as harmony in
music would much later establish itself as the truth in sound, given its
own logocentric bias for the tonic and the "well-tempered" musical
palette.

As Panofsky shows, however, there was considerable debate, both
implicit and explicit, over the idea or design of the work of art. Was
the idea to be found in nature and copied? Was the idea indepen-
dently engendered in the mind of the artist by means of experiencing

12. Ibid., p. 123.

and observing reality? Was it, as the medieval divines thought, the reflection of an original image immanent in God's intellect, a design from which the creation took its form? In other words, where exactly was the truth in art? Eventually classical views of art would turn against both metaphysics and empiricism. Idealism and naturalism were suddenly both untenable, the former being identified with un-verifiable Neoplatonic notions, the latter dismissed simply as the "aping of nature." Hence a normative, "law-giving" aesthetics would ally the truthful idea in art with reason and law. Of course, Renaissance artists were much freer than their medieval precursors to experiment with conceptual languages that had been, by the seventeenth century at least, somewhat, if not entirely, discredited. According to Georges Didi-Huberman, the paintings of Fra Angelico already played havoc with received tradition in the fifteenth century.[13] Not surprisingly, by the time perspective came into vogue, artists like Velasquez would exploit its contradictions in order to uncover paradoxical or illogical consequences that would result in calling its metaphysical presuppositions into question. J. S. Bach's *Art of the Fugue,* stylistically anachronistic for its time, similarly takes an established artistic language and pushes its logocentricism to the breaking point.

Michael Fried has argued that during the Renaissance the autotelic possibilities for the work of art became exceedingly self-evident; hence, it is not surprising that by the eighteenth century questions of individual absorption before the work become more and more pronounced.[14] As the writings of Diderot suggest, the work is an idea in whose total perspective or form we lose ourselves. This absorption would be defined in many ways during the nineteenth century, whether in terms of sharpening the faculties (Kant), the aesthetic play drive (Schiller), dialectical sublation (Hegel), or critical disinterestedness (Kant, Arnold). Already during the nineteenth century, however, modernist works of art were not only holding attention in order to structure complex cognitive relationships but were also scandalizing attention. This meant that art was quickly becoming an object intended for provocation rather than mere contemplative absorption. In

13. Georges Didi-Huberman, *Fra Angelico: Dissemblance et Figuration* (Paris: Flammarion, 1990).

14. Michael Fried, *Absorption and Theatricality: Painting and Beholder in the Age of Diderot* (Berkeley: University of California Press, 1980).

fact, the artistic affront to received ideas practiced by Courbet, Manet, Cézanne, and Picasso eventually led to the academic view widely accepted in our time that art is criticism and that the proper response to it comes about through university-sponsored research. The operative assumption is that the truth of the work is identical to its performance as a criticism whereby received meanings are overturned, transvalued, disrupted, and reconfigured. As criticism (or the idea of the work *as* criticism and hence *as* "research"), works of art are supposed to routinely question aesthetic and metaphysical protocols, among them, beauty, harmony, grace, balance, coherence, and truth. Although late modern works by artists such as Jackson Pollock were composed to challenge and critique traditional aesthetic assumptions about painting and truth, these works were still recoverable as a testament to the indomitability of the human spirit in the face of cultural dehumanization. What links artists as different as Marcel Duchamp, Jackson Pollock, and Eva Hesse is that in each case critics locate the truth of their work in their resistance as artists to the cultural establishment around them. For all its opposition to an aesthetics rooted in German idealism, even minimalist art has not been able to give up the notion that works of art are supposed to resist their culture; hence, the controversy surrounding Richard Serra's *Tilted Arc,* a site-specific sculpture made for the Federal Plaza in New York City which was removed in 1989 after protest by citizens that the work was ugly and obstructed normal pedestrian traffic flow. In this case, the truth of the work was thought by Serra and his supporters to be disclosed in its critical opposition to the implicit aesthetic assumptions held by government and the general public about sculpture. Admittedly, since the 1960s it has become increasingly difficult to determine whether artistic talent, content, form, or even intention are relevant anymore to what many people call "art." Yet, it is apparent that the less art has come to resemble art (anti-mimeticism could be said to be a fundamental ground for much recent art), the more it advances itself as resistance, criticism, and, in very recent years, social protest. For example, Jenny Holzer, Barbara Kruger, Hans Haacke, Chris Burden, Cindy Sherman, Martha Rossler, Judy Chicago, and Yvonne Rainer are all essentially thesis artists whose work represents radical (i.e., critical) ideas about art in its relation/nonrelation to other art, if not to the world in general. In them, the presupposition of a truth in art is uncontested if

only because their work is didactic, often to the point of preaching to
the viewer.

UNDOUBTEDLY, the most significant precursor of a postmetaphysical
consideration of art and truth is Friedrich Nietzsche, whose aphorism
"We have art in order not to die of the truth"[15] exposes a number of
theoretical aporias. When Nietzsche wrote that "we have art in order
not to die of the truth," he self-consciously inverted and ironized a
metaphysical cliché from antiquity that asserts that we have art in order
to live the truth. Whereas the inversion calls the presumption of truth
into question, it did not escape Nietzsche that he was merely displacing
one proposition about truth by substituting another in the form of an
aphoristic critique. He knew that in the subversion of truth there is
simultaneously a *restitution* of it in the form of a truth *of* truth. This
means that whenever one asks a question like "Is there truth in art?",
the issue is not a matter of the presence or absence of truth—is there
truth in art or not?—but of the displacement of one truth by another.

In *Spurs,* Derrida notes that Heidegger had discussed this practice
of reversal, or "Umdrehung," in his *Nietzsche,* where he "emphasizes
the very strongest of torsions, that in which the opposition which has
been submitted to reversal is itself suppressed."[16] Nietzsche, in other
words, does not simply overturn in order to establish another hier-
archy, but, rather, to transform value and hierarchy structurally. This
means suspending the priority of one variant over the other while
nevertheless turning them upon one another so that their differences
can be accounted for. When Nietzsche therefore advances an aphor-
ism that asserts the truth that "the truth in art" has no truth, he is
proposing a negative theology that is just as grounded on truth as the
statement it is trying to replace. It is surprising how many contempo-
rary critics, such as Terry Eagleton, fall into such a negative theology
without being aware that a metaphysical restoration is occurring in
the very place where metaphysics is supposedly being surpassed.

However, Nietzsche enables us to consider this truth-effect as "eter-

15. Friedrich Nietzsche, *The Will to Power,* sec. 822 (1888). I prefer the above translation
by Justin O'Brien (in Albert Camus, *The Myth of Sisyphus and Other Essays* [New York:
Alfred A. Knopf, 1955], p. 69) to Walter Kaufmann's stilted "we possess art lest we perish of
the truth."

16. Jacques Derrida, *Spurs* (Paris: Flammarion, 1976), p. 65.

nal return," the coming back of the same as different, or what Derrida has called "restitution." Hence at the outset of "Restitutions of the Truth in Pointing" Derrida writes:

> *Returning* will have great scope [*portée*] in this debate (and so will *scope*), if, that is, it's a matter of knowing to whom and to what certain shoes, and perhaps shoes in general, *return*. To whom and to what, in consequence, one would have to *restitute* them, render them, to discharge a debt . . . to discharge a more or less ghostly debt, restitute the shoes, render them to their rightful owner; if it's a matter of knowing from where they *return* . . . *outside* a picture, inside the *picture*, and third, as a picture, or to put it very equivocally, *in their painting truth.*[17]

Derrida modifies Nietzsche's "eternal return" by demonstrating that the indissociable thing that returns is only a share or cut (in this case, a divisible pair of shoes) that can, at best, only partially discharge a debt to the truth—in this case, the truth in art.[18] This is a point we will re-encounter in later chapters where the repetition (restitution or eternal return) of the metaphysical occurs at the hither side of its deconstruction, the return of metaphysics as something dissociable/indissociable that is and is not recognizable *as* metaphysics. Indeed, this is a claim I will be making for the aesthetic: that in our epoch of the end of beauty there is a restoration of the beautiful that is and is not identical to what one has commonly understood by this term. That this phenomenon of return or restitution is linked to the dis-

17. Jacques Derrida, *The Truth in Painting*, trans. Geoff Bennington and Ian McLeod (Chicago: University of Chicago Press, 1987), pp. 257–59.

18. Jacques Derrida, in *Ear of the Other* (New York: Shocken, 1985), speaks of the eternal return as an affirmative insistence or repetition that is selective with a differential relation of forces. This is essentially the condition under which the shoes return in "Restitutions," where the differential relation of forces is articulated in terms of so many different frames (outside the painting, inside the painting, as the painting, etc.). "Rather than a repetition of the same, the return must be selective within a differential relation of forces. That which returns is the constant affirmation, the 'yes, yes' on which I insisted yesterday. That which signs here is in the form of a return which is to say, it has the form of something that cannot be simple. It is a selective return without negativity, or which reduces negativity through affirmation, through alliance or marriage [*hymen*], that is, through an affirmation that is also binding on the other or that enters into a pact with itself as other." In *The Ear of the Other*, Derrida considers the eternal return in terms of Nietzsche's signature, in whose repetition his legacy is apportioned, divided, or parceled out. "The eternal return always involves differences of forces that perhaps cannot be thought in terms of being, of the pair essence–existence, or any of the great metaphysical structures to which Heidegger would like to relate them" (pp. 45–46).

placement (difference) and repetition (identity) of truth in the work of Derrida and, of course, also Nietzsche suggests that posing the question of truth in art is much more than a belletristic gesture whose purpose is to separate art from life.

Of course, Nietzsche's aphorism is a direct attack on belletristic understandings of art and truth because, even if the truth is fated or destined to return, there also is the implication, relevant to Heidegger, that the *true* relation between art and truth is suppressed and falsified by the copula "is," which functions to yoke them together as if they were identical or, at the very least, teamed up. Nietzsche recognized that the Neoplatonic conjoining of art and truth was everywhere embedded in nineteenth-century thought, for example, in Sainte-Beuve's insistence that a classic embodies unequivocal moral truth, eternal passion, as well as thoughts beautiful in themselves; or, Matthew Arnold's conviction that "the substance and matter of the best poetry acquire their special character from possessing, in an eminent degree, truth and seriousness."[19] It is this embodiment or possession of truth by art that Nietzsche questions because he suspects that the *truth* of art is that truth and art are not ontologically equivalent and therefore not grounded in a metaphysical identity in which we can situate ourselves as cultured beings.

Whereas Heidegger came to a similar conclusion based on his meticulous analyses of the language of metaphysics in antiquity, Nietzsche's suspicions are based on something far more immediate: his distrust of human motivations. Why are people so interested in telling the truth, given that they seem to have a natural inclination to lie? Nietzsche's answer is that society is afraid of the liar because that person puts us into an unreliable relation to the world. Lies are destabilizing and can be very dangerous, especially when perpetrated by those who have the power to mislead great numbers of people and put them in harm's way. Truth, therefore, is a condition of being-in-the-world which the arts, ironically, have been enlisted to reinforce. Whereas the contradiction scandalized Socrates, it was resolved by Aristotle, who rehabilitated art as equipment for living. This enlistment of art into the domain of a truthful correspondence to the

19. *Critical Theory since Plato*, ed. Hazard Adams (Gainesville: University Press of Florida, 1990), p. 607.

world would all be well and good, Nietzsche tells us, were it not for the fact that people cannot face the truth about themselves. Neither Plato nor Aristotle believed that metaphysics was essentially an accomplice to existential deficiency, the unimpeachable ground on which self-deception, bad faith, and cruelty to others were both justified and masked. For the ancients held themselves above cynicism: the view that human failings motivate the creation of a compensatory metaphysic in which ontology endows human actions with a standard of truth—the notion of the good—that legitimizes the very culture that violates it at every turn. That the truth in art is fundamental to this project is self-evident to Nietzsche.

What Heidegger sees as a metaphysical falsification motivated by a pragmatic will to power, Nietzsche saw as a consequence of human weakness and fallibility. Art takes the place of a truth we cannot acknowledge because of truth's overpowering and humiliating irrefutability. It is because the truth *is* true that we cannot face it. That is why the truth about ourselves has to be displaced by a metaphysics of truth, itself a philosophical art or fiction, that forgets the truth that motivated it. Art is therefore to be considered a species of metaphysics that, like metaphysics itself, forgets the truth in order that we not die of it even as it asserts a higher truth in its stead. The point here is not that art is simply constructed as a metaphysic and might well be constructed otherwise, but that art is fated to be metaphysical because we are a species capable of experiencing shame. This is a point that is entirely absent in the writings of Heidegger, Derrida, and Foucault, for whom Nietzsche has been so important. Nietzsche's incontrovertible insight is that to live under the unbearable weight of a truth that shames and humiliates us would not only require us to take on a moral responsibility for actions we cannot atone for, but would necessarily paralyze and negate all of our aspirations. From a Nietzschean perspective, therefore, a mandate to own up to the truth is entirely unrealistic because it is impossible, a fact that the Nazis surely gleaned from Nietzsche's writings and acted upon. Here, of course, we can see that it is not enough to say that truths are merely transitive, contingent, or constructed. For the truth in art is, however one constructs it, a matter of cultural group psychology, of the relation of truth to a being-in-the-world, if not of "the good." Nietzsche's aphorism might mean, therefore, that we have art in order not to die of our selves—of the awful truth of what we are.

Nietzsche, however, did not succumb to mere skeptical cynicism; that to him was but a species of asceticism. As if predicting the career of Ludwig Wittgenstein, Nietzsche wrote in "On Truth and Lies in a Normal Sense" that "even skepticism contains a belief: the belief in logic."[20] In other words, in the cynical or skeptical abandoning of truth something of it is conserved nevertheless. Nietzsche also suggests that the history of truth may well belong to those truth seekers in whose interest it is to be necessarily jaded. After all, to say that the truth of art is that there is no truth is a metaphysical variation that posits the subject as one who is not mystified, fooled, or *shamed* by things. That academics would readily assume this position is not surprising, given that they are paid not to be taken in by falsehoods and shamed by the untruth. The academic, in other words, is existentially defined as one for whom truth is always to be thought as a critical wariness whose *distance* from truth is its truth. In rejecting that position, too, Nietzsche sets the stage for an eternal and joyful return of truth as something that is other than truth as the metaphysical tradition has known it. In his Nietzsche seminar of 1940, Heidegger introduces us to this restitution of truth when he cites a marginal notation by Nietzsche of 1888: "Very early in my life I took the question of the relation of *art* to *truth* seriously: and even now I stand in holy dread in the face of this discordance."[21] As Heidegger well knew, much of his own thinking about truth was an elaboration of what Nietzsche called "ein Entsetzen erregender Zwiespalt," a stirring, terrifying conflict.

It is in opposition to the metaphysical persistence of art *as* art that the work of Heidegger is oriented, because as his point of departure he considers an understanding of art that comes *prior* to the advent of the Idea. Far from seeing truth as the verification of a bridge between beings and Being, such truth is thought as a *Seinsvergessenheit*, the forgetting or oblivion of Being by which Heidegger meant an appropriative event (*Ereignis*) wherein the relation between beings and Being is disappropriated (*Enteignis*). In Heidegger's lectures on the logos it is the interplay between appropriation and disappropriation that determines language as an event analogous perhaps to Nietzsche's ter-

20. Friedrich Nietzsche, "On Truth and Lies in a Normal Sense," in *Philosophy and Truth*, ed. Daniel Breazeale (Atlantic Heights, N.J.: Humanities Press, 1979), p. 94.
21. Martin Heidegger, *Nietzsche*, vols. 1 and 2, trans. David Farrell Krell (New York: Harper Collins, 1991), p. 142.

rifying conflict or discordance that does not constellate itself as the bridge between beings and Being. In this way, Heidegger alerts us to a prior advent of truth that signals an a priori destruction of truth as the metaphysical ligature between beings and Being. The coming to pass of truth as *Seinsvergessenheit*, therefore, speaks to a very different conception of truth from the one encountered in the brief history outlined, one that would be entirely opposed to maintaining the truthful correspondence of form and matter, beings and Being.

Heidegger, however, is not alone in this view. Such an understanding of truth is also maintained by Emmanuel Lévinas, whose difficult locution "the otherwise than Being" speaks to this sighting of a moment before the metaphysical advent of the Idea or Concept that, in Western thought, has been associated with the Divine, as in, for example, Aristotle's *Metaphysics* and, before that, Plato's *Timaeus*. By the "otherwise than Being," Lévinas is referring to the Law of God that comes prior to the preposition "of" that would relate that Law to the God of our Jewish ancestors. This has immense significance for Lévinas's relationship to the thought of Martin Buber. This location of a philosophical moment prior to Western metaphysics puts into question the very preposition whereby not only the bridge or ligature of law's relation to God is dismantled, but also the *I* to *thou* relation is fissured and invalidated insofar as it hearkens to an Aristotelian conception in which the ethical can be formalized according to a linkage between beings and Being, whether through art or other means, prayer among them. In Lévinas, then, the Law is profoundly unhermeneutical if by hermeneutics one understands interpretation as a bridging of the profane and the sacred by the human. Because the Law is not an idea or concept, it has to be radically re-encountered as something other, as what in many of his writings Lévinas has called the trace.

Although Lévinas has repudiated Heidegger, I think it is fair to say that Heidegger remains a crucial source for Lévinas's thinking, which, in many respects, demonstrates retroactively that for Heidegger there could have been an alternative to the return to the pre-Socratics and to the rehabilitation of a Greek philosophy supposedly thwarted from the start by pragmatism. Lévinas offers an alternative of a Hebrew tradition, namely, that of the Talmud, that in some respects parallels Heidegger's notion of the logos in Heraclitus, where language is

thought of in terms of a gathering, collocation, or assembly of rela-
tions that is violated when it is closed off or boxed in by a meta-
physics of the concept that provides closure and static definition.

Among Heidegger's major efforts in the 1930s was the de-finition of
definition, by which I mean, the breaking open of finite meaning by
establishing a field theory of etymological particles that, not unlike
atomic elements, join and repel one another in a more or less dy-
namic and reactive manner. However, this destruction of metaphysical
definitions is not something Heidegger could have achieved had he
turned to a Jewish tradition. For whatever his attitudes toward Jews
and Jewish history may have been—he was not unambiguous—
Heidegger required the history and disseminative interplay of Ancient
Greek etymologies in order to arrive at an intimation of logos, which,
in turn, required a very different understanding of truth from the
ones inherited from Plato, Aristotle, Plotinus, St. Augustine, Des-
cartes, and Kant.

According to Heidegger, the imposition by metaphysical thinking of
a transcendental Idea was, however violent and destructive in the in-
stituting of rigid conceptual forms, not entirely able to efface some-
thing that remains concealed in the particles of words that, like ety-
mological fossils, enable the researcher to reconstruct a philosophy
that came prior, to the very beginning of philosophy in a figure such
as Anaximander. What comes before is a truth that precedes the for-
malization of the ontological difference between beings and Being
which metaphysics constructs so that it can be bridged. In large part
Heidegger's considerations of truth are an attempt to name or de-
scribe a more originary difference that came prior to its metaphysical
formalization, something we can still glimpse in dialogues like Plato's
Parmenides, in which the demonstration makes undecidable the dif-
ference between being and non-being, the one and the many, identity
and difference, beings and Being.

Jacques Derrida, himself well versed in both Heidegger and Lévinas,
has also considered the undecidable difference prior to metaphysical
difference, and has called it *la différance*. It is well known that in *Of
Grammatology* the notion of undecidable difference was associated
with the arche-trace: writing as trace that comes before the ontologi-
cal difference of metaphysics and that can be read in the wake of the
actual written sign, in particular, the signature. For Derrida, as for

Lévinas, the arche-trace is evidence that the ontological difference be-
tween beings and Being no longer mends a caesura or rift concealed
by the Idea of metaphysics. That this caesura cannot be named, cir-
cumscribed, bounded, or even schematized is also of primary impor-
tance to Heidegger, because the caesura is not an Idea or concept, but
what Heidegger calls "*Lichtung,*" a pun in German that refers to both
a lighting up or brightening and to a clearing or opening. "Otherwise
than Being," this caesura, *différance*, or clearing, precedes the instan-
tiation of the difference between beings and Being.

This brings me to a point relevant to my analyses in the applied
chapters, namely, the relation of the ontological difference between
beings and Being to that of an existential difference between the hu-
man and what I will call the otherwise-than-human. Heidegger's proj-
ect, in *Being and Time*, was largely to call both of these differences
into question, and it is well known that he formulated a notion of
Dasein that would go beyond an Enlightenment conception of the
human, so that, eventually, an existential understanding of Da-Sein
could be uncovered that came prior to the advent of the Cartesian
subject, a Da-Sein that was, from an Enlightenment or humanist per-
spective, otherwise-than-human. This is a crucial point if for no other
reason than that when Heidegger undertook analyses of truth in semi-
nars like *Parmenides*, he did not incline toward a human definition of
truth in the Romanized sense of *veritas*, which was pragmatically as-
sociated with the human. Rather, he inclined to a notion of *aletheia*
that is not only "otherwise-than-human" but also entirely alien to the
metaphysical distinction between beings and Being on which tradi-
tional notions of the human and artistic truth have been based. It is,
moreover, precisely with respect to *aletheia* that Heidegger, in the
controversial *Beiträge zur Philosophie*, situated *Lichtung* in tacit oppo-
sition to *Aufklärung* and meditated on the caesura between beings and
Being as the dis-closure of a truth whose law is made manifest in the
destiny of *Seinsvergessenheit*, the forgetting or oblivion of an appro-
priative event in which the relation between beings and Being is vio-
lently disappropriated for the sake of *Ereignis*, a moment that would
cancel out the connections or relations according to which we con-
ceptualize the work of art *as* art.

Indeed, this clearing or opening of the caesura between beings and
Being is figured in the *Beiträge* as an abyss (*Ab-grund*) that also eradi-
cates an Enlightenment conception of anthropology of which it is

said that man becomes a being on which everything that exists is grounded in the manner of its being and its truth. It is in the eradication of this anthropology that the human gives way to what Lévinas has called the otherwise-than-being, which is also, if one can put it this way, otherwise-than-human. In Derrida this surpassing of the anthropological has occurred most forcefully when he turns to the question of writing. "As the phenomenology of the sign in general, a phenomenology of writing is impossible."[22] Which means that writing is entirely alien to an anthropological phenomenology that understands the sign as an indication or expression uttered or thought by a subject. In Lévinas, the surpassing of the anthropological occurs in an encounter with an Other that implicates one in the Law of God, whose truth exceeds the human as such. This is what Lévinas calls "*le hors du moi*," the beyond-me or outside-me. Crucial for Lévinas is that the beyond or outside exceeds ontological difference—the difference between beings and Being—and requires in its stead an ethics that is not reducible to either ontology or anthropology. In the applied readings to come, I argue that the otherwise-than-human is especially crucial to a consideration of truth from various postmetaphysical perspectives and that its ethical and political consequences are vexing and unpredictable in ways that elude a strictly ideological scripting of ideas. Having given a brief overview of some metaphysical and postmetaphysical orientations to the question of truth in art, I want to develop a far more detailed account of the philosophies of Heidegger, Derrida, and Lévinas relevant to the analyses in subsequent chapters.

HEIDEGGER I: TRUTH AND THE ONTOLOGICAL DIFFERENCE

During the winter semester of 1942–43 Heidegger wrote and delivered yet another seminar on the concept of truth. It is by any account a remarkable text and perhaps his most radical formulation of the problems he had been working on since the publication of *Being and Time*. If *Parmenides* has a major virtue, it is that in making a distinction between *veritas* and *aletheia* it is far more polarized than most of the previous writings on truth. *Parmenides* suggests that by 1942

22. Jacques Derrida, *Of Grammatology* (Baltimore: Johns Hopkins University Press, 1974), p. 68.

Heidegger had become openly hostile to a mimetic imperative in Germany which vouched for the political correctness of works in advance of philosophical inquiry. For this reason, *Parmenides* makes a direct assault on the Roman notion of *veritas*, which in its crudest characterization typifies National Socialist thinking.

Heidegger says that *veritas*, based on the Roman conception of *justitia*, requires the presence of an agent or agency to make a hard and fast distinction between the true and the false, the good and the bad. Heidegger argues that when the Romans contrasted the word *falsum* to the word *verum*, they intended *falsum* to substitute for the Greek term *sphallo*: to overthrow, bring to a downfall, or to make totter. Heidegger insists that, although this distinction typifies a Roman view, it falsifies the fact that in Ancient Greek a term like *sphallo* is not a "genuine" counterword to truth, *aletheia*, and that therefore the Ancient Greek notion of truth was never compatible with its Romanized redefinition according to the pragmatic and bureaucratic imperative to decide what is and is not the case. Heidegger insists that the Romans' need for decidability was mandated by a militaristic conception of victory that required one to think in terms of bringing adversaries to a downfall. *Falsum* is therefore linked to an imperial will to power that requires decisiveness or victory that not only brings about a fall, but also justifies this toppling in the name of truth.[23]

Veritas, then, is questionable because domination over an other is the defining or essential condition. Moreover, because it distinguishes so sharply between what is and is not the case, *veritas* is a notion of truth that depends on a mimetic model of direct correspondence between a representation and its referent: "The true *verum*, is what is right, what vouches for certainty, and in that sense it is the righteous, the just." A pragmatic and mimetic conception, *veritas* means *rectitudo*, *certitudo*, as well as *justitia*. In this way, *veritas* is said to express a will to power based on a command from above, which is to say, from the standpoint of the judge who applies the law or reason to various cases based on what is considered to be right, just, or true: "correct saying." Heidegger summarizes this broadly:

23. Martin Heidegger, *Parmenides*, trans. André Schuwer and Richard Rojcewicz (Bloomington: Indiana University Press, 1992), pp. 39, 41. German edition: *Parmenides* (Frankfurt am Main: Vittorio Klostermann, 1982), pp. 57, 60.

Truth is, in the West, *veritas*. The true is that which, on various grounds, is self-asserting, remains above, and comes from above; i.e., it is the command. But the "above," the "highest," and the "lord" of lordship may appear in different forms. For Christianity, "the Lord" is God. "The lord" is also "reason." "The lord" is the "world-spirit." "The lord" is "the will to power." And the will to power, as expressly determined by Nietzsche, is in essence command. In the age in which the modern period finds its completion in a historical total state of the globe, the Roman essence of truth, *veritas*, appears as *rectitudo* and *iustitia*, as "justice." This is the fundamental form of the will to power.[24]

In the context of the arts, *veritas* is that truth which gives one an advantage in judging what is and is not the case; *veritas* not only enables us to distinguish between works that "say correctly" and "say incorrectly" but also enables us to better understand the world in the light of how it is judged or considered by the work itself. It is on this basis, of course, that the National Socialists themselves faulted modern art as perverse, degenerate, or incorrect. In 1943 Heidegger is criticizing this kind of dictatorial use of the "truth" whose motivation is brute political will.

Veritas stresses the relation between the thing-concept of the work of art and the beholder who judges it as true or false in terms of a predominantly human, subject-centered, or existential relation. In *Parmenides* Heidegger argues that Roman *veritas* is also inhuman. For it is pragmatic (i.e., bureaucratic, institutional, procedural) and violently imposed by an impassive technocrat, a lord or overseer, who surveys everything from above and for whom everything has to be regulated by means of an instrumental command—what Heidegger calls truth as "essential domination." This, of course, is why in "The Origin of the Work of Art" Heidegger takes such a disliking to the metaphysical protocols whereby art is made utilitarian or equipmentalized; for, in such equipmentalization the work is put at the disposal of an overseer whose "truthful" relation or correspondence to the work is one of "essential domination." Here, by extension, the educational relationship of a work to an audience as mediated by an instructor, critic, or body of experts is, as *veritas*, determined as the justification of an essential domination by those experts over the

24. Ibid., p. 53; in German, p. 78.

work. In other words, Heidegger was wary of "educated elites" who as overseers are put in charge of judging the rectitude of the work by appealing to a decisive command of truth that enables a verdict to be passed on its success, that verdict being an expression of a pragmatic domination that carries the benign euphemism, education. Heidegger, of course, allegorizes his own historical predicament by looking to the distant past in order to consider *veritas* embedded in an inhuman and instrumental logic of an imperium whose educational mission is to Romanize the real. Small wonder, Heidegger hints, that in modern-day totalitarian regimes, mimesis (i.e., socialist realism) is the preferred mode of artistic representation.

Having made the case against *veritas*, Heidegger introduces the Ancient Greek term *aletheia*, truth as an attunement to beings that depends on the freedom of Dasein to be "open" and not bound by some form of rigid directedness, such as the command of an imperium. From the standpoint of *aletheia* the work of art is not something to be pragmatically adjudicated in terms of fixed principles wherein its correspondence to the world is deemed true or false, but it is indicative of the freedom of Dasein to experience its correspondence to beings in terms of a comportment that remains open to being. It is in this openness that the distinction between truth and falsehood—a variant on the beings and Being distinction—is dismantled by a prior distinction in Greek philosophy that, in Derridean terms, can be deemed undecidable in the sense that the distinction, namely the *différance* of concealedness and unconcealedness, both does and does not hold at the same time. Put simply, Heidegger was trying to formulate a notion of truth in which there was considerable interplay between elements coming into view and elements withdrawing from view which constituted a fluctuating presencing or appearing that suggested an entity was, in fact, not just a thing that can be taken for granted in its thereness—its thereness as an always being there—but that an entity's presence is temporalized in such a way that its disclosure of itself as present or there violates our usual or everyday sense of space-time. For Heidegger, the entity's "truth" is the event of its dis-closure as such.

In *Parmenides* Heidegger used *aletheia* as the word for the interplay of dis-closure, and he exposed the essence of this truth as a differentiatedness that, of course, contradicts the metaphysical understanding

of truth as something decisive or decided that is entirely identical or at one with itself (of one mind). In the following passage Heidegger addresses merely the coming into unconcealment of an entity as true, although here one can already see the numerous delicate differentiations Heidegger imagines are a part of this event:

> The unconcealed [*das Unverborgene*] is originarily what is saved from withdrawing concealment [*entziehende Verbergung Gerettete*] and hence is secured in dis-closure and as such is uneluded. The unconcealed does not come into presence indeterminately, as if the veil of concealment [*die Hülle der Verbergung*] had simply been lifted. The unconcealed is the un-absent [*das Un-abwesende*], over which a withdrawing concealment no longer holds sway. The coming into presence [*das An-wesen*] is itself an emerging, that is, a coming forth into unconcealedness, in such a way that the emerged and the unconcealed are assumed into unconcealedness, saved by it and secured in it. "Alethes," the "unconcealed," reveals its essence to us now more clearly precisely from its relation to Lethe. The unconcealed is what has entered into the tranquility of pure self-appearance and of the "look." The unconcealed is what is secured thereby [*das Unverborgene ist das also Geborgene*]. The clarification of the essence of the counter-essence [*der Wesenheit des Gegenwesens*], Lethe as withdrawing concealment [*der entziehenden Verbergung*], first allows the essence of dis-closure [*das Wesen der Entbergung*] to be brought into the light.[25]

The purpose of such an elaborate description of emergence, unconcealment, unforgetting, and disclosedness is to demonstrate how presence (i.e., the coming to presence *as* presence) is not an all-or-nothing affair—either something is present or absent—but quite to the contrary a complex interplay or unfolding between withdrawal and emergence, enclosure and dis-closure, essencing and counter-essencing, showing and concealing that divides presence as such and thereby exhibits presence as something other than a thing that by its very nature decides the difference between presence and absence. *Aletheia,* therefore, is not a term that guarantees a stable and just correspondence between one thing and an other—the presence of truth as guarantor of the thing's being as Being—but points to the display of presence as another sort of correspondence whose justice or justness is

25. Ibid., p. 132; in German, p. 197.

unstable in the sense that the difference between truth and untruth, essence and counter-essence, showing and hiding is fluctuating as an eventfulness or happening that cannot be reduced to having the mere function of vouching for the Being (spirit, beauty, goodness, truth) of people and things (beings, entities):

> We must think dis-closure [*das Ent-bergen*] exactly the way we think of discharging (igniting) [*Entzünden*] or dis-playing (unfolding) [*Ent-fal-ten*]. Discharging means to release the charge; displaying means to let play out the folds of the manifold in their multiplicity. Our first tendency is to understand disclosure or disconcealing [*das Ent-bergen*] *in opposition* to concealing [*das Verbergen*], just as disentangling [*Entwir-ren*] is opposed to entangling [*Verwirrung*]. Disclosure [*das Entbergen*], however, does not simply result in something disclosed as unclosed [*En-tborgenes als Unverborgenes*]. Instead, the dis-closure [Ent-*bergen*] is at the same time an en-closure [*Ent*bergen], just like dis-semination, which is opposed to the seed, or like an in-flaming [*Entflammen*], which does not eliminate the flame [*Flamme*] but brings it into its essence [*die Flamme ins Wesen bringt*]. Dis-closure is equally for the sake of an en-closure as a sheltering [*Bergung*] of the unconcealed in the unconcealed-ness of presence, i.e, in Being [*das Entbergen ist zugleich "für" die Ber-gung des Unverborgenen in die Unverborgenheit der Anwesung, d.h.* in das Sein].[26]

Here Heidegger is quite close to Parmenides insofar as the One is justified on other grounds than a presence that presumes a noncon-tradictory understanding of essence and self-identity. If truth is one with itself, we have to understand this oneness disseminatively, as a oneness that contradicts what we have come to presume when we use the number 1 in arithmetic. For the one that Heidegger speaks of is a

26. Ibid., p. 133; in German, pp. 197–98. The translators have interpolated a phrase that doesn't appear in the published German text. I italicize it within the following: "Instead, the dis-closure is at the same time an en-closure, *just like dissemination which is not op-posed to the seed,* or like in-flaming. . . ." *Ausstreuen* would be the proper German locution for the dissemination of seeds. There's no mention of this by Heidegger. On the topic of translation, I note that *Parmenides* contains some of the most aggressive and dazzling wordplay in all of Heidegger's work to have appeared. An English translation cannot do justice to the extremely destructive ground tone of a linguistic violence carried par-onomasially through the text with the use of prefixes such as *un-, ent-,* and *ver-*. The seminar could be read as a lengthy meditation on truth as *Vernichtung*. Last, the English translation does not conform to the German text's use of italics. The German edition italicizes many passages; the English translation disregards this. I have reintroduced the italics where they occur in the German.

many-faceted one that is not contained under the rubric of a thing concept, but is thought in terms of an excess or discharge: a flaring up or in-flaming that directs Being and Truth to its essence as a one that is not-one, a closure that dis-closes, a play that dis-plays:

> The word "dis-closure" [*Ent-bergung*] is essentially and advisedly ambiguous in that it expresses a two-fold with an intrinsic unity: on the one hand, as *dis*closure [Ent-*bergung*] it is the removal of concealment and precisely a removal first of the withdrawing concealment [*ent-ziehenden Verbergung*] (*lethe*) and then also of distortion and displacement [ver*stellenden und* ent*stellenden*] (*pseudos*); on the other hand, however, as dis*closure* [*Ent*-bergung] it is a sheltering en-closure [*das Bergen*], i.e., an assuming and preserving in unconcealedness.[27]

Recapitulating the statements above, Heidegger compresses his argument by advancing a definition that without the prior discussion would be quite impenetrable. "'Disclosure' [*Entbergung*], understood in its full essence, means *the unveiling sheltering enclosure of the unveiled in unconcealedness* [*die enthehlende Bergung des Enthehltens in die Unverborgenheit*]." Heidegger adds that this disclosure is "concealed essence [*bergenden Wesens*]." And, he remarks, "We see this first by looking upon Lethe and its holding sway, which withdraws into absence [*Ab-wesen*] and points to a falling away and a falling out."[28]

In summary, in contrast with the mimetic correspondence theory assumed by *veritas*, which is indebted to a metaphysical understanding of the thing as an entity present or absent, right or wrong, spiritual or unspiritual, true or false, the Heideggerian understanding of the word *aletheia* invalidates and utterly escapes the conditions of the thing or entity whereby the definition of truthfulness is imposed. Whereas *veritas* speaks to the correspondence or bridging of beings to Being—say, the work of art to spirit or beauty—*aletheia* shows itself as true in the fact that it calls this very correspondence or bridgework into question by breaking with the very law of contradiction that Western tradition has presumed to be the essence of truth, namely, the unambiguous disclosure that something is as such. The point that should not be lost on us, however, is that Heidegger's alternative and disseminative understanding of truth (as *aletheia*) is, in fact, pointing

27. Ibid.
28. Ibid. German edition, p. 198.

to a violent rupture or opening characterized by an incendiary dis-
charging or in-flaming that is at once hidden (secret) and exposed
(not secret).

HEIDEGGER II: TRUTH AND THE EXISTENTIAL DIFFERENCE

Already in the seminar *Platon: Sophistes* (1924), Heidegger had
thought of *aletheia* as a negative rather than an affirmative term that
defined truth as an un-forgetting or dis-closure. Heidegger draws
from this seminar in section 44 of *Being and Time* in which he argues
that Dasein could only achieve a primordial or originary understand-
ing of "Being-true" if this term were equated with "Being-uncover-
ing" [*entdeckend-sein*]. Anticipating the *veritas* argument in *Parme-
nides*, Heidegger writes: "*The primordial phenomenon of truth has been
covered up by Dasein's very understanding of Being—that understand-
ing which is proximally the one that prevails, and which even today has
not been surmounted* explicitly *and* in principle."[29]
 In other words, because Dasein has misunderstood Being by means
of a metaphysical apprehension of Being, an originary phenomenon
of truth has been concealed or covered up. Surprisingly, Aristotle is
said never to have defended the thesis "that the primordial 'locus' of
truth is in the judgment. He says rather that the logos is that way of
Being in which Dasein can *either* uncover *or* cover up." Aristotle,
therefore, is said not to have invested in the thesis that truth lies in
propositions or assertions (one could even say, works); rather, truth is
located in how propositions and assertions are grounded in Dasein's
uncovering, unconcealment, or disclosedness. In this sense, "Truth,
understood in the most primordial sense, belongs to the basic consti-
tution of Dasein. The term signifies an *existentiale*"—which is to say
that the kind of Being truth possesses is inseparable from the being of
Dasein as disclosedness. "*'There is' truth only in so far as Dasein is and
so long as Dasein is.*" Far from being an Idea or Ideal Form, truth is
that being-unconcealed that cannot be formalized at all and is there-
fore considered in the *Beiträge zur Philosophie* in terms of *Ereignis*. In

29. Martin Heidegger, *Being and Time*, trans. John Macquarrie and Edward Robinson
(New York: Harper and Row, 1962), p. 268.

Being and Time, however, Dasein as a "being-uncovering" still presupposes truth insofar as it is an entity that *cares* for the truth, which is to say, for an understanding of the truth. "Only because Dasein is as constituted by disclosedness (that is, by understanding), can anything like Being be understood; only so is it possible to understand Being."[30]

In *Being and Time* the disclosure of truth was especially relevant to the difference between Dasein and Cogito, Dasein being a description of a more primordial understanding of consciousness that was intended to go beyond Husserlian phenomenology. At the same time Heidegger was also thinking of an existential difference that distinguishes the human from the nonhuman. *Dasein*, for example, does not apply to animals, flowers, or stones. For it is "human" being that cares for the truth, not just any being whatsoever. But by the time Heidegger wrote his lectures on the "goddess truth" of Parmenides in 1942–43 (the goddess is also cited in Section 44 of *Being and Time*), Dasein is hardly mentioned at all, because it has been superseded by what Heidegger calls "the open": in *Parmenides*, the "difference" between *Ent*bergen and Ent*bergen*.

Already in the early 1930s Heidegger had begun wondering whether there was not something even more originary or primordial with respect to Dasein that went *beyond* the existential difference between the human and the nonhuman. This inquiry is preliminary to the analyses that is eventually undertaken in *Parmenides*. In his lecture course, *Vom Wesen der menschlichen Freiheit*, Heidegger found a conception of freedom that opens or clears the way for the naming of Being. Heidegger theorized that rather than being subordinated to an existential understanding of Dasein, freedom comes just prior to the determinability of the "and" that links Being "and" time. Indeed, Heidegger wondered if the "and" linking Being and time assumed a causality or determinism that forgets or conceals a freedom or opening that releases Being and Time from their essential relation. As a corollary, Heidegger wondered whether this originary or primordial understanding of freedom was not also concealed in the hyphen separating Da-Sein. For are not this Da and this Sein but a repetition of Time (the temporality of the Da) and Being (the existence of being)?

30. Ibid., pp. 268, 269, 272.

Yet, if this is the case, in what correspondence does freedom bring Da-Sein with respect to the question of Being "and" time?

The answer to this question rests with *aletheia*, because the kind of freedom Heidegger has in mind is not only the opening whereby *aletheia* shows itself, but also it is itself the freedom that is concealed or withdrawn when human beings come into their own as beings who are said to possess freedom. Primordial freedom is withdrawn precisely because it is a freedom that mankind cannot ever have, though in its very withdrawal it points to the difference or opening between Da and Sein that gives Dasein the opportunity of understanding Being in the openness or clearing where Being as dis-closure comes to pass as truth.

The question of freedom returns in Heidegger's famous essay, "On the Essence of Truth" ("Vom Wesen der Wahrheit"), written in the 1930s and published the year Heidegger gave *Parmenides*. There he argued that

> the openness of comportment as the inner condition of the possibility of correctness is grounded in freedom. *The essence of truth is freedom.* [. . .]
> Freedom was first determined as freedom for what is opened up in an open region. How is this essence of freedom to be thought? That which is opened up, that to which a presentative statement as correct corresponds, are beings opened up in an open comportment. Freedom for what is opened up in an open region lets beings be the beings they are. Freedom now reveals itself as letting beings be.[31]

It is in this letting things be that the will to dominate or master has been renounced for a receptivity to being in which something else or *other* than the there or the present can be disclosed, because the region or field of one's apperceptions is no longer dominated by a pragmatic framework that is entirely answerable to merely human needs and concerns: "To let be [*Seinlassen*]—that is, to let beings be as the beings which they are [*das Seiende nämlich als das Seiende, das es ist*]—means to engage oneself [*sich einlassen*] with the open region and its openness [*auf das Offene und dessen Offenheit*] into which every being comes to stand, bringing that openness, as it were, along

31. Martin Heidegger, "On the Essence of Truth," in *Martin Heidegger: Basic Writings*, ed. David Farrell Krell (New York: Harper and Row, 1977), pp. 125, 127. "Vom Wesen der Wahrheit," in *Wegmarken* (Frankfurt am Main: Vittorio Klostermann, 1967), p. 84.

with itself. Western thinking in its beginning conceived this open region as *ta alēthea*, the unconcealed."[32] It is at this point, however, that Heidegger returns to the question of Dasein. For the open, he says, is something that lets Dasein be the being that it is, namely, a being that can err or go astray. The open is the unconcealment not just of what is true but also of what is not true. Errancy results in mistakes, lapses, and oversights. As such, errancy obscures or covers over what is otherwise shown in the open. "Error is not just an isolated mistake but rather the realm (the domain) of the history of those entanglements in which all kinds of erring get interwoven."[33] Indeed, a notion like *veritas* is itself a consequence of how in an openness where beings are let to be the beings they are, an errancy occurs that belongs to a metaphysical history of entanglements. *Veritas* therefore is to be considered an "untruth" in which is hidden the "truth" of *aletheia*, though, of course, from the perspective of *veritas* (the philosophy of logic, reason, system) it is *aletheia* that is errant, illogical, untenable, and hence untrue. Heidegger's argument is that such an "untruth" is nevertheless essential to that openness (the freedom, in itself undecidable, to err and not err), in which "truth" can be said to emerge. In fact, the "untruth" is part of and essential to the "truth" insofar as both are intrinsic to freedom and to the interplay of closure/disclosure outlined in *Parmenides*. Were one to think of this discussion from a Derridean point of view, it would become evident that the relation between truth and untruth conforms to a difference between *veritas* and *aletheia* that is not entirely decidable with respect to the criterion of distinguishing between what is true and what is false. This is not to say that truth is relative, impossible, or bogus as a concept; rather, truth is not separable from an interplay in which terms like *veritas* and *aletheia* play a major role.

HEIDEGGER III: THE ORIGIN OF THE WORK OF ART

In *Beiträge zur Philosophie* Heidegger meditates again at great length on the question of truth, and in a section on "space-time" he argues that an *Abgrund* (abyss, literally "not-ground") is the primor-

32. Ibid.
33. Ibid., p. 136.

dial essencing (*Wesung*) of the very ground that is "das Wesen der Wahrheit" (the essence of truth). Space-time, he said, was to be understood as grounded in this not-ground—the "primordial oneness of Space and Time." Here the "not-ground" or abyss is quite analogous to what has elsewhere been called openness, clearing, or even freedom. Heidegger invokes *Ab-grund* not just to have yet another synonym, but because he is trying to imagine the groundless ground for the oblivion, destruction, or ruination of self-positing: Da-Sein. As such, the *Ab-grund* is the primordially essential "*lichtende Verbergung, der Wesung der Wahrheit* [*clarifying concealment* of the Essencing of Truth]."[34] This reliance of the ground on the abyss is a reliance on truth as the vanishing point in which the ground *as* ground is swallowed up into what Heidegger calls "die Leere," emptiness. Not nothing, the emptiness "is" that zone in which something is held back, renounced, or kept. In other words, the emptiness is the zone where concealment occurs, that very concealment which is so essential to the disclosure of truth. Whereas in *Parmenides* the discussion of truth involved a parceling out of all those particulars that pertain to a coming to presence in which concealment necessarily takes place, the *Beiträge* subordinates the manifestation of truth to the larger issue that surrounds it, namely, the overcoming of nihilism by clarifying or clearing the ground of philosophy as the truthful disclosure of a Being whose vanishing, going under [*Untergang*], or *ruination* is the very precondition for its emergence.

In short, what is true for truth in *Parmenides* is also true for Being in the *Beiträge*, which is why Heidegger says that truth is Being and Being is truth. Here, of course, a major point to note is that at the hither side of dismantling the metaphysics of being and truth, Heidegger restores or restitutes the very metaphysical jointure or hinge that is so characteristic of a metaphysical understanding of truth and being, namely, their interchangeability. After all, if Plotinus stood for anything, it was for the fundamental connection of truth and being as the ground or precondition for art. It is notable, then, that at the very moment Heidegger is surpassing metaphysics, that he re-encounters and rehabilitates its most fundamental ground: that Being is truth and truth is Being. But does this mean that metaphysics is

34. Martin Heidegger, *Beiträge zur Philosophie* (Frankfurt am Main: Vittorio Klostermann, 1989), p. 380.

simply being recovered? In the *Beiträge* the metaphysical common-place—that Being is truth and truth is Being—is constituted as a hyphenated interplay of grounding/ungrounding within the word *Ab-grund* that deconstructs metaphysics as such.

In "The Origin of the Work of Art" we encounter a spectral female presence whose Dasein occurs in the wake of an openness or clearing whose ground is the *Ab-grund*. What conceals this truth is the fact that it is easy to mistake the famous illustration of the peasant woman toiling in the field for a positive illustration of landed peasant folk whose understanding of ground is commensurate with the Nazi conception of *Boden*. It is this suspect political conception of ground that the peasant woman renounces by means of *Versagung*: the unsaying of a metaphysical conjunction between being and truth that is propped upon the presence of the laboring peasant vouched for by Vincent van Gogh's painting of her shoes. Of course there can be no doubt that Heidegger purposely leads the reader on to assume a socialist representation of what Nazism could take to be the "truth" of the peasant as revealed to modernity. But Heidegger, as we have seen, is not partial to *imitatio* and *veritas* because they posit a ground of self-assertion that is indebted to a judgment that relies on the possession of the power of life and death over others, what Heidegger calls "essential domination." The conjecture supplied by Heidegger that the shoes in van Gogh's painting are those of a peasant woman's is a deliberate attempt to stage the presence of a figure foundational for a Romanized conception of artistic and political *veritas* and, hence, for a conception of a social subject antithetical to Heideggerian *Dasein*.

That Heidegger rejects *veritas* in "The Origin of the Work of Art" is self-evident, because the whole point of the essay is to develop art in terms of *aletheia*: "Van Gogh's painting is the disclosure of what the equipment, the pair of peasant shoes, *is* in truth. This entity emerges into the unconcealedness of its being. The Greeks called the unconcealedness of beings *aletheia*."[35] Whereas the description of the peasant woman toiling in the field reveals how the shoes bring soil and

35. Martin Heidegger, "Origin of the Work of Art," in *Poetry, Language, Thought,* trans. Albert Hofstadter (New York: Harper and Row, 1971), p. 36. "Van Goghs Gemälde ist die Eröffnung dessen, was das Zeug, das Paar Bauernschuhe, in Wahrheit *ist.* Dieses Seiende tritt in die Unverborgenheit seines Seins heraus. Die Unverborgenheit des Seienden nannten die Griechen *aletheia*" ("Der Ursprung des Kunstwerkes," in *Holzwege* [Frankfurt am Main: Klostermann, 1972], p. 25).

world into a relation that establishes the peasant woman within a topos, or place—what we might call her *Heimat*—there is also a reliance of this ground on the *Abgrund* that the shoes unconceal in their truthfulness. In other words, notions of *Heimat* and *Boden* conceal the *Ab-grund* in whose clearing Dasein comes to be as something other than the presence of a peasant who exemplifies an authentic Germanic [*sic*] type:[36]

> From the dark opening of the worn insides of the shoes the toilsome tread of the worker stares forth. In the stiffly rugged heaviness of the shoes there is the accumulated tenacity of her slow trudge through the far-spreading and ever-uniform furrows of the field swept by a raw wind. On the leather lie the dampness and richness of the soil. Under the soles slides the loneliness of the field-path as evening falls. In the shoes vibrates the silent call of the earth, its quiet gift of the ripening grain and its unexplained self-refusal in the fallow desolation of the wintry field. This equipment is pervaded by uncomplaining anxiety as to the certainty of bread, the wordless joy of having once more withstood want, the trembling before the impending childbed and shivering at the surrounding menace of death. This equipment belongs to the *earth*, and it is protected in the *world* of the peasant woman. From out of this protected belonging the equipment itself rises to its resting-within-itself.[37]

Here female Dasein is shown to be metaphysical, because it implies a motherhood that bridges beings and Being. Similarly, the shoes are metaphysically posited as equipment that mediates the being of the peasant woman with the Being in whose draft she toils. In this, and similar details, the work of art is posited metaphysically as an entity that "truthfully" bridges beings and Being. But this, of course, is the understanding of art that Heidegger wants to displace, because for him it is merely the condition under which the truth in art is hidden

36. Van Gogh's geographical reference would certainly be Drente, a province in the Netherlands. Hence the peasant woman would obviously be Dutch. That many Dutch citizens would resent Heidegger's implication that they are really Germans or Germanic in origin is something I'll just note here in passing. Indeed, the scene of the peasant woman is a representation Heidegger gathers from his own experiences near Todtnauberg, Germany, and projects onto the van Gogh painting, hence, the association with the authentic Germanic type, a linking that makes sense in the context of Heidegger's delivery of his essay in Germany during the late 1930s when fascist representations of the peasantry glorified workers in the field.

37. Heidegger, "Origin of the Work of Art," pp. 33–34.

or veiled. In other words, the objectionable political interpretation of the peasant woman as authentic human being stands in the way of and hence obscures the disclosure of a truth that requires this illustration's destruction. Indeed, her very absence in the place of her representation (van Gogh painted only the shoes, not their owner) suggests as much to Heidegger.

Rather than address that feature of the painting directly, however, Heidegger turns his attention to the destruction of the shoes by focusing on equipmentality. In fact, this notion of equipmentality pertains to art, generally, insofar as ancients and moderns have viewed art as *essentially* equipmental, something we are meant to work with, whether in the writing of propaganda, the teaching of art in the classroom, or the curating of works in museums. In the case of van Gogh's painting, it would be usual to think of the shoes as a content to be used for some purpose, a content ideationally extrapolated from the world, given form, and hence turned into art. This supposes a mimetic alignment of content (idea), form (matter), and world (referent) in whose correspondence a transcendental or higher order is revealed that would be of use to humankind. In other words, the shoes have to be mimetically rendered, staged, and made present by the artist in such a way that they convincingly negotiate a series of correspondences that have use value. In opposing this interpretation, Heidegger argues that of importance is the fact that the shoes are equipment that is being worn out. If the shoes are said to be reliable—"by virtue of this reliability the peasant woman is made privy to the silent call of the earth"—they are also being used up and destroyed. "A single piece of equipment is worn out and used up; but at the same time the use itself also falls into disuse, wears away, and becomes usual. Thus equipmentality wastes away, sinks into mere stuff. In such wasting, reliability vanishes."[38] Indeed, the reliability of the shoes is not separable from their finitude as temporal beings. As temporal, the shoes are, at the moment of their coming into being or use as equipment, withdrawing or receding into oblivion (the *Abgrund*) with each step the woman takes. In short, the shoes do not ontologically support or ground the woman, but withdraw their being from her and, hence, her relation to the world. As in *Parmenides*, Heidegger is advancing a

38. Ibid., p. 35.

description that breaks open the unity and continuity of presence. Far from being arrested as timeless entities in van Gogh's painting, the shoes are disclosed in their "truthfulness," their temporal eventfulness as a destabilizing interplay between concealment and unconcealment, emergence and withdrawal, ground and not-ground. The work of art is not immune to this retraction (withdrawal) and protraction (persistence) of the shoe as thing, because the work of art's dependence on the self-presence of the shoes falsifies and conceals the truth of how being as presence-to-itself is based on a forgetting of time, that is, the protraction and retraction of the thing in time.

In *Vom Wesen der menschlichen Freiheit*, Heidegger argued that the "and" that separates being and time is equivalent to the hyphenation of Da-Sein in which Da stood for the temporal and Sein for the ontological. The hyphen represents a freedom or opening "of the conflictual within being and therefore the occasion and *possibility of a breaking apart or breaking open* of beings *in their diversity and alterity.* Here lies, at the same time, the *central problem of the possibility of truth as unconcealment.*"[39] What Heidegger's figure of the peasant woman and the shoes initially conceal is the breaking open of beings that is illuminated by the coming to pass of time. In *Vom Wesen der menschlichen Freiheit,* Heidegger associated this breaking open with monstrosity, and in particular, the monstrosity of rupturing a metaphysical connection between mankind and God.

By withdrawing in such a way that she is absent in the place of her representation, Heidegger's peasant woman does us the favor of a similar monstrosity by renouncing herself so that a temporalized essence (*Wesen*) of the shoes can appear as the truthful breaking open of beings in their diversity and alterity. Hence her *retrait* enables an unconcealment of the truth in art that is this breaking open or destruction. Only because an ordinary figure has canceled herself out can the shoes be disclosed *as* art. This suggests that art requires an abnegation of a human existence that, if present, would conceal or block from view the temporalized nature (*Wesen*) of the shoes. Yet, without her

39. Quoted in Herman Rapaport, "Time's Cinders," in *The Hegemony of Vision,* ed. David Michael Levin (Berkeley: University of California Press, 1993), p. 226. In *Vom Wesen der menschlichen Freiheit,* Heidegger makes references to how time shines on or illuminates being. Later in texts such as *Beiträge zur Philosophie* Heidegger equates this illumination with the unconcealment of a truth that has not undergone corruption into the "undeterminability of 'consciousness' and perceptio." See pp. 226–27 of "Time's Cinders."

presence could the shoes come to appearance as they do? Does not Heidegger's description of her suggest that her presence is itself a disclosure of truth about the shoes that the shoes cannot do without? It is here that the hyphenating of Da-Sein becomes relevant to the peasant woman, because it points to a thereness of the woman that shows the conflictual within being and the occasion of a breaking open of things in their diversity, the peasant shoes among them.

In "The Origin of the Work of Art," Heidegger emphasizes the withdrawal and decay of Ancient Greek temples when he considers their persistence in a temporality of withering away, their world having withdrawn from them over the eons, even as they themselves have perished in their persistent presence. The being of the work, Heidegger is saying, is temporal and its truth cannot be disentangled from the fluctuation of time. Again, it is as if the thing required the renunciation or self-cancellation of the human in order to stand forth in its truth, despite the fact that just as things like shoes are in essence clothes worn by people, temples are essentially places where humans gather. Because art is temporal, it disrupts the closure in which Being would house it, because as temporality the work of art presences itself in a way that obliterates the circumstance of Being and opens, in its stead, a withdrawal, renunciation, or refusal of Being that comes to pass in the dis-closure of *Ab-grund* as Openness. That the human with all its motivations, purposes, and designs conceals or prohibits the disclosure of art in its grounded/ungrounded relation to being and truth is just as crucial to Heidegger as the recognition that essential for the truth in art to appear is the trait or trace of the human that ought to be thought of as otherwise-than-human because the trait is postmetaphysical and posthuman. It is here that Heidegger enables us to rethink traditional understandings of how the existential and the ontological come into a truthful relation.

DERRIDA AND THE TRUTH IN ART

Jacques Derrida's *The Truth in Painting* might be considered the occasion for my entire project insofar as I imagine my own work as a reprise of Derrida's book in the same sense that Clarice Lispector's *Apple in the Dark* is a reprise of Dostoyevsky's *Crime and Punishment*.

the two have everything and nothing in common. Derrida's *Truth in Painting* collects four essays, "Parergon," " + R (Into the Bargain)," "Cartouches," and "Restitutions of the Truth in Pointing." According to Derrida, the title *The Truth in Painting* is a signature, because it is a phrase quoted from Cézanne, who wrote it in the context of a contractual agreement to Emile Bonnard on October 23, 1905. "I owe you the truth in painting and I will tell it to you." This statement, which Derrida calls a performative speech act, functions as a signature insofar as it commits Cézanne to do something. But, Derrida asks, can one deliver on this kind of performance? Is it possible to perform the disclosure of truth? And is not Cézanne's promise knowingly ironical in this regard, and hence a promise that Cézanne knows cannot be kept? The thematic of the performative contract from a book on Francis Ponge entitled *Signéponge* is repeated here even as the Heideggerian implications of an event of truth that appropriates and disappropriates resonates in the background. As to the constative speech act implied by Cézanne's "the truth in painting," Derrida advances four meanings that he sets up as problematics. And here, in place of the speech act theorists, he has Heidegger very much in mind.

1. Cézanne's "the truth in painting" refers to his being able to restore the truth "in person, without mediation, makeup, mask, or veil. In other words, the true truth or the truth of the truth, restituted in its power of restitution, truth looking sufficiently like itself to escape any misprision, any illusion." Yet, the work must be divisible so that it can appear as the truth of truth: a truth that we can see faithfully represents a truth we otherwise could not see. Already here the Heideggerian understanding of *aletheia* is in evidence.

2. Cézanne's phrase refers us to *adequatio*: to the accuracy of the representation. Derrida calls this the "truth faithfully represented, trait for trait, in its portrait." This, of course, is the *veritas* concept which Heidegger develops at length in *Parmenides*. According to Derrida, "the value of adequation has *pushed aside* that of unveiling. The painting of the truth can be adequate to its model, in representing it, but it does not manifest it *itself*, in presenting it. But since the model here is truth, i.e., that value of presentation or representation, of unveiling or adequation, Cézanne's stroke [*trait*] opens up the abyss."[40]

40. Derrida, *The Truth in Painting*, p. 5.

Derrida then points out that Cézanne is caught between the two no-tions of truth—of *aletheia* and *veritas*—in a way that produces the following entanglements: "presentation [unveiling] of the representa-tion [the veil or copy], presentation [unveiling or disclosure] of the presentation [unveiling], representation [veiling] of the representation [veil], representation [veiling] of the presentation [unveiling]."[41]

3. The "truth in painting" could also refer us to the truth insofar as it can be displayed in a given medium, in this instance, easel painting. This raises the question of all those things which are said to be "proper" to painting as an art. The rules, operations, or practices common or proper to painting are of significance in that they regulate and organize painting as a field that can be said to have certain essen-tial properties. Derrida's subversion of this understanding of truth rests with his emphasis on idiom, what already in Heidegger is con-sidered a matter of tonality or attunement that escapes any practical aesthetic logic or order.

4. The "truth in painting" necessarily refers to how the truth *in* the work of art addresses the truth *of* the work of art. Derrida calls this "truth in the domain of painting and on the subject of it."[42] Truth, then, is found to be both internal and external to the work. Derrida argues that this divisibility of truth means that the question of the border or framework separating the internal from the external is vul-nerable, since it is not possible to keep the truth on the inside and the outside from parasiting on each other. Beyond that, he holds the Heideggerian suspicion that the inner truth of the work and the outer truth of art to which it addresses itself are akin to the being/Being distinction wherein the well-known ontological difference situates it-self.

When Cézanne says that he will tell the truth in painting, therefore, he is constatively invoking what Derrida calls the "four truths," even as he is performatively signing a contract that is itself divided between two promises, to tell and to paint the truth. But in doing all this, Derrida suspects Cézanne really has the following in mind: "Thus one dreams of a painting without truth, which, without debt and running the risk of no longer saying anything to anyone [of not interesting

41. Ibid., p. 6. Brackets mine.
42. Ibid., p. 7.

anyone], would still not give up painting."[43] It is in this refusal still not to give up painting that something is restored or restituted and that, as I argue in a later chapter, the question of truth and metaphysics returns after its having been set aside.

It may be somewhat ironical that the brilliant and often dizzying analyses Derrida conducts in the four main chapters are, to a very large extent, entirely compatible with Plato's major objection to the arts in Book X of the *Republic*—specifically, the attempt of the work of art to create the illusion that it is an entity proper to itself (that it has authentic being) when, in fact, what one has are simulacra (ontological fakes) whose definition or borders are a fiction. Therefore, when in the *Republic* Socrates invokes the schema of the divided line in order to fault the arts for being an imitation of an imitation of an imitation, that turns out to be surprisingly compatible with Derrida's analysis of Titus-Carmel's "Pocket Size Tlingit Coffin," a "work" that consists of 127 pocket-size coffins in whose serial repetition no privileged paradigm or ground can be established. Because the coffin is a bottomless crypt, the coffin encrypts itself as a groundless or abyssal entity: a reflection of a reflection of a reflection.

Like Socrates, Derrida is arguing that the work has no ground and therefore cannot be considered to have an origin or basis wherein that which is proper to the work could be established. Yet, Derrida notices, the work as paradigm nevertheless returns or restitutes itself as something that is posited or posed as a thing transcending the abyssal interplay of imitation. Whereas Socrates views this as a scandal whereby art underhandedly arrogates a truth for itself that it does not, in fact, have, Derrida parasites the Heideggerian problematic of *aletheia* to situate this grounding of the groundless in terms of hiding and unhiding. "The little one (paradigm) will have been built like a crypt, so as jealously to keep its secret at the moment of greatest exhibition."[44]

This means that in the pocket-size coffins, Derrida has found a mimetic analogue to Heidegger's vocabulary of hiding and unhiding, concealment and unconcealment, *Grund* and *Ab-Grund*, with the result that the work of Titus-Carmel is necessarily to be considered exemplary of an *idea of art*. By appealing to Heidegger, Derrida resti-

43. Ibid., p. 9.
44. Ibid., p. 195.

tutes that metaphysical ground, so familiar to Panofsky's readers, to what otherwise might appear to be a groundless interplay of simulacra. Switching to the problematic of how the truth in art is always a truth about Truth (the truth of the particular work in relation to a transcendental Truth), Derrida thinks of the work in terms of "multiple movements of appropriation" that gather the work unto itself as if it were a single proper entity, even while it cuts the work off from the world by delivering it over to a transcendental Truth so that it "remains" cut off from the world as something singular, paradigmatic, or "truly beautiful." Once this happens, Derrida says, the work undergoes a cut whereby we cannot any longer appropriate it to ourselves (i.e., take it back) because it accedes to the status of an untouchable remainder, what Derrida immodestly calls "a turd one would like to make one's own."[45] In this way Derrida approaches a vulnerable difference between the beautiful and the repellent, arguing that they are both operationalized by the same logic of the "remainder": art as taboo fetish of fascination and horror. It is here that truth comes into proximity with evil.

In "+ R (Into the Bargain)" Derrida again broaches an abyssal interplay of simulacra, but in this case he is addressing Valerio Adami's illustrations of *Glas*, a text by Derrida that already addresses the question of truth:

Verily [*Voire*]. [. . .] This word will henceforth come down to saying the truth (*verus, voirement*), but also the undecided suspense of what remains on the march or on the margin within the true, but nevertheless not being false in no longer being reduced to the true. [. . .] Elsewhere defined: *le vraiment feint*: the truly feigned, the true lies fine. [. . .]

Now this double theory (or double column taking note of the general equivalence of subjects or contraries) describes the text, describes itself as it feigns to recount some pictures, some *"works of art,"* as the suspense of the *verily*: remain(s) beyond the true and the false, neither entirely true nor entirely false. *That [Ça] is stretched between two subjects absolutely independent in their distress but nonetheless interlaced, interwoven, entwined like two lianas orphaned from their tree.*[46]

45. Ibid., p. 203.
46. Jacques Derrida, *Glas*, trans. John Leavey Jr., and Richard Rand (Lincoln: University of Nebraska Press, 1986), pp. 43b, 44b. Italics are mine.

The interlace is crucial for Derrida with respect to painting because he wants to establish that mimesis (re-production) is not a one-on-one correspondence, but a complex interlacing or intertwining that remains beyond the true and the false, that is neither entirely true nor entirely false. This "verily" of the work of art is what Derrida thinks of as "stretched" like a canvas between two subjects: the thing painted and the thing that is the painting.

Adami's drawings are themselves illustrations of sentences taken from *Glas*. And the irony is that these drawings are lies that speak to what from Derrida's point of view are the "truths" of *Glas*, truths that Derrida reappropriates to himself in " + R (Into the Bargain)." This extends even to Adami's drawing a scene that "under no circumstances" can "be found in *Glas*." Hence "[Adami] shows what is passing or happening, forbidden to *Glas*, out of range of its signatory." In drawing a fish hanging by a hook, traversed by text (the scene is divided by borders) Derrida claims that Adami has drawn something from behind the looking-glass of the text—a "fish" that ought to be called "Ich"—the "I." "Ich signs the absolute reverse of a text, its other scene" because, if anything, *Glas* is a text entirely written from the side of the *Ça* (id), not the *Ich* (ego). Still, the drawing is that "destructive simulacrum"—saying the reverse of what *Glas* was meant to say, *the reverse of its truth*—which draws a surplus value of meaning from *Glas* and throws that into the bargain. Derrida views the doubleness of the drawing by Adami and the text by himself as a chiastic relation signed by the letter *X*, a "trait" that interlaces two works that are at once mutually reinforcing and mutually incompatible, that interlace following the logic of a stricture, a restricted circular economy of appropriation/reappropriation whereby the work is the effect of multiplying imitations that author and artist "throw into the bargain": I draw your work, you write about mine.

In "The Parergon," where Derrida writes about Kant's *Critique of Judgment*, the logic of the "dangerous supplement" from *De la grammatologie* is reintroduced. The supplement, of course, is that element needed to complete a set which is thought not to belong to it. This means that by a very curious twist of logic a supplement is absolutely required to stage the truth of a work at the risk of being deemed merely accessory, ornamental, marginal, and hence not properly *of* the work itself. In painting this refers us to entities like the frame, which

is absolutely required to show or stage the truth of the work, even though it is itself not thought to be a part of the work. There is a bit of a joke here with respect to the title of the essay on Adami, because the frame is often what some art dealers "throw into the bargain" as if it were not really part of the deal. Here commerce imitates Kantian philosophy insofar as Kant, too, would have us throw the frame into the art bargain as if it were merely superfluous and of no intrinsic value other than that the frame is a holder or support for the painting. But Derrida, of course, exposes the frame as a complex interlacing of differences pertaining to what constitutes the work of art proper. In doing this, he reappropriates the frame as a support or prosthesis whose interlacings deconstruct the difference between the truth in the work of art (as Seiendes) and the truth of art (as Sein). In this way the frame becomes that border or margin which reappropriates ontological difference as *la différance.*

In "Restitutions or the Truth in Pointing" all these strategies are recapitulated as Derrida undertakes ·a cross-examination of Heidegger's "The Origin of the Work of Art." Pushing further the thesis on Kant, Derrida demonstrates that a work has no content distinguishable from its frame and that, in the end, a pair of peasant shoes painted by van Gogh is entirely reappropriated by a complex interplay of interlacings of which the shoes' laces are themselves but a literal example. As in the essay on Adami, Derrida argues that one cannot censor out what lies beyond the range of the signatory and that scenes behind the mirror of production more than likely circulate in such a way that the work owes them a certain debt or obligation, despite the fact that these other scenes are not "proper" to the work, but apocryphal. Derrida's investigation of the criticism of Heidegger and Meyer Schapiro is an interrogation of a frame-up by those who try to imagine what lies behind the mirror. The lessons from the essay on Titus-Carmel are also brought to bear insofar as the painting of peasant shoes belongs to a series and that the shoes, like the coffins, are empty structures haunted by the specter of the body. This absence is the place where a restitution of spirit suggests itself and why Derrida says that what we have got is a ghost story on our hands.

In all the chapters of *The Truth in Painting*, Derrida has placed death at the center of the work. The empty shoes in the painting by van Gogh, the coffin series by Titus-Carmel, the drawings of the death

knell by Adami, and, in the essay on Kant, the serialized blank spaces within delimited textual frames that separate or rupture the text (one of them a coffin with the word "mourning" in the upper left-hand corner of the frame). That is to say, throughout *The Truth in Painting* the question of truth is inseparable from the unconcealment of a space, opening, or *Ab-Grund* where death is framed. "Restitutions," specifically, alerts us to the presentation of the shoes as those of the dead who, from our historical perspective, were consumed in flames during the Nazi Holocaust, their shoes being left behind. What, Derrida wonders, do these shoes restitute? And to what extent can we not think of these shoes as being part of a work and its critical reception, despite the fact that what we are thinking lies beyond the range of the signatories involved? How can we *not* think of certain things that are inappropriate or irrelevant to the work, and why would censorship of those things run against the very logic of the interlace and supplement that is so central to Derrida's concerns throughout? Here, of course, the question of "truth" is divided or torn because the work cannot sustain the difference between what it is and what it is not. Simply put, we are supposed to wonder about what the work is attached to.

"Restitutions" also refers, in large part, to the need of both Meyer Schapiro and Martin Heidegger to restitute the ground of the work and, in so doing, to establish the thinghood of its contents. According to Derrida, readers of Heidegger ground the shoes by attaching them to the feet of a peasant woman laboring in the field. Schapiro, for his part, attaches the shoes to van Gogh's feet. But Heidegger, unlike Schapiro, does not simply stop once he has found a ready-made subject to put on the shoes. Because Heidegger has another restitution in mind, too: that of going back to the Ancient Greek notion of thing as *hypokeimenon*, a term that subtends the Latin *subjectum* but whose real ground is beneath or more primordial to even that of the *hypokeimenon*:

> The thing is still more hidden away or wrapped up underneath its investiture than appears to be the case. At the very moment when he [Heidegger] calls us back to the Greek ground and to the apprehension of the thing as *hypokeimenon*, Heidegger implies that this originary state *still* covers over something, falling upon or attacking it. The *hypokeimenon*, that underneath, hides another underneath. And so the Latin

underneath (*substantia-subjectum*) causes to disappear, along with the Greek ground, the Greek underneath (*hypokeimenon*), but this latter still hides or veils (the figure of veiling, of veiling linen as over-under, will not take long to appear, and the hymen which will draw it into undecidability will not be unrelated to the sock, the socklet, or the *stocking* [*le bas*], between foot and shoe) a "more" originary thingliness. But as the "more" carries itself away, the thing no longer has the figure or value of an "underneath." Situated (or not) "under" the underneath, it would not only open an abyss, but would brusquely and discontinuously prescribe a change of direction, or rather a completely different topic.[47]

How, given this abyssal construction of the un-ground, are the shoes to be attached to the land, if not to say, to the feet of one whose being is so closely connected to the soil? Moreover, in what sense might truth be restored if in the restitution of the ground all we encounter is the *Ab-Grund*, a perhaps infinite deferral of ground beneath ground? Derrida's essay suggests that in answering such a question one would have to be attentive to how the question of truth is itself an effect of "attachment" and "interlacing" whereby the thing is at once recovered and lost *as thing*. That the canvas is itself a thing stretched and attached to a frame mimics or illustrates the very representational problems raised by what is depicted on it.

Unlike the critics of Plato's attack on the arts, Derrida has not attempted to stanch the abyssal multiplication of representational constructions, let alone the production of undecidable frames, bottomless grounds, and false appearances. As Plato suspected, the work cannot ever reliably decide the truth, let alone present the truth clear and simple. It cannot even determine its difference adequately enough to distinguish what is proper or essential to itself. In fact, it may be the case that nonbeing (i.e., death, the unrepresentable) is interlaced in such a way that the essence of the work of art cannot be disentangled from it. Proper to the work, then, would be nothingness. And the work would be as much an attachment to nonbeing as it might be to beings, say, an interlacing of the two, were that at all conceivable. Whereas for Plato this would merely give us more reasons why we should distance ourselves from the arts, for Derrida it is a first step in exploring the restitution of art on the hitherside of its deconstruction.

47. Derrida, *The Truth in Painting*, p. 291.

LÉVINAS'S ANTIPHENOMENOLOGICAL PHENOMENOLOGY

During 1943 when Jean-Paul Sartre published *Being and Nothingness* Emmanuel Lévinas was a French soldier imprisoned in a German prisoner of war camp where he was contemplating a philosophical study. Written shortly after the war, it was entitled *Existence and Existents.* Like Sartre, Lévinas had been trained in phenomenology and had reacted to the hardships of war by attempting to philosophize about personal and interpersonal experiences in ways that went beyond psychologism in order to draw from a number of phenomenological approaches, the most influential, perhaps, being those of Edmund Husserl and Martin Heidegger. Of course, given Heidegger's political associations during the 1930s and the fact that the allies had found him objectionable enough to merit a six-year suspension from teaching at the University of Freiburg meant that French thinkers found themselves in an awkward position with respect to their philosophical indebtedness to him. However, the fact that Heidegger had become a problematic figure meant that French phenomenologists could take considerable liberties with his thought without being faulted. For example, after the war, Sartre's *Being and Nothingness* was considered a masterpiece of philosophical exposition despite the fact that it reintroduced elements of a Hegelian dialectic, based on the lectures of Alexandre Kojève, which vitiated the philosophical advances made by Heidegger in *Being and Time.* As Heidegger himself pointed out to Jean Beaufret in his "Letter on Humanism," Sartrean existentialism slid back into the very metaphysics that Heidegger tried to overcome, because Sartre reintroduced a classical form of ontological difference when he distinguished between existence and essence.

However, Sartre rightfully saw in Heidegger's thought a blatant disregard for ethical philosophy and concluded that Heideggerian notions like *Mitsein* (being-with) and *Sorge* (care) were too abstract and disembodied from practical everyday affairs to adequately describe interpersonal human relations. In response to this problem, Sartre's *Being and Nothingness* reworked Kojève's path-breaking insights about radical alterity or Otherness in Hegel. Sartre explored at great length how the alterity of the Other as the Other's irreducible freedom is constitutive for consciousness insofar as one's consciousness is predicated on an Other whose difference (e.g., freedom) introduces a

structural fissure or break within consciousness (alienation before the Other) that is dialectically in play within the overall unified "project" of being an existential subject whose life or biography is, in retrospect, treated or judged as linear and coherent. Hence in his writings on literature, Sartre rejected Heidegger's speculations on the arts in favor of a conception of the work of art as a confirmation or negation of the world as a moral situation mediating our day-to-day existence. If the work has truth, one has to think of it as an event, response, or action produced in the existential situation of the writer who in encountering others either confirms or negates them in ways that give the work definition as part of an existential project whereby the individual courageously chooses an ethical stance that will be perceived as just and right in relation to existing social, political, and cultural forces.

Whereas many intellectuals attempted to follow and build on Sartre's insights, a number of thinkers had envisioned alternative phenomenologies of otherness. Among them were Maurice Blanchot, Georges Bataille, Simone de Beauvoir, Frantz Fanon, Maurice Merleau-Ponty, Jacques Lacan, and Emmanuel Lévinas. Perhaps Lévinas's most suggestive and revolutionary work was *Existence and Existents*, which, in contrast to *Being and Nothingness*, is pointedly terse. Even today it is most disorienting in its reformulation of phenomenological and existential themes common to both *Being and Time* and *Being and Nothingness*. Although on account of his situation during the war Lévinas claims not to have read Sartre's book, it is difficult not to imagine that before publishing *Existence and Existents* he had gleaned enough about Sartre's project to intuit its indebtedness to Heidegger. "The dialectic of being and nothingness continues to dominate Heideggerian ontology where evil is always defect, that is, deficiency, lack of being: nothingness."[48]

In focusing on the Sartrean reading of Heidegger, Lévinas contests the idea that evil is defect or lack by asking: "Is there some sort of underlying evil in [Being's] very positivity? Is not anxiety over Being—horror of Being—just as primal as anxiety over death?" Lévinas's suspicion that anxiety of Being is the precondition for anxiety over death immediately suggests to him the possibility that we should

48. Emmanuel Lévinas, *Existence and Existents*, trans. Alphonso Lingis (The Hague: Martinus Nijhoff, 1978), p. 20.

not oppose Being and nothingness, because there is something yet more primordial, the "*il y a*," or "there is." This is an extremely striking formulation in that it intuits something in Heidegger that Lévinas could not have known about, namely, Heidegger's writings on *Ereignis* in the unpublished manuscript *Beiträge zur Philosophie*, composed in the late 1930s. Indeed, like *Ereignis*, the "*il y a*" stands for a primordial or originary event or occurring of Being that comes prior to the difference between being and nothingness (*Sein und Nichtsein*). Moreover, Lévinas argues that because of the "*il y a*," "subjective existence which existential philosophy takes as its point of departure, and the objective existence of the old realism merge." This means that Sartre's dialectical fissure between the "for itself" (subjective projection) and the "in itself" (objective construction) is not operative with respect to the horror of the "there is" because the "there is" comes prior even to our dread before an Other, since it is the "there is" that will not let us take death lightly given the fact that it forces us to acknowledge our existential involvement in Being. Whereas we might immediately imagine such involvement as life-affirming, for Lévinas at issue is the horror of the impossibility of death, "the universality of existence even in its annihilation." Killing and dying are merely attempts to escape being, to avoid being by means of a choice that enacts the freedom of the "for itself" to negate what is. "Horror," Lévinas writes, "is the event of being which returns in the heart of this negation, as though nothing had happened."[49]

It is at this point that Lévinas turns to art, specifically, Shakespeare's *Macbeth*, by invoking the following remark by the play's protagonist, "And that is more strange than the crime itself." Lévinas returns to Shakespeare toward the end of the following quotation:

> In the nothingness which a crime creates a being is condensed to the point of suffocation, and draws consciousness out of its "retreat." A corpse is horrible; it already bears in itself its own phantom, it presages its return. The haunting spectre, the phantom, constitutes the very element of horror. The night gives a spectral allure to the objects that occupy it still. It is the "hour of crime," "hour of vice," which also bear the mark of a supernatural reality. Evil-doers are disturbing to themselves like phantoms. This return of presence in negation, this impossibility of escaping from an anonymous and uncorruptible existence

49. Ibid., pp. 20, 61.

constitutes the final depths of Shakespearean tragedy. The fatality of the tragedy of antiquity becomes the fatality of irremissible being.[50]

For Lévinas, the final depth of Shakespearean and Ancient Greek tragedy is that the questions of being and of survival—living on as the fate of irremissible being—are inseparable. No doubt, the subtext of a commentary on the survivors of the Shoah is not difficult to detect and is quite prophetic if one considers the writings on the Shoah by survivors such as Charlotte Delbo, whose works develop the return of presence in negation as a spectral allure that illumines objects and evil-doers whose existence or survival is an infamy.

The "*il y a*," therefore, speaks to an event, the beingness of being, that prevents us from sleeping, relaxing, or being off-guard. Nevertheless such wakefulness is not the same as consciousness, because it is entirely depersonalized and anonymous. It is not the me who is vigilant in the night, for in insomnia it is the night that watches. "It watches." Yet, it is in this night that consciousness is exposed to being, and "all the thoughts which occupy my insomnia are suspended on *nothing*. They have no support." Philosophically this goes beyond phenomenology in that anonymous vigilance goes beyond the phenomenon and intuition. "The fatality of these strange states, which it is impossible to recount, is due to the fact that they do not happen to me as their subject." Apparently the being of which Lévinas speaks cannot be said to belong to anyone.[51]

Of course, this kind of thinking breaks with the philosophical accounts we are given in Sartre's *Being and Nothingness*, where the closest we get to something like the "*il y a*" would be "la nausée," arguably Lévinas's point of departure. But whereas "la nausée" is rooted in the thereness or persistence of the body—an "insipid taste which I cannot place, which accompanies me even in my efforts to get away from it . . . a dull and inescapable nausea [which] perpetually reveals my body to my consciousness,"[52] the "*il y a*" is an event of Being that precedes consciousness, let alone consciousness of ourselves as entities or *existents*. Again, in Sartre's treatise, phenomena cannot be existentially thought apart from their happening or occurring to a subject.

50. Ibid., p. 61.
51. Ibid., p. 67.
52. Jean-Paul Sartre, *Being and Nothingness*, trans. Hazel E. Barnes (New York: Washington Square Press, 1966), pp. 444–45.

We might say therefore that from a Sartrean point of view what takes place in Lévinas is an "antiphenomenology" in the sense that he is inquiring into the effects of nonphenomenal phenomena whose occurrence cannot be equated with any sort of event or activity we would be able to define from the point of view of being an existent to which things happen. Unexistential is Lévinas's idea that consciousness is not, as Heidegger thought, an *ek-stasis* or coming forth— "thrownness" would be an analogous term—but a *re-trait* or withdrawal from the anonymity of nonphenomenal phenomena. In this withdrawal or retreat from existence, consciousness becomes personal and positions itself as an existent. This occurs, according to Lévinas, because consciousness has suspended the anonymous "there is" and has cleared a domain for itself that is privative (e.g., negative). Anonymity therefore is subtracted, evacuated, or taken away. Only by means of such privation does consciousness posit itself as a being that belongs to Being. Hence it becomes aware of itself as an entity that is embodied and assumes a being that is his or her being. This only happens, Lévinas cautions, because as an existent, consciousness takes refuge from the anonymous "there is." Consequently what we call a human being in the fullest existential sense is, in fact, an entity or existent that has in the most primordial sense withdrawn from the irremissible being of existence. We can see that whereas Heidegger views a Western history of the forgetting of Being as a fall into a restrictive existence characterized by pragmatic and rationalist limitations, Lévinas views the forgetting of Being as fundamental to a withdrawal from a horror from which consciousness steps away and against which it protects itself by means of establishing its own domain.

In short, the "truth" of the human condition consists in the necessity of withdrawing from the horror that is existence, the flight into the shelter of an existent *that must keep itself apart from irremissible being.* That this condition precludes authenticity and truthfulness is most evident in that, whereas from the perspective of a Greco-Roman tradition it is extremely desirable to become one with being—here Plotinus and his followers come to mind—for Lévinas this oneness would be terrifying, destructive, and inhuman. Consistent with Lévinas's Jewish tradition would be Jonah's flight from God understood as a flight from irremissible being, a judgment or law that, whether it

destroys or reprieves the people of Nineveh, brings everyone face to face with the horror of existence. Indeed, Jonah's survival is itself a sustained crisis insofar as he cannot escape or forget the law that exposes him to the irremissibility of being—the fact that the people of Nineveh live on. The Book of Jonah, therefore, could be read as a scripture that reveals the moral scandal that is the irremissibility of being as one that characterizes the proximity of God to the Hebrews as one of horror, the "*il y a.*" Of course, Jonah recognizes that survival means an existence that is not sheltered by faith in a predictable law that punishes evil and rewards good, but rather that this survival is an exposure to the "*il y a*" as *the beyond of good and evil*: a horror that is oddly analogous to Heidegger's notion of *aletheia* insofar as this horror requires an un-forgetting of being. The Jonah story also brings up another matter, the relation of the prophet to the Other. According to the early Lévinas, the I/Thou relation is never symmetrical and exposes the existent to an alterity that awakens the subject to the "*il y a*," that rouses insomnia, the counter-withdrawal of the existent into existence. Jonah's flight, of course, is entirely symptomatic of this thrownness back into a primordial existence of irremissible being where life suddenly becomes a bad thing rather than a good one. That this horror is symptomatic of a "truth" that is awakened in us by an other is a point that Lévinas considers later in terms of the concealment/unconcealment of the face.

LÉVINAS AND ART

Like Nietzsche, Lévinas also takes the view that we have art "in order not to die of the truth." In fact, Lévinas has been extremely critical of those who attempt to rescue the arts from Plato's condemnation by claiming art to be that thing which is also an idea, if not a truthful one. Yet, even though Lévinas appears to support the most hostile attitudes toward the arts bequeathed to us from ancient times—that art is false seeming at best and idolatrous at worst—he nevertheless takes this in the direction of the nonphenomenal phenomenology broached in *Existence and Existents*. This is why in reading an essay such as "Reality and Its Shadow" (1948) one has to be careful not to assume that Lévinas has taken a position against the

arts that simply reprises Socrates' condemnation of art as mimetically false, affectively infectuous, and morally deleterious.

As if taking up the objection that the arts are merely seductive and know nothing of the truth, Lévinas cautions that, contrary to what Socrates argues, art is aggressive or invasive. It concerns a *dispositif* or image that substitutes itself for an object and in so doing releases or detaches that object from its conception or idea. "Already by action we maintain a living relationship with a real object; we grasp it, we conceive it."[53] But the image, Lévinas says, neutralizes that grasp or living relationship because it effaces our direct experience of an object. I may see skillfully painted lemon rinds on silver platters in Dutch art of the early seventeenth century, but I cannot have any direct experience of them as lemon rinds because the image does nothing to realize the object as a being that can act on me in any other way than as passive showing. Nevertheless, because the image is passive and neither my subjection nor my freedom as a subject is being engaged, the image succeeds in imposing itself on me without my consent. Hence, it is aggressive.

We fall under the spell of the image, as it were, without actively assuming it for ourselves. In music, "rhythm represents a unique situation where we cannot speak of consent, assumption, initiative, or freedom, because the subject is caught up and carried away by it." Platonic as this sounds, Lévinas means something quite different: that such captivation "is a mode of being to which applies neither the form of consciousness, since the I is there stripped of its prerogative to assume, its power, nor the form of unconsciousness, since the whole situation and all its articulations are in a dark light, *present*."[54] Where Plato assumes that the work of art seduces a subject that is taken in, emotionally swayed, or mimetically duped, Lévinas is arguing that the passivity of the work functions to bypass us as *existents* by evading our self-consciousness. It is as if the work took to the side of *existence* in Lévinas's negative sense of the "*il y a*" and was therefore not to be considered a phenomenon but something nonphenomenal.

In addressing music, Lévinas explains that "sound is the quality

53. Emmanuel Lévinas, "Reality and Its Shadow," in *The Lévinas Reader*, ed. Seán Hand (Oxford: Blackwell, 1989), p. 132. Originally published in *Les Temps Modernes* in 1948, the essay was preceded by the editors' Sartrean objections to Lévinas's views.

54. Ibid., p. 133.

most detached from an object." This is not to say that sound is just a poor copy, akin to the programmatic imitation of trains in the music of Heitor Villa-Lobos, but that in the detachment from substance we discover a severing of the sound's relation to the essence of the substance or thing. Hence the sound "resounds impersonally" (as "*il y a*"). Lévinas continues, "even its timbre, a trace of its belonging to an object, is submerged in its quality, and does not retain the structure of a relation. Hence in listening we do not apprehend a something, but are without concepts." In short, the form as concept (*eidos*) drops away from the object; and the quality of a sound emerges which is therefore other than a concept or form. This notion departs from our usual assumption that a piece of music can be formally organized according to compositional rules and practices that follow the dictates of an overall formal conception such as sonata-allegro form that can be apprehended, after all, as some distinct entity or thing: a work. Contrary to what we have been taught, "Reality and Its Shadow" assumes that music posits a *dispositif* of sounds whose autotelic relationships alienate or distance the sound from the object as a phenomenon intended for intellection. Even where one has mimesis or resemblance, Lévinas says that we cannot take the correspondence "to be a comparison between an image and an original, but as the very movement that engenders the image." Presumably this movement refers us to those relationships which establish the distance (e.g., the autonomy) of the music, painting, or poem from what Lévinas calls the original. Summarizing, Lévinas says, "Reality would not be only what it is, *what it is disclosed to be in truth*, but would be also its double, its shadow, its image." But in that case, reality would be something that is not identifiable with the existent (the phenomenon in its retreat from Being) so much as with existence (the non-phenomenality of the "*il y a*"). Here, of course, Platonism has been inverted in that it is the shadow that is more real (which is of the order of existence) than the original (which is of the order of the existent).[55]

But if art flees from the existent to existence, there is also a counterescape from existence to the existent. If we have art in order not to die of the truth, it is because the essence of being is not content

55. Ibid., p. 135. Italics are mine.

simply to be, but is itself characterized by restlessness, flight, or escape. Although this is reminiscent of the later Heidegger's definition of Being as an appropriation that disappropriates, for Lévinas this fugitive nature of Being is not hidden from humankind, a secret that philosophy itself has sealed and forgotten. Rather, the fugitive nature of a Being restless in its Beinghood is everywhere practiced by humankind and particularly in terms of the arts where the essence of the work of art is itself the project of keeping us from dying of the truth of irremissible Being (existence). But in order to do that, art has to accomplish what Being will not, namely, the creation of a timely end (death) whereby irremissible Being is converted into a catastrophe that consciousness can grasp, accept, and move beyond. Heroic fights to the death, tragic downfalls, star-crossed love, and self-sacrifice are all resemblances or representations of events that are left behind as stories in the wake of being. This, too, manifests a withdrawal from irremissible being into phenomena.

According to Lévinas, reality does not refer to itself anymore but to its "shadow," its "allegory of being":

> A being is that which is, that which reveals itself in its truth, and, at the same time, it resembles itself, is its own image. The original gives itself as though it were at a distance from itself, as though it were withdrawing itself, as though something in a being delayed behind being. The consciousness of the absence of the object which characterizes an image is not equivalent to a simple neutralization of the thesis, as Husserl would have it, but is equivalent to an alteration of the very being of the object, where its essential forms appear as a garb that it abandons in withdrawing.[56]

As we learned from *Existence and Existents* at issue is the emergence of the *existent* out of existence by way of a *retrait* or withdrawal from irremissible being. If, as we saw earlier, the work of art slips away into existence, the passage just cited from "Reality and Its Shadow" suggests the performance of a counter-movement: an original object that shows itself in its truth as an existence that also has the capacity to withdraw from itself (i.e., existence) in order to become a resemblance (an existent). Hence existence gives itself at a distance from

56. Ibid., pp. 135–36.

itself and comes to pass as an existent. This positing of the existent as art reflects a delay behind being that appears as absence of the original, as no-thing, which nevertheless has a presence. But if the existent withdraws from existence, existence also pulls away from the existent which it leaves behind as a residue or remainder of being. This process is equivalent to "an alteration of the very being of the object," its essential form (the existent) cast off in the withdrawal or retreat of being (existence).

As an existent left behind in the wake of being, art is passive. As having pulled away from existence, art is active. Yet, if the work is left behind by existence or is even said to have detached itself from existence, it also cannot maintain its distance or estrangement from existence, because, as we have seen, the work of art is also in flight from the phenomenal realm of the existent. Consequently as an existent, the work of art still puts us in touch with an existence that Lévinas thinks of as the horror of irremissible being. Indeed, everything in "Reality and Its Shadow" that follows the quotation just cited speaks to this curious reappropriation of the existent by existence: hence Lévinas's problematic of *the failure of art (as existent) to keep its distance from the unbearability of existence.*

Evidence for this failure is seen on several fronts, among them the horror of imprisonment in a world without a genuine temporality where there is an open future for different outcomes to occur from the ones prescribed in advance. Lévinas complains that the work of art "cannot complete its task" as an entity in the present because its reality is predetermined, meaning that it cannot assume anything, can take on nothing, and exists as just an anonymous instant. Because the present is unable to "force the future," it restricts itself to being merely fate. And "fate has no place in life." This means that the "freedom" to act in the work actually reflects the subjection and powerlessness of agencies—say, in opera, fiction, and paintings—who are prisoners condemned to an irremediable being. In Vermeer's paintings of women intently reading letters we see the infinite prolongation of an empty interval to which the figure is condemned. Lévinas sights that interval in the stories of Poe, where the anxiety is prolonged and heightened "as though death were never dead enough, as though parallel with the duration of the living ran the eternal duration of the

interval—the *meanwhile*."[57] Lévinas concludes, "The eternal duration
of the interval in which a statue is immobilized differs radically from
the eternity of a concept; it is the meanwhile, never finished, still
enduring—something inhuman and monstrous." Because the mean-
while never ends, Lévinas reasons, it can never improve or incline to
the better. Because the meanwhile cannot end, it is not open to the
salvation of what might happen or become and therefore cannot be
surpassed. In short, the meanwhile is problematic because it cannot
experience its own death. Put another way, the work of art is prob-
lematic because it is by definition a survivor, a living-on that discloses
the irremissibility of being, what for Lévinas is the unbearable truth
in art that forbids us Nietzsche's optimistic aphorism that we can have
art (the existent) in order not to die of truth (existence).

DESPITE the apparent differences between Heidegger, Derrida, and
Lévinas, they engage a complex interplay of turnings whereby truth is
pushed beyond the either/or logic of its being either present or ab-
sent. Heidegger, who takes Nietzsche seriously when he writes of a
raging discord between truth and art, exacerbates a propriative di-
mension of truth with respect to veiling/unveiling and concealment/
unconcealment. Moreover, he notices that already in antiquity, the
question of the propriation of truth was complicated by the divide
between the existential and the ontological, something that Nietzsche
recognized but did not take far enough. In Heidegger, this division is
both meticulously harried and reasserted in ways that defy the logical
divisions common in much philosophical thought, if not to say, the
cynical reductionism to human fallibility that occurs in Nietzsche. At
the very least this enabled Heidegger to situate the question of truth
in a way that cannot be reduced to the structure that frames the
familiar debate between Platonists and Aristotelians. Moreover,
Heidegger has shown truth to be something quite other than a tran-
scendental idea or spirit that enjoys conceptual independence even
while it participates in a pantheon of like notions, such as beauty,
goodness, and being. Heidegger also alerts us to the possibility that
truth can be variously articulated according to the divide between
aletheia and *veritas* and that this division points to a history in which

57. Ibid., p. 141.

the relationship between truth and being has been practiced or acted out by Western society. Yet, if Heidegger dismantles the metaphysical tradition, he also anticipates its restitution at the hither side of deconstruction by situating art squarely in relation to truth and being.

Derrida, whose book on the truth in painting develops Heidegger's thoughts in "The Origin of the Work of Art," makes the interesting turn back to Plato in order to stress the abyssal nature of the work of art (the abyss as propriation) as itself essential to any positive understanding of the truth in art. That the idea or truth of art is restituted by being "thrown into the bargain" when we enter an appropriative/disappropriative relation with art is among Derrida's more general claims. It is here, of course, that the Heideggerian understanding of *aletheia* is reinscribed in a very different vocabulary. Like Nietzsche, Derrida recognizes that it is only because the work cannot determine the truth that truth itself will be thrown into the bargain much like a frame, since, in the end, it hardly costs the dealer anything, because truth is, after all, merely "academic." And yet, retrospectively, is it not truth that is valued above everything else?

Lévinas differs from Heidegger and Derrida in that he does not treat Being as a neutral ontological notion; for Lévinas, rather, Being is humanly unbearable and we are human insofar as we retreat from the fullness of Being. Art itself is an existent left behind in the wake of Being, though art carries within it the traces of Being's horror, the "*il y a.*" These traces point to art's failure to completely evade or avoid Existence, something that Lévinas notices when he considers how the presence of the work arrests within it a sense of eternal duration whose endurance exposes us to the monstrosity of irremissible Being. The truth of the work of art, then, concerns the work's capacity, as representation, to reproduce and hence point to a condition of irremissible Being. But the truth of the work also concerns an allergy or resistance to that very Being to which it points, namely, the human need to retreat from such Being. To some extent, this understanding of truth is not entirely unlike Heidegger's conception of *aletheia*, except that for Lévinas the approaches toward and retreats from Being suggest a rift between the existential and the ontological that delimits a fundamental incompatibility between the two. Whereas Heidegger views the forgetting of Being as foundational for a Western spiritual crisis that concerns Dasein's alienation, for Lévinas the forgetting of

Being is entirely acceptable in that for him Dasein is an existent that has necessarily taken shelter from existence. In the chapters that follow I apply various aspects of these postmetaphysical conceptions of truth to music, environmental sculpture, poetry, fiction, film, and photography, in each case, showing how consideration of a specific example makes an active contribution to postmetaphysical thinking.

2 Anton von Webern's "Two Rilke Songs," Op. 8

In August of 1908 Anton von Webern set two poems by Rainer Maria Rilke to music. The second poem ends with the lines "weil ich niemals dich anhielt, / halt ich dich fest [because I never held you, / I hold you fast]."[1] Although these lines are addressed to a beloved, I take them to refer, obliquely, to the holding fast of music to language, or sound to text. The "Two Songs of Rilke for Voice and Eight Instruments," Op. 8, are respectively only 15 and 17 measures in length, and whereas Webern's previous settings of poems by Stefan George, Opus 3, called for only piano accompaniment and rather dense musical textures, the "Two Rilke Songs" are scored for medium voice and an octet consisting of B♭ clarinet (changing to bass clarinet in the second song), French horn, trumpet in B♭, harp, celeste, violin, viola, and cello. None of these instruments can be said to properly accompany the voice in that none of these instrumental parts supports or reinforces the vocal line, let alone color or help inflect the text. The solo violin, for example, plays only seven notes in the first song and not much more than that in the second. The viola enters only four times in the first song with double stops. The trumpet plays but nine notes, the harp only nineteen, and the celeste twenty-seven. The second song is a bit less sparing in the use of strings, but overall the density of sound texture is similar.

Whereas the musical settings for Opus 3 are shaped to intensify programmatically the sense and feelings evoked by George's poetry, in

1. Rainer Maria Rilke, *Sämtliche Werke* (Frankfurt am Main: Insel, 1987), 6:936.

Opus 8 such a correspondence is abandoned, both in the articulation of the accompaniment and in the construction of the vocal part. No doubt, in the "Two Rilke Songs" language and music are being dissociated at the very moment the composer brings them into proximity. And yet, when read metapoetically, the Rilke verses do obliquely address this peculiar artistic estrangement: "because I never held you, / I hold you fast."

<center>৵৹</center>

In the "Items for a Musical Encyclopedia" with which Pierre Boulez ends *Notes of an Apprenticeship*, we read that Webern "utilized [voice] in a severely restricted domain, pure 'song,' willingly ignoring the paramusical resources of which more general usage is prodigal."[2] In this sense, Webern clearly departed from his teacher and friend of twenty years, Arnold Schönberg, who in *Erwartung* and *Pierrot Lunaire* drew heavily on those paramusical resources invoked by Boulez—spoken delivery and poetic associations. Like Schubert and Brahms before him, Schönberg wanted to exploit the poetic and histrionic resources of language to expose the hidden orders of tonalities and rhythms that could be brought into correspondence by and with music. In *Pierrot Lunaire*, for example, the tonalities of nostalgic sighing or outright mockery are exploited by the vocalist and accompanied by instrumentalists whose role it is to imitate and thereby musically to continue the tonalities and rhythms of speech. What Schönberg aimed for was a chamber piece that ambiguated the difference between speaking and singing, theater and music, the cabaret and the concert hall. Although musicians still are not sure how to execute properly what Schönberg called *Sprechgesang*, they all agree that whether one inevitably has to emphasize singing over speaking or speaking over singing that, in fact, a correspondence, relation, or dependency between the two is being established. Even if, as Schönberg seems to have suggested, one sacrifices the indicated pitch in the score to a spoken utterance whose pitch level is always merely approximate, at no point are music and text going their separate ways. Rather, a certain improvisation is called for in which each

2. Pierre Boulez, *Notes for an Apprenticeship* (New York: Knopf, 1968), p. 382.

performer tries her best to bring speech and music into a proper attunement or accord.

Webern's "Two Rilke Songs," drafted before Schönberg had composed *Pierrot Lunaire*, exemplifies a very different approach to language. It is an approach, I think, that can be best summarized by Martin Heidegger's remark in an essay called "Die Sprache" that *"Language speaks as the peal of stillness [Die Sprache spricht als das Geläut der Stille]."*[3] Not only does such a remark address the perception that Webern used voice in a severely restricted domain that eschewed histrionics, programmatic accompaniment, and tonal support in the sense of traditional harmonic chord sequences, but it also pertains to the following complaints made by Pierre Boulez from the perspective of conducting. "It is very difficult to present [Webern's] works in concert because of their brevity, but even more because of their restricted sound-dynamic, which makes use of nuances at the edge of the audible." Boulez notes a familiar problem that all conductors face when performing Webern in sizable recital or concert halls. "The environing noise has a tendency in itself to cover the dynamic level of the music."[4] In fact, this dynamic level is often so fractured into very subtle manifolds of differing dynamic levels that one senses what Heidegger is calling the "Geläut der Stille" as if it were a musical "event horizon," a limit close to silence where sound is directed away from audibility.[5] This retreat of music from audibility would put us on the hitherside of what can be heard and is reminiscent of Heidegger's observation concerning language: "Thus language not only holds back when we speak it in the accustomed ways, but this its holding back is determined by the fact that language holds back its own origin and so denies its being to our usual notions."[6] Webern's setting of Rilke's two poems performs such a retreat by musically withdrawing from the ear and thereby depriving us of a perception of music's presence or thereness. Whereas music traditionally takes pains to con-

3. Martin Heidegger, "Die Sprache," in *Unterwegs zur Sprache* (Pfullingen: Neske, 1959), p. 30. Translated by Albert Hofstadter as "Language," in *Poetry, Language, Thought* (New York: Harper, 1975), p. 207.

4. Boulez, *Notes*, p. 380.

5. The "event horizon" is a term borrowed from astrophysics; it is the limit at which light is prohibited from streaming away from a black hole's gravitational pull.

6. Martin Heidegger, "The Nature of Language," in *On the Way to Language*, translated by Peter Hertz (New York: Harper and Row, 1971), p. 81.

trast sound with silence, as Beethoven does after the heroic dactyls that initiate the last movement of the Ninth Symphony, Webern establishes the perception that what one hears is merely the tonal residue or trace of something that has passed into the hitherside of audibility. Such music, we might say, is inherently *Nachträglich* and as such estranged from its origin.

But if the music slips into the stillness, the sung text remains stranded or "stood up" by the music. Given Webern's literary source, this is not inappropriate. Webern found Rilke's two songs in the latter part of *The Notebooks of Malte Laurids Brigge*, wherein the songs are themselves already unaccompanied and exposed. In fact, there is something oddly exhibitionistic about the way in which Abelone, the young singer, bares herself before the recital audience to deliver the song. The narrator, however, finds this aspect of not only her singing, but vocal singing in general, so uncomfortable that he literally stands behind a door in the hall's adjacent corridor, as if to lower the dynamics of singing and thereby approach the peal of stillness that he considers essential to music. Of course, such a gesture contradicts the impulses of any conductor or performer, for whom the dampening or silencing of sound is merely an obstruction to bringing the work forth so that it can be properly met or received by an audience. But in Rilke, and much more pointedly in Webern, this obstruction is the intended accomplice to the work's withdrawal into what Heidegger calls the peal of stillness where the presence or presentation of the work is *en retrait*. Moreover, this obstruction facilitates the detachment of sound from word, the destruction of a correspondence that leaves language in the lurch.

In "The Nature of Language" Heidegger says about Hölderlin that "song is not the opposite of a discourse, but rather the most intimate kinship with it; for song, too, is language [Der Gesang ist nicht der Gegensatz zum Gespräch, sondern die innigste Verwandtschaft mit ihm; denn auch der Gesang ist Sprache]."[7] Although the remark would appear to contradict Webern's treatment of Rilke's poetry, Heidegger asks us to consider the following lines from Hölderlin as a key to interpreting the idea that song is not the opposite of a dis-

7. Ibid., p. 78. "Das Wesen der Sprache," p. 182.

course. "This is a law of fate, that each shall know all others, / That when the silence returns there shall be a language too" [Schiksaalgesez ist diß, daß Alle sich erfahren, / Daß, wenn die Stille kehrt, auch eine Sprache sei]."[8] Are Webern's delicate musical retreats a means of sounding this theme, that when silence returns there shall be a language too? If so, we would be likely to imagine that the language spoken of is not that of a programmatic language, one in which words and the music mandate translation into one another, but of a language, and a poetical one at that, bereft or detached from tonal support. Poetical language, then, would be what remains in the aftermath of music's withdrawal, an aftermath that sounds itself as the sung peal of silence.

Yet, in "The Nature of Language" Heidegger himself has not gone quite this far. After all, he is concerned with how the "word passes into darkness" and how that retreat can be understood as a granting of speech that he strongly associates with the naming of things. Indeed, Western music in its more familiar tonal traditions has brought the granting of speech into proximity with the granting of being by means of harmonically and melodically sustaining words so that their tonality and temporality reveal correspondences that are otherwise concealed when we merely speak. However, Webern's two Rilke songs musically step back from what Heidegger calls naming by purposely abandoning or detaching the word. Yet this process, too, is not entirely un-Heideggerian. Recall, for example, Gerald Bruns's point that in order to read the later Heidegger we must be careful to adopt the motto, "leave everything open."[9] Webern, I would like to suggest, comes to a similar conclusion in his Opus 8 with respect to Rilke's texts; for Webern, too, was content to leave the words "open," "exposed," or "unprotected" by musical utterance. Only when the music leaves language unprotected, does poetry come to be. And only when the word retreats from its power to name, does music or song disclose itself from the hitherside of that that speaks, that is, from the limit where it ceases.

8. Heidegger, "The Nature of Language," p. 78. In German, p. 182.

9. Gerald Bruns, *Heidegger's Estrangements* (New Haven: Yale University Press, 1989), p. 126.

❧

In a study of Debussy Arthur Wenk points out that "a musical setting subdues the richness of multiple suggestions contained in a poem while heightening certain of the poem's images, connections, and structural relationships."[10] The song embodies a particularly human manifestation of the word that is itself inextricable from the voice of the performer. It is this voicing of the word which heightens images, connections, and structural relationships in ways that are not reducible to the art of literary interpretation. In Debussy's "En sourdine," a song based on a text by Verlaine, the piano, not the human voice, executes the motive of the nightingale. Yet, the accompaniment, in speaking to the matter of the text, makes a poetic image musically audible and grants the word a human identification. In Debussy the bird can be said to be given human support by the music, because it is brought into dialogue with the voice of the singer. In Webern, however, there is not this impulse to voice what otherwise would remain concealed or mute. Contrary to Debussy, Webern touches on the Heideggerian point that "the peal of stillness is not anything human [Das Geläut der Stille ist nichts menschliches]."[11] In other words, like Heidegger, Webern is inclined to think that the tonality of what is still may not necessarily be held fast to what is humanly representable or to the human itself; rather, such a peal or appeal abides in what one might call the otherwise-than-human, a trait of the nonhuman that bears on Heideggerian stillness. Indeed, the Rilke poems demonstrate this otherwise-than-human in their estranged relation to music, as if the words had suddenly lost or shed themselves of their humanity.

As we have noticed in terms of performance, Webern's work resists the human by not meeting its audience; rather, the work undergoes effacement or destruction as delicate dynamics and note-to-note correspondences are muted by the presence of something other. Already the equipmentality of music making—that is to say, the instruments—cannot refrain from violating Webern's work. Clarinets, especially bass clarinets, make distinct clicking sounds with the keys that intrude on the work. The valves of the horns, the pedal mechanism

10. Arthur Wenk, *Claude Debussy and the Poets* (Berkeley: University of California Press, 1976), p. 23.
11. Heidegger, "Language," in *Poetry, Language, Thought*, p. 207. "Die Sprache," p. 30.

on the harp, the action of the celeste, and all the inadvertent sounds string players must necessarily make to produce music are suddenly threatening to art. The work, it could be said, is allergic to the human. Because the work cannot withstand being exercised, rehearsed, or played, it cannot survive its own hearing.

And yet, in this abeyance which accompanies the work's allergy to performance and listening, the peal is nevertheless making an approach to the ear. That is to say, the withdrawal into stillness is not just a recession into soundlessness. "What is Stillness? It is in no way merely the soundless."[12] In Webern, as in Heidegger, the stillness of the work comes forward as that which requires a degree of listening unheard of in Western music. Not only are the pieces so close to silence or hushing that they cannot withstand the intrusion of a player or a listener, but also these works make silence audible—they bring silence to the fore.

Webern himself suggested as much when he said, "I had the feeling that when the twelve notes have all appeared, the piece is over."[13] He was suggesting that, once the chromatic scale had been entirely sounded, the work had, in fact, come to appear as something not yet heard. In this way, even before the work emerges from its scale, it has earned the right to retreat or dwell in stillness. Indeed, it was Webern's conviction that to write the work, rather than listen to its vibration in the stillness of its not having been written, is to desecrate the work. For such a work, in any case, can be said to inherently rest or lie in the chromatic row of notes. As such, the work can be heard from within the still correspondences suggested by the scale, something Heidegger enables us to recognize when he says: "In soundlessness there persists merely a lack of the motion of entoning, sound-

12. Heidegger, "Language," p. 206. "Was ist Stille? Sie ist keineswegs nur das Lautlose" ("Die Sprache," p. 29).

13. Anton von Webern, letter to Alban Berg, Vienna, 12 February, 1932, in *Schoenberg, Berg, Webern, the String Quartets: A Documentary Study*, ed. Ursula V. Rauchhaupt (Hamburg: Deutsche Grammophon Gesellschaft, 1971), p. 309. Webern was addressing his Bagatelles for String Quartet, Op. 9. From the same letter: "I wrote down the chromatic scale in my sketchbook and struck out single tones from it. Why? Because I had convinced myself that the tone was already there. It sounds grotesque, incomprehensible, and it was immensely difficult. The ear decided absolutely correctly that the man who wrote down the chromatic scale and struck out single tones from it was *not a fool*." A strong argument could be made here for *musique sous rature* (music under erasure), a concept entirely in line with Heideggerian "Ent-*bergung*" (dis-*closure*).

ing." Moreover, "As the stilling of stillness, rest, conceived strictly, is always more in motion than all motion and always more restlessly active than any agitation."[14] For Webern, similarly, the work is already completed as our anticipation of it in the stillness, in its resting, lying, or reclining in the scale, a resting that, nevertheless, is restless.

Of course, the work, if it is to appear as work, must be allowed to persist or dwell as something other, that is, as something different, from the chromatic scale, the elementary ordering of pitches. The work must appear as something other than that in which it rests and is stilled. Heidegger would caution us that indeed the work comes forth in the rift between what is silent and what is audible, *Stille und Geläut*. One might even go so far as to say that thanks to the granting of this dif-ference the scale can be said to have been given utterance by the work. And in the context of Webern's "Two Rilke Songs" this utterance would be defined as the continuation, duration, or persistence of the scale as something other—as *Sprache* or *Gesang*. But what is this "otherness" of *Sprache* or *Gesang* in relation to the scale in which the work silently rests than *Menschlichkeit*? What is this utterance if not profoundly human?

Suddenly the utterance of the chromatic scale as the work brings to our attention the coming into proximity of the human with the inhuman, of that which utters and that which remains silent. Perhaps it is this difference or rift between the human and the inhuman that bears on what one might call truth in art, provided that we consider such truth the unforgetting or *aletheia* of the difference. This is the rift that becomes exposed when the work opens up or unfolds the scale, with the consequence that the work can no longer rest assuredly within it because the work violates or ruptures what stands apart: the twelve-tone scale and the work that rests in its stillness.

Just as the work abided in the scale, so now the scale abides as the working-through of the work, as what Schönberg called a-tonality. Heidegger calls such difference "the carrying out that carries through," and, indeed, the work's giving utterance to the scale constitutes such carrying through in terms of the musical delivery of the difference between what is silent and what is sounded.[15] Thanks to the rift between the scale and the work, it is possible for music to ap-

14. Heidegger, "Language," pp. 206–7.
15. Ibid., p. 202.

proach the listener, even though in so doing the work has had to betray the inhuman purity of its quietude, has had to violate the inhuman, because un-uttered, resting place within the chromatic row.

In *What Is Called Thinking?* Heidegger speaks of the "carrying through" in terms of "continuance": "Continuance is the coming-to-the-fore that is at rest, has come to rest before the unconcealedness of what lies before us. Rest in duration is not, however, the absence of movement. Rest, in the presence of what is present, is a gathering. It gathers the rising to the coming-to-the-fore, with the hidden suddenness of an ever-possible absenting into concealedness."[16]

Webern was exceptional insofar as he intuited that music is precisely that which does not survive the work, because music cannot bear duration or, as Heidegger puts it, continuation. Because music is a time-based art, we might put this a bit more strongly and say that music is precisely that which cannot bear time. Perhaps this is what also lies behind Webern's remark "I had the feeling that when the twelve notes appeared, the piece was over." What is music, according to Webern, but an art threatened by its own temporality, duration, persistence, or continuance? What is music but something other than the work that we hear, the work as timely utterance? Clearly, Webern's remark about twelve notes being enough suggests that what continues is not really music, but something else that we call the work of art, that something else which is destined to meet its hearer in the concert hall. Yet, Webern knew quite well that without continuance, and a coming-to-the-fore of what is at rest, music does not come into being at all. Indeed, if the truth of the musical work is destined to be conveyed to an auditor by means of someone who performs or brings the work into being in time, this appearance of the work must be defined in Heidegger's terms as a "gather[ing of] the rising of the coming-to-the-fore" that nevertheless holds fast to the "ever possible absenting into concealedness." To put this another way, Webern asks us to consider that music is not simply a time-based art in the sense of that which needs duration in order to come to the fullness of its being as art. Rather, Webern's work suggests that the temporality of music may be the very condition under which there is an ever-possible absenting of art into concealedness. What remains in time, therefore, is the oth-

16. Martin Heidegger, *What Is Called Thinking?* (New York: Harper and Row, 1968), p. 237.

erwise than authentic being of the work—a being that is inhuman.
What remains is the trace of silence, the dis-appearance of the work,
which comes to the fore as a work that barely survives performer and
listener, but that nevertheless proffers itself as something human, au-
dible, transmittable, temporal, understandable, and truthful—that is
to say, as the otherwise-than-silence, the otherwise-than-time. It is
here, of course, that Webern approaches a Heideggerian conception of
aletheia as the presencing of an essence by means of the coming to
pass of a counter-essence. That this "truth" is counterpointed by an-
other understanding of truth, that of *veritas*, is a matter that requires
a consideration of the poems Webern selected.

<p style="text-align:center">❧</p>

The two Rilke texts Webern set to music read as follows.

<p style="text-align:center">—i—</p>

> Du, der ichs nicht sage, daß ich bei Nacht
> weinend liege,
> deren Wesen mich müde macht
> wie eine Wiege.
> Du, die mir nicht sagt, wenn sie wacht
> meinetwillen:
> wie, wenn wir diese Pracht
> ohne zu stillen
> ins uns ertrügen?
> Sieh dir die Liebenden an,
> wenn erst das Bekennen begann,
> wie bald sie lügen.

> [You, whom I do not tell that I lie awake
> weeping at night,
> whose manner makes me sleepy,
> like a cradle;
> you, who does not mention
> when she is awake because of me.
> How if we were to endure
> this glory without remaining silent?
> Behold the lovers:
> once they have begun to confess,
> how untruthful they become.]

—ii—

Du machst mich allein, Dich einzig kann ich vertauschen.
Eine Weile bist dus, dann wieder ist es das Rauschen,
oder es ist ein Duft ohne Rest.
Ach, in den Armen hab ich sie alle verloren,
du nur, du wirst immer wieder geboren:
weil ich niemals dich anhielt, halt ich dich fest.

[You alone create me. You alone I can interchange.
For a while it is you; then again it is the rustle,
or it is a fragrance disappearing.
Ah, in my arms I have lost them all;
you only, you are always born again:
because I never held you, I hold you fast.][17]

In Rilke's *Malte*, these two verses are sung by the young Danish
woman who says, "I am really going to sing . . . not because they
demand it, nor for appearance sake, but because at this moment I
must sing [Ich will wirklich singen . . . nicht weil sie's verlangen, nicht
zum Schein: weil ich jetzt singen muß]." The narrator does not enter
the recital space but stands back in a hallway. "I remained behind
[zurück]," he says. The narrator is allergic to the concert crowd with
all its rustling and jostling. "But then," he says, "suddenly all was still.
A silence fell which a moment ago no one would have thought possi-
ble; it lasted, it grew more tense, and now arose in it that voice (Ab-
elone, I thought, Abelone). . . . She sang an unknown German song.
She sang it with singular simplicity, like something necessary."[18] There
is astonishment after the song is over, a moment of silence, and then
again the noise of an unsettled audience: "They were about to pass
over into a general obliterating hubbub, when suddenly the voice

17. Rainer Maria Rilke, *Die Aufzeichnungen des Malte Laurids Brigge,* in *Sämtliche Werke,*
6:936. Translation by Marc Vignal, *The Complete Works of Anton Webern,* Pierre Boulez,
Conductor. Columbia Masterworks, M435193 (CBS, 1978). I prefer these translations of the
poems to those of M. D. Herter Norton in *The Notebooks of Malte Laurids Brigge* (New
York: Norton, 1949). Norton's translations of Rilke's prose, however, appear below.
18. Rilke, *Die Aufzeichnungen des Malte Laurids Brigge,* pp. 935–36. *The Notebooks,* p.
207. "Aber da wurde es mit einemal still. Eine Stille ergab sich, die eben noch niemand für
möglich gehalten hätte; sie dauerte an, sie spannte sich, und jetzt erhob sich in ihr die
Stimme (Abelone, dachte ich. Abelone.) Es war ein unbekanntes deutsches Lied. Sie
sang es merkwürdig einfach, wie etwas Notwendiges."

broke out, resolute, broad and intense: 'you make me alone.'"[19] In Rilke's text, music is that which needs to be expressed, which gathers the rising of the coming-to-the-fore. As such, music quiets the crowd; it not only meets its audience, but also demands the listeners' attention even to the point of stilling the most uncomprehending of the lot. The narrator triumphantly reports, "No one had expected it. They all stood as if bowed beneath that voice. And in the end there was an assurance in her so great that it seemed she had known for years that at that moment she would have to start singing."[20] Abelone's voice is Orphic and barely disguises a will to power. Music is nothing less in this context than the utterance of the will as that which comes to presence as art. Hers is the tradition of Beethoven and Wagner, though the lyrics of the poems suggest something entirely different, as if even in Rilke the words were stranded. In the first poem there are a pair of lovers who are not telling each other the truth. They are, in fact, keeping silent, and, as such, have withdrawn from one another. There is a lover who does not tell about her tears in the night or of her weariness of being. And there is a lover who does not admit his sleeplessness, which occurs because of her. This lover is the one who does not tell how the couple should endure their glory without being stilled. Then, as if from a very detached perspective, we are told to look upon this pair and note how untruthful they are at that very moment they open their hearts and confess what has been held back. Apparently, truth ends where communication begins, where one breaks the silence.

One wonders. Was it accidental that Webern chose to set a poem to music that dwells on the rift between utterance and silence? Ironically, the lovers are said to be more truthful when they don't confess their involuntary sacrifices for one another. That is to say, they are closer as lovers when they remain more distant from one another, when they remain relatively withdrawn. It is precisely when they communicate and share their feelings that they probably feel closest and most uni-

19. Rilke, *Die Aufzeichnungen des Malte Laurids Brigge*, p. 936. In English, p. 208. "Schon wollten sie in ein allgemeines verwischendes Geräusch übergehen, da brach plötzlich die Stimme aus, entschlossen, breit und gedrängt: Du machst mich allein."

20. Rilke, *Die Aufzeichnungen des Malte Laurids Brigge*, p. 936; 208. "Niemand hatte es erwartet. Alle standen gleichsam geduckt unter dieser Stimme. Und zum Schluß war eine solche Sicherheit in ihr, als ob sie seit Jahren gewußt hätte, daß sie in diesem Augenblick würde einzusetzen haben."

fied; and yet the verse tells us that at this moment they are being least truthful. The verse cautions us against Saying or utterance; it suggests to us that those who retreat from communication, saying, or utterance and thereby conceal their feelings—their humanness toward one another—are the more truthful. But of course this runs counter to all our literary expectations. For example, Petrarch teaches us in one of his sonnets that love and truth are revealed by the beloved's devoted (*pietose*) and sweet (*dolce*) words (*parole*). Or, one can turn to the Spanish poet Antonio Machado, who sarcastically writes to his beloved,

> And I'll send you my song:
> "One sings what one loses,"
> plus a green parakeet
> to say it on your balcony.[21]

Rilke too is addressing the familiar sentiment that one sings or parrots what one loses. But unlike Machado, whose tonalities of sarcasm tenaciously hold on to a sense of self-dignity or humanity, Rilke suggests that love is betrayed when people touch on that which is most dignified or human. Indeed, the lovers are most human when they confess their secrets to one another, and yet the truth of their relationship does not lie in that direction. Rather, the truth is to be found at the edge of audibility, the horizon of silence and secrecy, the not-said. Curiously, it is in the abeyance of truthfulness that the lovers would be most truthful to one another. Of course, the point is not so much that deception is, after all, ironically what is the most true about any passionate relationship; rather, Rilke's poem suggests that in the continuance of a passionate relationship truth is betrayed by the attempt to maintain verbal bindings or supports, even though without them, no relationship can continue to exist.

The second poem may be regarded as an elaboration of the first. You create me, the verse says. And with you I can trade places. For a while you remain, as a rustle, a disappearing fragrance. In my arms everything is lost, save this idea I have of you. You are always born again. Because I never held you, I hold you fast. Whereas the lovers in

21. Antonio Machado, "Otras canciones a Guiomar, #55," in *Antonio Machado: Selected Poems* (Cambridge: Harvard University Press, 1982), p. 249. "Y te enviaré mi canción: / 'Se canta lo que se pierde,' / con un papagayo verde / que la diga en tu balcón."

the first poem try to hold one another fast by means of confessing their secrets to one another, here the speaker has let the beloved go. He or she is always there, but only as a latent other who rests within the sound of a rustle, the dissipation of a fragrance. Because the speaker has never disrupted this absence, he or she is nevertheless compensated: "Because I never held you, I hold you fast."

Webern's biographers tell us that the composer set Rilke's poems to music during August 1910, a time when he was passionately in love with his cousin Wilhelmine. These critics further clarify that the genealogical tie made it impossible for the composer and his cousin to act on their feelings. The logic of this relationship is something like "because we're already bound so tightly, we cannot have each other." The last verse of Rilke's second poem merely inverts this statement. The first poem, too, stresses the inversion of Webern's biographical impasse. By remaining distant, Webern is telling Wilhelmine by way of Rilke, that they are in fact brought closer. Only when they disclose the truth of their feelings for one another do they betray their passionate bond.

Because the songs can be read as an open letter, the biographers assume that, in fact, the "Two Rilke Songs" are little else than direct expressions of unrequited love. Like the narrator of Rilke's *Malte*, Webern's biographers assume that these songs are being delivered because of a passionate will to be heard by an other. Consequently, musicologists have written about the songs as if lyric and music were just programmatically bound. In this, of course, the musicologists rely quite heavily on what Heidegger in *Parmenides* called *veritas*, a mimetic or correspondence theory that adjudicates works on the basis of their faithfulness, expressiveness, or realism. Walter Kolneder in his authoritative study, *Anton Webern*, writes of the "Two Rilke Songs" that "the voice dominates in long melodic lines, which are completely conditioned by the meaning of the text."[22] This statement is nowhere demonstrated by Kolneder, only asserted in an analytical vacuum. But it rests on the assumption that the songs are a unified expression (or imitation) of the composer's longing for his cousin and that, as such, lyric and music correspond and reinforce each other at every point. In fact, the vocal part of the songs does not support such an assump-

22. Walter Kolneder, *Anton Webern* (Berkeley: University of California Press, 1968), p. 67.

tion insofar as that part is really much more suitable for an instrument than a singer. In other words, the vocal part is profoundly estranged from the kind of music writing that lends itself to vocal performance, suggesting, of course, that the vocal part of the "Two Rilke Songs" was purposely composed in such a way that the singer would not be able to perform the conjunction or correspondence between sound and sense that commonly occurs in opera and art song. Again, the lyrics themselves deny the very type of confessional correspondence that the biographical reduction presumes. Like the estrangement of the vocal part from voice, the lyrics, too, champion the otherwise-than-human; they, too, announce the coming to pass of communication or utterance only in the act of its being given up, withdrawn into a silence and secrecy that breaks with human contact or society. That Webern may have wished there were less of a human or genealogical connection to Wilhelmine goes without saying, and a Freudian intuition would suggest that there is more than a little motivation for Webern to think in terms of the "otherwise-than-human," something that Webern pursues in a music that can be heard as the peal of stillness. No doubt, there even remains an obvious imitative connection between lyric and music that reminds us of Professor Kolneder's remark that the songs are "completely conditioned by the meaning of the text"; however, such a parallel is not, as we say in legal contexts, binding. The music, though a response to the thematic of detachment in the Rilke lyrics, is nevertheless unbound from the text. Both lyric and music hold themselves apart, though in so doing the work and the lyric achieve what Rilke is calling truth and a holding fast.

Of course, we need to be aware that here the trait of *veritas* is restored or restituted at the hitherside of *aletheia*. In other words, if the Webern songs speak to the coming to pass of the work as a bringing of sound into relation with sense, it is not because the textual meanings are determining musical lines or vice versa. Rather, the mirroring of lyric in music and music in lyric follows from the condition of there not being an essential or necessary tie between word and sound. The mirroring or mimesis (what I am calling the trait of *veritas*) merely accompanies the rift of difference—a restraint—that grants to sound and word their estrangement as well as their companionship. Heidegger's following remarks may be helpful to us: "Every authentic hearing holds back with its own saying. For hearing keeps

to itself in the listening by which it remains appropriated to the peal
of stillness. All responding is attuned to this restraint that reserves
itself. For this reason such reserve must be concerned to be ready, in
the mode of listening, for the command of the dif-ference."[23] To hear
authentically the relation of word and music one must be prepared to
think of them in terms of restraint and dis-appearance—the holding
back within authentic hearing that bears on what is given in stillness
as the peal of silence. But by now we can see that in Webern's work
this holding back is nothing other than the overcoming of a human
emotion that demands not only an appeal to an other but also mutual
confession and consent, what a less restrained vocabulary would call
consummation or the establishment of a passionate bond. For
Webern, however, the bond or tie latently exists. Just as the work
anticipates its appearance in the materiality of the twelve-tone scale,
Webern's relation to Wilhelmine is granted by a genetic biological
code. Although the genetic code and chromatic row are not strictly
analogous, they both express relations that are most binding when
they are concealed in the not-yet-expressed peal of stillness. They
would appear most satisfactory when they are otherwise than human,
estranged or hidden from human society.

<center>ॐ</center>

In comparing Webern's score to the performance of the "Two Rilke
Songs" by soprano Halina Lukomska, we will immediately notice
that this interpretation, conducted by Pierre Boulez (see note 17 for
discography), resists silence and the inhuman. The rift of truth
opened by the work, then, is itself concealed by a performance whose
aim is to demonstrate or declare Webern's artistry. In the vocal part
the pianissimo dynamic markings are not heeded, forte markings are
sometimes turned into occasions for fortsando attacks, and liberties
are taken with the tempo in order to infuse the words and shape the
poetic lines with intense intimate expression. In so doing, the vocal

23. Heidegger, "Language," p. 209. "Die Sprache," p. 32. "Jedes echte Hören hält mit
dem eigenen Sagen an sich. Denn das Hören hält sich in das Gehören zurück, durch das es
dem Geläut der Stille vereignet bleibt. Alles Entsprechen ist auf das an sich haltende
Zurückhalten gestimmt. Darum muß solchem Zurückhalten daran liegen, hörend für das
Geheiß des Unter-Schiedes sich bereit zu halten."

part is sung, for the most part, at a dynamic level of mezzo forte. And the text is subjected to a declamatory style reminiscent of the nineteenth-century art song. That the music abandons the words, or that the dynamic markings suggest a certain disappearance of the human is nowhere accounted for in this interpretation. And one wonders, of course, whether this reflects less a failure of the musical performers than the degree to which Webern's markings in the score are fundamentally alien to musical performance. Webern's markings on the score run counter to the grain of vocal training in the art song, particularly since the singer is precisely one who is trained to meet an audience, to render the work in such a way that it is fundamentally a profound expression of human desire. The singer, in short, is charged with rescuing the work from oblivion. She is the one who must bring the work out of the silence that is the score. She must necessarily violate the score as if to rescue the work from its truth (*aletheia*), which is to say, its own self-destructive impulses. Perhaps the most telling feature of the Lukomska performance is that it violates the music for the sake of Rilke's words, that is, for the sake of saving the text. And indeed, the poems have to be rescued from the nihilistic implications of the music if they are to ground the singer's performance with meaning and feeling (*veritas*). No doubt, from the singer's point of view, her performance must do more than merely survive the work; it must establish the work as the arrival or occurrence of a truth that can be communicated as the granting of the work's being. In *What Is Called Thinking?* Heidegger speaks of this granting as the "let to lie before us" as well as the "taking to heart."[24] The music takes place only as what lies before us or as what the performer takes up. In this way the work is brought into a human relation with us, and one would be mistaken to presume that for the singer there are really other options. For singing is, in its very essence, the bearing of what is most human. Hence the singer is charged with delivering the work into a "radiant self-manifestation," or "continuance," as "the coming-to-the-fore." In this sense, the work is not merely a thing or construct that the artist produces for us, but a coming to appearance or hailing of relationships that bear on different modalities of presencing: "unconcealedness, the rising from unconcealedness, the entry into unconcealedness, the coming and going

24. Heidegger, *What Is Called Thinking?* p. 230.

away, the duration, the gathering, the radiance, the rest, the hidden
suddenness of possible absenting."[25] These are the traits of presence,
and for Heidegger, of course, the work is never a synthesis of these
traits, but the continuance or correspondence of nonbinding traits.
Performance (which Heidegger does not discuss in the treatise on
thinking) is the temporary nearing or closing in of the work, a mo-
mentary apportioning of the traits bearing on a human or communi-
cative relation that permits the work to appear as art.

Given that Webern's score and performance often seem so antith-
etical to one another, and precisely in terms of how one considers
the unconcealment of the work's truth, one may be extremely sur-
prised to learn that Webern himself declared that "die Musik ist
Sprache."[26] Certainly, this would appear to vindicate any performer's
violation of the score for the sake of saving the poetic text. Yet, we
have already found too much evidence to suggest that Lukomska's
kind of violations are, if somewhat inevitable, still the means
whereby the delicate interplays between poetry and music would un-
dergo effacement. In other words, the Boulez/Lukomska interpreta-
tion of the songs reflects an understanding of "die Musik ist
Sprache" that, if superimposed on the score, utterly forgets a way of
thinking of this phrase to which the score seems quite committed.
Such a thinking, of course, turns on Rilke's verse, "because I never
held you, I hold you fast."

If we look at the score of the "Two Rilke Songs," we will notice that
in terms of traditional counterpoint Webern's intervallic relationships
are either too near or too far.[27] Either the vocalist is asked to sing
minor or major seconds, or she must sing their expansions, which
require her to negotiate major and minor ninths. At times the singer
must enter after a short rest, that is, a brief moment after an instru-
ment enters with a note just a minor second away from what is scored
for the singer. This happens in the first full bar of the first song, for
example, when the singer has to enter on a B♮ just after the violin has
entered with a C♯. In bar 7 of the second song the French horn plays

25. Ibid., p. 237.

26. Anton von Webern, *Der Weg zur neuen Musik* (Vienna: Universal Edition, 1960), p.
46.

27. I wish to thank Arthur Nestrovsky, a composer fluent in atonalism, for helping me
with the analysis of the music.

concert C♯ to the singer's B♭, B♮, while the cello is leading to A♭. In bar 10 the vocalist has to sing G♮ in relation to the violin's high G♯, and in bar 11 the vocalist barely anticipates the violin's high C with a B♭. In the last bar the singer's last and important phrase begins with a C♯. Beneath this the cello is sounding a C♮ in unison. Although atonal music is extremely dissonant and makes frequent use of seconds and sevenths, there is, again, something unusually mimetic about the relation of the score to the text in the "Two Rilke Songs," given that the proximities of the notes appear both too close and too far apart. Moreover, in relation to the instruments as a whole, the vocal part is not entirely synchronized, as if the part were inhabiting a structure quite estranged from some of the other parts. This is especially evident in bars 10 and 11 of the second song in which the wind instruments are playing notes quite unrelated to the vocal part, even as voice and violin distantly mirror one another. That is to say, the instrumental parts both approach and distance themselves from the vocal line in ways unusual in the context of Western music.

This phenomenon of nearing and distancing relates even more strongly to that aspect of formal analysis that reveals that the "Two Rilke Songs" are generated out of a note cluster, C♯, D, E♭, F, G, and G♯. In other words, Webern's Opus 8 does not engage in strict seriality. In fact, each of the songs bears most heavily on one particular note—an ersatz tonic—even though this is not evident to the ear. D♮ is structurally the most significant pitch in the first song, and E♭ is the structural focal point of the second song. The first song ends on what could be considered the dominant or fifth of D, namely, A. And the second song ends with the harp softly repeating a very low E♭ that functions in musical context as the dominant of A♭. That the songs privilege D and E♭, respectively, suggests that the "Two Rilke Songs" are very closely tied to the structural principle of the minor second, the closest note-to-note relation possible in the chromatic scale. Each of the songs ends on A, although in the second song the note cluster E♭, E♮, F♯, A, B, C, C♯ suggests a 7th chord on E♭ that could go to what might be perceived as a root chord on A♭ (A♭, C, E♭). Here again the minor second relationship is upheld, though now between the A♭ chord and the A♮ scored in the vocal part. In other words, even as one is faced with a note cluster in which all the notes are bunched too

tightly together in major and minor second relationships, one can still visually deduce from the score an embedding of a harmonic movement from E♭ to A♭ that cannot be distinguished by ear. Most curious, perhaps, is that the vocal part ends on an A♮ that binds the ending of the second song to the ending of the first even as that pitch entirely violates or stands outside of the E♭ to A♭ movement; not coincidentally, it is precisely here that the singer is articulating the word "fest" or "tight." One is tempted to say that Webern is exploring an undecidable musical relationship in which the voice is at once within and outside of a binding formal structure. This is not surprising, given the nature of the poems that Webern has set to music. But it calls to our attention a general structural principle, namely, that the "Two Rilke Songs" are extremely imitative even as they violate the very correspondences on which imitation depends. They imitate the human attachment or binding even as they perform the inhuman detachment or letting go. And these songs do so at the expense of disenfranchising or abandoning a particular note, the pitch designated concert A. Here a certain limit between what is bound and what is detached has been musically deconstructed. The music has been structured such that a pitch comes into the open as "*la différance.*"

Overall, we can see, then, that two rather different orders have come to light, the vocal order supporting the closure of the work, the written order supporting an openness or noncoincidence of elements in the work. If for Webern "die Musik ist Sprache," then one can only suppose that this thought has to be internally divided. For if speech subsumes music in a performative or expressive moment in which the human comes to the fore, the music also subsumes speech in a writerly moment in which the work inclines toward a stranding of notes and words which leaves human expression behind. In other words, Webern's notion that "die Musik ist Sprache" involves two orders, each of which does violence to the other. Yet, without the difference of these orders—the one inclining toward the human, the other away from it—Webern's Rilke songs could not come about and an essential relation between music and speech would not be revealed. In what follows, that relation concerning the coming into proximity of the human with the inhuman, is developed further in terms of what Heidegger calls the Open.

In *Parmenides* Heidegger developed the concept of the Open and, in so doing, glossed Rilke's "Eighth Duino Elegy," a poem that guides Heidegger's thinking, once more, in "Wozu Dichter?" The poem begins with the following lines:

> Mit allen Augen sieht die Kreatur
> das Offene. Nur unsre Augen sind
> wie umgekehrt und ganz um sie gestellt
> als Fallen, rings um ihren freien Ausgang.
> Was draußen *ist*, wir wissens aus des Tiers
> Antlitz allein; denn schon das frühe Kind
> wenden wir um und zwingens, daß es rückwärts
> Gestaltung sehe, nicht das Offene, das
> im Tiergesicht so tief ist. Frei von Tod.
> *Ihn* sehen wir allein; das freie Tier
> hat seinen Untergang stets hinter sich
> und vor sich Gott, und wenn es geht, so gehts
> in Ewigkeit, so wie die Brunnen gehen.
>
> [With full gaze the animal sees the open.
> Only our eyes, as if reversed, are like snares
> set around it, block the freedom of its going.
> Only from the face of the beast do we know
> what *is* outside; for even little children
> we turn around and force them to look backward
> at the world of forms, and they do not see the open
> so deep in the animal's eyes. Free from death.
> Only we see *that*; but the beast is free
> and has its death always behind it and God before it,
> and when it walks it goes toward eternity,
> as springs flow.][28]

Heidegger is especially interested in how Rilke's metaphysical notion of the open might differ from an interrogation of Openness based on pre-Socratic thinking. In particular, Rilke's poem is said to be metaphysical because it separates man from animal, reason from unreason,

28. Rainer Maria Rilke, *Duino Elegies*, trans. C. F. MacIntyre (Berkeley: University of California Press, 1961), p. 61.

and self-consciousness from unself-consciousness, though Heidegger credits Rilke with resisting a Christological notion of creation in which mankind is set off as hierarchically superior to the realm of plants and animals. In fact, Rilke has noticed that it is the animal who sees the openness in which the coming to pass of being and truth can be detected. "Man sees the open so little that he is in need of the animal in order to see it."[29] If truth comes to pass in the open, therefore, as Heidegger has argued, man first requires the animal or the inhuman as mediator. This means, of course, that for Heidegger, Rilke has already challenged the difference between animal and man, the inhuman and the human. Heidegger suggests that if the eighth elegy is to succeed as a work of art that discloses the coming to pass of *aletheia* in terms of the open, it can do so only by teaching us how to negotiate the unhuman in such a way that the metaphysical difference between the human and the unhuman is dismantled. Still, Heidegger wonders whether Rilke has really brought us to this pass.

Although Heidegger suspects that Rilke was aware of the possibilities for disassembling differences that underwrite a number of traditional religious and philosophical orientations, he rejects Rilke's "Umkehrung," or overturning, on the grounds that it both does and does not know about the coming to pass of truth. Although Rilke is correct to turn toward the inhuman as a means of approaching or anticipating the disclosure of truth, he does so recklessly, because at the heart of his turn the antinomies between the rational and the irrational, the self-conscious and the unself-conscious are still active. Heidegger criticizes Rilke for not supposing that man is ever anything other than a subject who stands before an object. The elegy says as much in the following verse: "And we: onlookers, always, everywhere, / turned toward everything and never from."

Heidegger maintains that if one is going to dismantle the difference between the human and the unhuman, one must pay attention to the metaphysics of the subject position. Furthermore, one must be capable of dismantling even the distinction between what is open and what is closed, a dismantling that subverts our understanding of how

29. Martin Heidegger, *Parmenides*, trans. André Schuwer and Richard Rojcewicz (Bloomington: Indiana University Press, 1992), p. 155. "Der Mensch sieht das Offene so wenig, daß er erst des Tiers bedarf, um es zu sehen." *Parmenides* (Frankfurt am Main: Vittorio Klostermann, 1982), p. 230.

the human is foregrounded against the inhuman. For Rilke the open seen by the animal is merely "das Grenzenlose, das Unendliche [the limitless, unbounded, or unending]"; hence it follows that for him human perceptions are traps that enclose and imprison. For, unlike the animal, we are aware of our finitude and therefore know and can anticipate horizons such as death. The animal, in contrast, is horizon-less. Heidegger rejects this view by noting that only a human can see the Open because only a human is capable of asking the question of being. Whereas the animal merely exists in the difference between what is open (or unconcealed) and closed (or concealed), the human comes to be as human at that moment the difference between concealment and unconcealment has been transcended by means of re-conceptualizing the limit as something other than a binary division. Truth is not what comes to presence as such but what is disclosed in the rift between what founders in the wake of concealment and what perseveres as the "un-absent." Truth, we might say, is the showing forth of the structure or trait of the rift itself, a structure that could be thought of as an Opening in the Heideggerian sense that dismantles the difference between the bounded and the unbounded, human and animal.

In "Die Sprache," Heidegger writes that "the structure of human speech can only be the manner (*melos*) in which the speaking of language, the peal of the stillness of the dif-ference, appropriates mortals by the command of the dif-ference."[30] This suggests that, even in the retreat of the work into what is unhuman, the work appropriates or hails mortals by the command of the difference. In the most delicate moments, when notes and rests broach the difference between stillness and sound in Webern's music, a hailing of the listener occurs as a drawing toward the peal of what remains concealed or unheard. In Webern the inability of the work to survive its own performance bears on a stillness that in rejecting disclosure alerts us to the otherwise-than-human: the trait of the *a-logon* that in Rilke is symbolized by the wordless condition of the animal. If this wordlessness can hail mortals, it is because the work of art discloses it in terms of *a-letheia* as an

30. "Das Gefüge des menschlichen Sprechens kann nur die Weise (das Melos) sein, in die das Sprechen der Sprache, das Geläut der Stille des Unter-Schiedes, die Sterblichen durch das Geheiß des Unter-Schiedes vereignet." Heidegger, "Die Sprache," p. 31.

un-forgetting or un-veiling, an interplay of wordlessness and word. The work's hailing is itself, therefore, an effect of the rift of the work's openness (*a-letheia; a-logon*) where the difference between the peal and the stillness appropriates even as it disappropriates mortals. It is in the openness of this dif-ference (*Unter-schied*) that the work persists as the not-absent. In *Parmenides* Heidegger stresses that truth comes to our attention only because of the persistence of a hail that remains, rests, or abides in the wake of the work. No doubt we should not hesitate to say that it is nihilism that arrives in this *retrait* of the work, a retreat that bears on the limit of the work's mortality. However, it is from the hither side of that limit that the work survives, calls, or hails in the openness of the draft of negativity. That Heidegger refuses to think of that hitherside as something merely negative, dead, inhuman, or nihilistic sets him apart from his contemporaries.

Because Webern intentionally wrote music that did not elude its destruction or mortality, he was suggesting something we, as a culture, have forgotten—that the nature or essence of music is not objectifiable as an expression that comes to presence in a now. Like Heidegger, Webern suggests that music cannot be held by pincer distinctions such as presence/absence, accessibility/inaccessibility, hearability/nonhearability. Rather, music occurs in a way that distances itself from any manifestation in toto within the framework of a temporal present. Indeed, music constitutes an approach in the wake of something that has died away. That is, in its simplest terms, music is an emergence and withdrawal in time. Whereas composers have always resisted the temporality of emergence and decay by means of creating forms that transcend time by abiding in the memory of the hearer, Webern's music consists of forms or structures that listeners cannot remember or retain. In that sense, the music is never experienced by the listener as an objectifiable or idealized whole, but is recollected as a number of pitches that have been sounded and that have passed away. Instead of trying to transcend time, as music has traditionally attempted to do, Webern's pieces take place in time without any desire to violate the ephemerality of any of its moments. Given this strict respect for time, Webern's music gathers our attention, not by revealing itself in terms of a will to power as work, but in terms of hailing us out of its stillness in time. Such a hailing is what we might call from a musical perspective the peal of time.

The hailing of the work, then, has to be considered as a call on mortals whose basis is not to be found in human expression but in a temporality that releases the music from the transcendental and objectifying presence of the work *as work*. At the same time, this hailing is also the trait of the rift between the human and the inhuman whose truth is the dismantling of their difference. And this dismantling occurs in time at the limit where music persists in the abnegation of its coming to presence as something that transcends the moment. In *Parmenides* Heidegger calls this persistence of what is un-absent. What sounds in this un-absent is the peal of the un-destroyed, the undestruction left behind in the wake of temporality. What is undestroyed, furthermore, is what has persisted in a temporality that is open, a temporality, for example, not defined in terms of a human expression that insists on delimiting the work as a thing whose essence is predicated on the capacity to transcend time.

We have now reached the point where we can begin to see a number of issues that converge around Heidegger's notion of openness. What we did not expect to find here, perhaps, was temporality, although from a musical perspective, it was given all along. In fact, this is why the Webern songs are so important to us; they offer an example in which an artist or composer has by a very different route touched on a set of problematics that might at first seem particular to Heidegger's thinking alone. Considering Weberns pieces also offers the advantage of helping us think about how music and language are intimately tied to questions that pertain to temporality and how this tie is a crucial link to an understanding of how the human and the inhuman are brought into proximity in terms of a rift in whose difference truth comes to pass. Webern, like Heidegger, has taken us in this direction by way of Rilke's poetry, but whereas in Heidegger such poetry is rarely considered in a way that does not favor spatialization, in Webern that poetry is opened or released temporally in such a way that the critique Heidegger makes of Rilke is taken to task by the two musical settings that Webern composed. For example, in the first of the poems, the narrator says, "How if we were to endure this glory without remaining silent?" Here endurance is the temporality in which glory is concealed and unconcealed. And it bears on the differences between truth and lie, attachment and detachment, silence and sound. As Heidegger knew, time is crucial to understanding the differ-

ence between the human and the animal, and this difference is to be grasped in terms of how each endures stillness. For the animal the crossing into the Open is a crossing into limitlessness but largely because for the animal time is absent. Enduring means something other than a reckoning with temporality. But for the human time is what persists as un-absent. It is what sounds as the silent peal of the undestroyed. Stillness is that silent peal. And as such it is the endurance of time or time as endurance. If, as I suggested, the work cannot survive its own time—such an undoing of the work is itself nothing else but the adherence of the work to the peal of stillness. But how is music to reflect this glory of time's peal without breaking faith with its silence? By stepping into an open region where letting go and holding fast take on new meaning. At one point in "Die Sprache," Heidegger asks what the peal of stillness breaks on. Heidegger does not claim to have an answer for this question, but the two Rilke songs of Webern may well have brought us closer to an answer. For what the endurance of the peal broaches is something Heidegger never considers in "Die Sprache," namely, a bringing into the Open of time. Here, of course, temporality is no longer subordinated to that which transcends it but endures in a glorious stillness that nevertheless commands us to respond. On what does the peal of stillness break? On the truth of art as our response to time.

3 Brushed Path, Slate Line, Stone Circle

Much visual art of the twentieth century can be interpreted as a resistance to Kant's *Critique of Judgment*, in which the essence or truth of the work of art is directly correlated to art's being made for someone to apprehend. That is, Kant never imagined art as anything other than an aesthetic entity that was made to be shown or presented by the artist to his or her audience. How, not whether, the true work of art is supposed to be apprehended is the matter of the Third Critique. Already in the case of Webern's "Two Rilke Songs," however, we saw that it was just this assumption about the way in which the work discloses itself to an audience that implied a very different notion of truth from the one Kant assumes when he posits the "thereness" of the work "*for* consciousness." Webern, as we saw, stressed a Heideggerian orientation to truth—truth as *aletheia*—according to which concealment or withdrawal of the work of music into silence and hence away from the listener is understood as a counter-essence essential to the authenticity of the work of art. In this case, the aesthetic does not come about in consciousness as a response, however intellectual, by the mental faculties to external stimulation, but could be said to be in retreat from this kind of encounter even to the point of a stillness indicative of what Heidegger calls oblivion. If there is beauty in Webern, therefore, it is a beauty at the furthest edge of its extinction, what the poet Jorie Graham has called "the end of beauty." That this end is not entirely incompatible with the notion of there being a truth in art is, of course, what our previous investigations into Heidegger's conception of *aletheia* have suggested.

In this chapter, I turn to an investigation of the philosophical im-
plications of the environmental art of Richard Long in order to look
at another aspect of the Heideggerian understanding of *aletheia*,
though this time from the perspective of the return or restitution of
beauty in contemporary art. That this return points to a restitution of
the aesthetic after the dismantling of metaphysics rather than to an
anti-aesthetic or absolute end of beauty is of particular interest to me
because it is yet another destiny or effect of the understanding of
truth that Heidegger was investigating throughout his career. Whereas
both Heidegger and Derrida are quite aware of this return to the
aesthetic, it should be said that neither of them has undertaken the
kind of analysis that shows the extent to which contemporary artists
have produced work whose philosophical implications are of enor-
mous importance for thinking through many of the questions that
both Heidegger and Derrida have raised.

☙

Chiefly considered as belonging to the British land art movement—
other artists include Roger Ackling, Andy Goldsworthy, Chris Drury,
Ian Hamilton Finlay, Raymond Moore, and Linda Taylor—Long's
"work" takes place outdoors but is on view indoors.[1] He is well
known for his linear "walks," such as "A Line of Ground 94 Miles
Long" (England, Autumn 1980), as well as shorter circular walks, such
as "Granite Stepping-Stone Circle: A 5 Mile Circular Walk on
Dartmoor Passing Over 409 Rock Slabs and Boulders" (England,
1980). In addition to his native England, Long has undertaken lengthy
walks in Iceland, Lapland, Bolivia, Japan, Nepal, Central Africa, and

1. The major reference source is R. H. Fuchs, *Richard Long* (London: Thames and
Hudson, 1986). For an even more recent volume, see Anne Seymour, Hamish Fulton, and
Richard Cork, *Richard Long: Walking in Circles* (London: Thames and Hudson, 1991). Also
see *The Unpainted Landscape*, foreword by Simon Cutts (London: Coracle Press, 1987). For
useful history and overview of earth art during the 1960s and 1970s, see *Art in the Land*, ed.
Alan Sonfist (New York: Dutton, 1983). Last, it is instructive to compare the work of Andy
Goldsworthy, which makes a much clearer distinction between art and non-art than does
the work of Long. For example, Goldsworthy's leaf or icicle sculptures photographed in
Andy Goldsworthy, *Stone* (New York: Abrams, 1994) are perhaps perilously close to the
kind of commercial art environments one encounters in magazines such as *Graphis* or
Architectural Digest.

the United States. He has made site-specific sculpture out of drift-wood, seaweed, snow, and stone. He has "marked" the land with wa-termarks, stone scratchings, and the brushing or clearing away of nat-ural debris. Some of his museum installations consist of mud splashings on walls, watermarks, stone circles, and slate lines. The walks themselves are documented with photographs and verbal con-structions bordering on poetry. And an overall consideration of Long's work would have to recognize that it ambiguously negotiates performance art, site-specific sculpture, conceptual art, minimalist art, photography, the construction of museum installations, poetry, appropriation art, the artist-book, and, most recently, video art.

Long is controversial within the international art community be-cause in laying aside a Kantian notion of the work of art, he simul-taneously recovers or restores familiar appearances of beauty. That is, Long juxtaposes radical anti-aesthetic practices with a conventional rehabilitation of beauty that some have equated with romanticism and others with the aesthetics of Zen gardening. Given Jacques Der-rida's considerations of the parergonal in art and his interrogation of the problematic of restitution in the tradition of painterly expression, it is instructive to analyze a highly self-conscious conceptual artist who has, quite independently of Derrida, paid considerable attention to both the enframing of the work of art and the question of restitu-tion. Indeed, Long's placement of the anti-aesthetic in relation to the aesthetic also parallels a major moment in Heideggerian thinking when comments are made on the recovery or restitution of the aes-thetic in the wake of its being laid aside during the dismantling of metaphysics. Heidegger, therefore, provides another mode of theoreti-cal acess to the work Long has been producing. Yet, given that Heidegger provides no artistic example of what he means by the lay-ing aside and picking up of the aesthetic, it is useful to consider Long's artistic practices both as a means of developing Heidegger's thought and in its relation to Derrida's own meditations on it in *The Truth in Painting*. Hence, if Heidegger and Derrida provide theoretical access to the aesthetic questions raised by a contemporary artist such as Long, Long also enables us to understand better what Heidegger and Derrida mean by the restitution of an aesthetic left behind in the wake of the destruction of metaphysics.

In "A Dialogue on Language," the Japanese interlocutor says to Martin Heidegger: "Meanwhile, I find it more and more puzzling how Count Kuki could get the idea that he could expect your path of thinking to be of help to him in his attempts in aesthetics, since your path, in leaving behind metaphysics, also leaves behind the aesthetics that is grounded in metaphysics." Heidegger immediately cautions: "But leaves it behind in such a way that we can only now give thought to the nature of aesthetics, and direct it back within its boundaries [Aber so, daß wir das Wesen des Ästhetischen jetzt erst bedenken und in seine Grenzen verweisen können]." For Heidegger the boundaries do not refer to the limits or borders of the work as object but to the interplay of art within an openness that brings forth what is called stillness of delight ("Stille des Entzückens"). In fact, Heidegger's dialogue does not stress the making of the work of art, but its coming to appear out of concealment as a consequence of "graciousness," or *Huld*. In Japanese this is called *koto*: "the happening of the lightening message of the graciousness that brings forth [das Ereignis der lichtenden Botschaft der Anmut]."[2] This definition, which pertains directly to the question of *aletheia*, reflects the moment in Heidegger when the aesthetic is taken up once more, after having been dropped, and it points to the aesthetic as that which comes out of concealment in such a way that it bears on a Saying that allows us to grasp stillness in relation to delight. Such a manifestation of delight could not take place without graciousness, which is synonymous in Heidegger for the "gift" or "granting" of Being. The Japanese speaks of this succinctly in the dialogue when he refers to the petals that stem from *koto*, the gift that springs from graciousness. Heidegger is quick to add that *koto* "names something other than our names, understood metaphysically, present to us." And this suggests, among much else, that in picking up the aesthetic in a Japanese vocabulary, Heidegger is picking it up as something other, as that which names something else than our names name.

2. Martin Heidegger, "A Dialogue on Language," in *On the Way to Language*, trans. Albert Hofstadter (New York: Harper and Row, 1971), p. 42. "Aus einen Gespräch von der Sprache," in *Unterwegs zur Sprache* (Pfulligen: Neske, 1959), pp. 138, 145, 142.

Helpful for an understanding of these thoughts is "Conversation on a Country Path" ("Zur Erörterung der Gelassenheit") in which Heidegger suggests that to grasp stillness in its relation to delight would mean to think beyond representation and objecthood. In this context, therefore, *koto* would name something other than a thinking about the aesthetic that would be understood in the traditional contexts of re-presentation or mimesis. The metaphor for this other way of thinking is the country path that opens on to what Heidegger calls a region. The term *region* is meant to radicalize the Husserlian notion of horizon, which, of course, pertains to an understanding of an object world. Heidegger's notion of region, then, is the path along which some metaphysical baggage can be dropped by the wayside. It is the open, the clearing where one approaches what names something other than what our names name. Of major importance is the following exchange:

> Teacher: The region gathers [*Die Gegend versammelt*], just as if nothing were happening [*gleich als ob sich nichts ereigne*], each to each and each to all into an abiding [*das Verweilen*], while resting in itself. Regioning [*Gegnen*] is a gathering and re-sheltering [*versammelnde Zurückbergen*] for an expanded resting in an abiding [*zum weiten Beruhen in der Weile*].
>
> Scholar: So the region itself is at once an expanse and an abiding [*die Weite und die Weile*]. It abides into the expanse of resting. It expands into the abiding of what has freely turned toward itself [*des frei In-sich-gekehrten*]. In view of this usage of the word, we may also say "that-which-regions" [*gegnet*] in place of the familiar "region" [*Gegend*].
>
> [. . .]
>
> Scientist: I believe I see that-which-regions as withdrawing rather than coming to meet us. . . .
>
> Scholar: . . . so that things which appear in that-which-regions no longer have the character of objects.[3]

After concluding that the things no longer come to appear as objects, the discussants ask how the thing comes to rest or lie in the region, and the teacher explains that resting comes about in the returning to that which abides "of the expanse of their self-belonging" (p. 66). When the scientist complains that one has difficulty re-presenting

3. Martin Heidegger, *Discourse on Thinking* (New York: Harper and Row, 1966), pp. 66–67. *Gelassenheit* (Pfullingen: Neske, 1959), pp. 39–40.

such notions, the scholar explains that "probably it can't be re-presented at all, in so far as in re-presenting everything has become an object that stands opposite us within a horizon." Of course, the word *Feldweggespräch* in the German subtitle for this dialogue ("Aus einem Feldweggespräch über das Denken") is not insignificant, because it ironically keeps supplying what the discussants find so hard to grasp: that nonrepresentational thinking is akin to walking a path while discoursing in the countryside, what the scientist of the dialogue calls thinking as the "coming into the nearness of distance" (p. 67). The title suggests, then, that thinking is an event or occurrence that is always in movement toward as well as in retreat from. And indeed the walk is a good metaphor for this movement also mirrored in discourse, because during a walk something is always coming closer while something else is always receding. Moreover, Heidegger likes to think of the region as a coming together of time and space in which thought abides as both a coming closer and a moving further away. Drawing on *Parmenides*, Heidegger discusses the region as an Openness in which the subject–object relation has been set aside and, in its place, a releasement or letting go has come to pass.

This releasement, or *Gelassenheit*, is nothing less than movement within the region, or, a walking along the path, although as such it cannot properly be named or represented. Yet, Heidegger provides us with a supplementary apparatus, of which the title is but a part, that is, with geographical metaphors and the very representational analogy of the walk in the country. Heidegger is suggesting that this supplementary representational apparatus is, in fact, a negation of that regioning of which he speaks. Yet, in order to speak of that which regions, Heidegger has to take up this representational language, a language that is aesthetic. In short, having put the representational aside, Heidegger does, at some point, find it necessary to pick it up once more.

This "taking up," however, is addressed in terms of naming and what lies beyond it. And as in "A Dialogue on Language," Heidegger has recourse to the notion of Saying. In the 'Conversation," the scholar asks by virtue of what designation could something be given a name. And the teacher says: "Perhaps these names are not the result of designation. They are owed to a naming in which the nameable, the name, and the named occur altogether" (p. 71). In other words,

the name is to be understood in terms of a Saying in which language is a regioning where the nameable, the name, and the named are released into "a coming into the nearness of distance." What is most peculiar about this Saying or regioning of language is that for Heidegger "everything is in the best order only if it has been no one's doing" (p. 71). That is, only when the subject has been withdrawn or released from its hold over things—and this, of course, would include expression, representation, creation—does it allow the regioning of the nameable, the name, and the named to come to the fore as both identical and different, as near and far. Moreover, and this is most surprising, it is in terms of such a regioning that man comes to be as "the appropriated." In other words, man comes to pass as an event, happening, or movement in which the "that which regions" comes forth. Given that man belongs to that which regions, regioning cannot come to pass without the one who crosses over into it. Hence the coming to pass of regioning depends not only on man, but also, presumably, on man's ability to perform this relation, a performance that is reflected in Heidegger's choice of the dialogue as a genre of writing in which language itself is disclosed as regioning.

Once more, the aesthetic has been taken up after having been laid aside. That is, the aesthetic now has to be understood as the "gathering everything together and letting everything return to itself, to rest in its own identity" (p. 86). Indeed, the dialogue is the gathering and returning in which regioning comes to pass. And as such it is not easily separable from the notion of the walk that Heidegger, in "A Dialogue on Language," considers stillness in delight or *koto*. Dialogue, which could be contrasted to argument, is a regioning of language that comes about through "graciousness": the nonoppositional gathering of words. "Graciousness," then, is a term that would give testimony to a discourse that has put something aside, namely, the oppositionality or difference of utterance, what Paul Ricoeur calls the "conflict of interpretations." Representationality, then, would be a matter of conflict, which is to say, of that which stands out in opposition to. Hence representation is not gracious. In contrast, the dialogue and the walk are, to Heidegger's way of thinking, events that allow for a stepping into what is called an Openness that is not to be confused with the mimetic. Such openness pertains to dialogue insofar as it facilitates an understanding of language in which one can pick up and

put down terms outside of a mimetic framework determined by confrontation. Moreover, openness pertains to the walk because it facilitates an understanding of regioning that gives up the kind of subject–object relation on which a familiar notion of landscape (or being-in-the-world) depends.

<div align="center">᠅</div>

Ever since their inception in the 1960s, Long's walks have remained uniform in conception and execution, perhaps even to the point of single-mindedness. Yet they have remained compelling and elusive as well. His walks have raised numerous questions pertinent to conceptual and minimalist art touching on notions of the objectification, presentation, and situation of the work of art. Some might argue that the walks themselves are not even the work, but that the work comes to appear in the impermanent modifications to the environment that the wanderer makes. On some occasions Long has walked back and forth along a straight line and has, merely by walking, brushed the earth or its vegetation enough so that from a distance one can clearly see the impermanent trace of where the wanderer has been. On other occasions, Long has moved stones or has, at various determined points, gathered and carefully ordered stones into lyrical structures. One wonders: Does the art consist in or as these stone constructions, these monuments to his walks? Does the art consist in the act of making the constructions within the framework of the walk? Or are these modifications to the landscape merely the trace of something that has never come to presence as work but which persists as idea?

Given that Long is a solitary wanderer, how is it possible for his work to appear as work before an other? Moreover, as the one who walks, is Long himself in a position to objectify or constitute the walk as work? Like Christo, Long documents his performance work by providing maps, photographs, and texts. But whereas Christo's photography complements the monumentality of his expensive outdoor drapery, Long's photographs are contradictory in that they are a tracework that does not shy away from supplementing the ineffable with extremely traditional representations reminiscent of commercialized nature photography. In that context, Long's "works" are ironically overly

accessible and stand in stark opposition to the conceptual and performative unrecoverability of the walk.

The photographs, then, signal a moment in which the aesthetic, dropped or laid aside by the act of walking, is once more taken up. However, this recovery is far from being an uncomplicated one, because even the photographs participate in the walks' dismantling of an aesthetic tradition. As supplementary documentation these photographs are merely traces in the wake of a work that remains concealed. Curiously, the traditional mimetic representation—the positive contact print—functions like a photographic negative or negation of the walk as art. But when this negative or negation of the work is displayed in museums or sold to collectors, it functions to affirm and display the work even as it puts the walk as work under erasure. In offering to the collector an object, however supplementary, that can be seen or purchased, Long is suggesting that the walk can be detached from time and place and turned into an art commodity, as so many pictures signed by the artist.

Are the photographs, then, some kind of joke that Long is playing on the art market? And do they, by way of negative example, point to the peculiar condition of the walk as inappropriable and allergic to the traditional mimetic assumptions that inform museums and art markets? Certainly, the photographs must be making some such point, particularly since Long has made remarks deprecating their significance, as if to suggest that the photographs are little more than ancillary souvenirs that only point to the ineffability of the walks as works. To put this in terms of Heidegger's "A Dialogue on Language," the photographs can be seen as the very aesthetics that the walks have dropped by the side of the road. This would account for the deliberate staging of the pictures in a romantic aesthetic that is so commonplace in commercial nature photography. That is, the romantic representation of the outdoors as raw beauty falls away in its appearance as souvenir or document as if to "release" the walk from a certain aesthetic burden. The walk, then, might be comprehensible as detached from the requirements of a Kantian aesthetic in which the work must manifest itself as something intended to be seen or disclosed, as the something consciousness requires in order to be "conscious of." Perhaps Long even takes matters a step further than Heidegger, since for Heidegger the walk imitates thinking as an event or occurrence that is

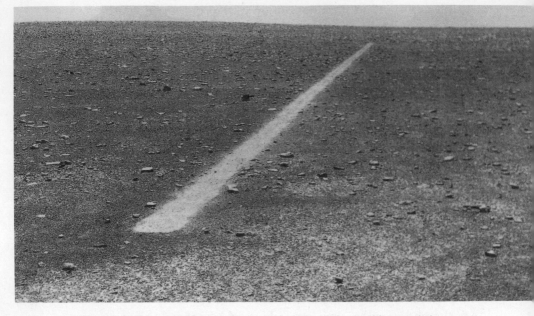

Richard Long, "Dusty Boots Line." *The Sahara* (1988). Reprinted by permission.

in movement toward and in retreat from, while for Long the walk does not address a movement toward or away from an event of thoughtfulness; rather, the movement would be more indicative of what cannot be thought or reflected on. If the photographs are approximating mere prettiness (some might even say, kitsch), they may be doing so to mark a "coming into nearness of distance" that is insufficient to disclose or approach the work of the artist as either work or event.

And yet, if these photographs can be viewed as the very aesthetics that the walks leave behind, like some old shoe, Long has also addressed them as being exemplary of high art. In other words, if the photographs suggest the dropping of an aesthetics, they also manifest the very aesthetic that is being picked up in the aftermath of minimalism. The photographs, then, could be seen as an instance of what Heidegger is enigmatically calling the redirecting of the aesthetic within its borders or boundaries. What appears, therefore, in the photographic documentation is a representation of beauty that has returned, after having been put aside, as if to say that when beauty is recovered, it will arrive as if from outside or beyond the work as work, as an accessory to the region that delimits the walk.

This return of beauty does not come in the form of a return of the repressed, because there was nothing traumatic about its having been left behind in the first place. Perhaps this is one more indication that Long's "work" has been released in a Heideggerian sense, because from the standpoint of an agonistic history of art the aesthetic is laid aside and taken up with serenity. In "A Dialogue on Language" the Japanese says, "A stilling would have to come about that quiets the breath of the vastness into the structure of Saying which calls out to the messenger." The stilling, here, is a moment of the laying aside and the structure of Saying a moment of re-appropriation or return. Something can be said, because something has first been stilled. However, contrary to our usual expectations, the relation between stillness and saying is non-oppositional. Indeed, what speaks to the messenger is not a saying that takes the place of silence, but the coming to attention of silence as that which can be said. No doubt this saying is a modality of Koto, "the appropriating occurrence of the lightening message of grace." In other words, saying is the event of an appropriation that is released in grace as a letting be which radiates.[4]

The photographs of Long are reminiscent of such a saying, for they, too, follow a stilling in ways that are not necessarily to be understood as oppositional. The photographs, from this perspective, do not necessarily supplement in the sense of substituting, but are indicative of an appropriation in which the walk comes to attention as something other than the walk, namely, the region in which the concealed and the unconcealed (i.e., silence and saying, the nonvisual and the visual) come to pass as graciousness, letting be, releasement, or clearing. However, as such, the photographs nevertheless must bear on a saying that can be understood; and therefore they do not necessarily have to say in a way that is unfamiliar.

Whereas art of the avant-garde has struggled to create new languages in order to change the ways we comprehend the world, Heidegger, and by extension Long, suggest that Saying is not essentially tied to the production of new and unfamiliar representations. In fact, Saying may be most radical when it chooses not to take the path of defamiliarization but, instead, reappropriates something familiar that has temporarily been put aside. Of course, to reappropriate in

4. Heidegger, "A Dialogue on Language," pp. 53, 45.

this way is not to return, in our context, to the very aesthetic one has left, but to take up that aesthetic in a way that puts its identity and difference with respect to itself in question. In other words, one would be violating Long's photographs if one merely categorized them as a style that is presumed to be self-identical and historically fixed in terms of an art movement.

Indeed, the photographs concern a turning in which a nineteenth-century aesthetic is put aside so that an aesthetic of Saying can come about. Such a turn is not agonistic or oppositional but rather a stepping into a region where aesthetics is released or liberated from the stylistic and historical conflicts that have characterized Western perceptions of the arts. Not least important is the release of the aesthetic from the will of the artist. Heidegger writes, "Everything is in best order only if it has been no one's doing."[5] No doubt, as an artist, Richard Long does something; however, he has often attempted to take only minimal actions, many of them quite commonplace and not particular to what we might call "artistry." The walks, for example, are difficult to distinguish from ordinary hiking, and the stone installations in museums require actions that any mason might be able to perform. Similarly the photography is not beyond the skills of any amateur who knows the zone method of light metering. Long might point out furthermore that not only are the actions hard to recover as "art"—contrast this, for example, with brush strokes in van Gogh, the handling of line in Gauguin, and composition in the sculpture of Henry Moore—but also that the works come to pass largely on their own.

In the artist book, *Planes of Vision*, for example, Long vertically records a series of words that undergo modulations in spacing. The series is merely "given" by the walk and is therefore a recording of what has come to attention. A typical series would be: cloud sky cloud sky clouds wire clouds tree hedge grass boots holly sky.[6] The words remind us of steps, and the variations in vertical spacing are reminiscent of pacing or adjusting stride. The words do not talk about the landscape but merely record what the wanderer notices as he passes through the countryside. Narrative, commentary, and personal expression have been set aside or stilled so that the

5. Heidegger, *Discourse on Thinking*, p. 71. *Gelassenheit*, p. 47.
6. Richard Long, *Planes of Vision* (Aachen: Ottenhausen, 1983), unpaginated.

words can speak from the side of what is simply given in nature. And the series of words, like the series of steps, comes into appearance not as an intended verbal construction that reflects the action of a writer, but as the appropriation or gathering of what was there when the wanderer passed through. No doubt, the wanderer writes down what was seen, or, more precisely, what he happened to see. But he has done this from the side of the things themselves. He has, to put it in terms of "A Conversation on a Country Path," submitted to the "region" and set aside his subjecthood so that the "work" comes to pass as that which is appropriated. Here, of course, we can see the relevance of the quote above from "A Conversation" to Long's art. "The region gathers, just as if nothing were happening, each to each and each to all into an abiding, while resting in itself. Regioning is a gathering and re-sheltering for an expanded resting in an abiding." Clearly, Long's art is a gathering or appropriation that occurs in the absence of the imposition of will and the increased awareness of paying attention to how things rest or abide. Re-sheltering (*Zurückbergen*) is significant insofar as it points to the concealment or unrecoverability of this happening, a concealment that appears to us as trace, supplement, purposive construction, or, to put it in a word, art.

However, if such a notion of "art" takes up the aesthetics of Heideggerian Saying even as it puts aside a nineteenth-century Kantian aesthetic, it nevertheless carries that abandoned aesthetic along into the region of Saying. Such a carrying forward can be seen everywhere in the stone constructions, the brushed paths, the photographs, the maps, and the artist books. And we have to consider the question of what it might mean in this context to redirect the aesthetic back within its boundaries. Again, if one considers the museum installations of stone circles and slate lines, one will once more be able to detect Heideggerian Saying as "a gathering together and letting everything return to itself, to rest in its own identity." And one can argue, as well, that these slate lines and stone circles are in dialogue: they manifest a regioning that occurs through a nonoppositional gathering or collocation. Here, too, an Openness is broached in which appropriation comes to pass and the stones speak from the side of things.

And yet boundaries are given here as well, particularly in terms of the figures of line and circle—those boundaries that are most plain and therefore most accessible or appropriable. Indeed, the line and

the circle are not forms that create a mere arrangement of the stones, but, rather, they come to appearance as a formalization that is graciously released or given by the stones as if the forms disclosed how the stones return to themselves as what Long calls, simply, "being themselves."[7] Therefore, Long can be credited with having directed the aesthetic back within its boundaries by simply gathering stones in such a way that they return to being themselves, a return that takes up the aesthetic as if to disclose the aesthetic as an aspect of Being. Similarly, the normative formalization of the photography functions in this way. It gathers the region in terms of what appears a normative aesthetic so that the region can return to itself as what it is: stillness in delight. Furthermore, if we consider the gathering of stones as similar to the gathering of photographs, maps, and texts, we should be in a good position to understand the extent to which these so-called parergonal structures relate in an important formalized manner to what Long prefers to call simply "art," an art that has carried the Kantian tradition into what lies beyond its dismantling.

‮ క

In *The Truth in Painting* Derrida has written what is undoubtedly one of his greatest introductions to deconstruction, "The Parergon," and one of his most difficult and breathtaking close readings, "Restitutions."[8] Judging from commentaries on "Restitutions" alone, one might not guess that the essay is, in fact, a dialogue or conversation. Moreover, "Restitutions" is about a debate and concerns the paintings of shoes by van Gogh over which Martin Heidegger and Meyer Schapiro are debating, although, of course, it's a one-sided debate with Schapiro taking up all of its length. Somewhat in this vein Derrida's text mimes a dialogue in which one person plays all the parts and we are left wondering whether it is a matter of dividing one train of thought or whether, in fact, two or more different trains of thought are being represented. However, as in Heideggerian dialogue, the dividing of parts may well be done in a nonoppositional manner. That

7. Interviewer: "Do the stones contain meaning which I don't understand?" Richard Long: "Well, you shouldn't have that problem with my work. The stones are being themselves." See "Interview: Earth, Water, Wind," *Contemporanea* 3, no. 4 (April 1990): 69.

8. Jacques Derrida, *The Truth in Painting* (Chicago: University of Chicago Press, 1987).

is, even if the representation of the Schapiro and Heidegger debate manifests sharp, if not bitter, conflict, the setting up of "Restitutions" as a dialogue mimes Heidegger's own genre of dialogue, which is non-combative or nonoppositional. This difference between the nature of the debate (as reflected in the writing of Schapiro) and the dialogue (as reflected in the writings of Heidegger) is easily overlooked and constitutes what Derrida in an earlier text called the "double séance." This "double session" can be a parergonal structure to the extent that it mandates within a mimetic tradition, some means of properly representing (or doubling) something that has already taken place. "The two faces are separated and set face to face: the imitator and the imitated, the latter being none other than the thing or the meaning of the thing itself, its manifest presence."[9] But Derrida also conceives of a doubling that is not circular and therefore fails to return to its "proper" a priori referent. Such doubling may be a writing that "both marks and goes back over its mark with an undecidable stroke." Such doubling takes place not once but many times as dislocation and displacement. "Let us read [Mallarmé's] *Mimique*. Near the center, there is a sentence in quotation marks. It is not a citation, as we shall see, but the simulacrum of a citation or explication:—'*The scene illustrates but the idea, not any actual action*'" (p. 196). Derrida disabuses us of idealism by remarking that it is not sufficient in this case to imagine that the "idea" can take the place of the referent, actual action. Rather, we must be prepared to realize that the idea is a term that marks absence. The idea is a white page. Hence the Mime imitates nothing, reproduces nothing, speaks of nothing. But what kind of "thing" results? Derrida replies, with his attention on "what" kind of text Mallarmé is writing: "A mimodrama 'takes place,' as a gestural writing preceded by no booklet; a preface is planned and then written *after* the 'event' to precede a booklet written *after the fact*, reflecting the mimodrama rather than programming it. This Preface is replaced four years later by a Note written by the 'author' himself, a sort of floating *hors-livre*" (p. 199). The "thing" or "text" is all mimicry: a double that is anticipated by nothing. The mimic or mime alludes, although without referring to anything. Such alluding "alludes without breaking the mirror, without reaching beyond the looking glass"

9. Jacques Derrida, *Dissemination*, translated by Barbara Johnson (Chicago: University of Chicago Press, 1981), p. 193.

(p. 206). Instead of pointing to reality, there are merely "reality effects," and the real itself becomes akin to death insofar as the real would break the speculum of mimicry. Derrida notes further:

> In this speculum with no reality, in this mirror of a mirror, a difference or dyad does exist, since there are mimes and phantoms. But it is a difference without reference, or rather a reference without a referent, without any first or last unit, a ghost that is the phantom of no flesh, wandering about without a past, without any death, birth, or presence.
>
> Mallarmé thus preserves the differential structure of mimicry or *mimēsis,* but without its Platonic or metaphysical interpretation, which implies that somewhere the being of something that *is,* is being imitated. (p. 206)

Let me break off, for a moment, in order to return to "Restitutions." It is Meyer Schapiro who wants to maintain an aesthetic high ground by demonstrating that Heidegger has "forgotten" mimesis; after all, did van Gogh not paint real shoes, and not only that, but did he not paint his own shoes rather than the peasant shoes of which Heidegger speaks? In other words, to recall Plato's Sophist, are these shoes not icastic representations of real objects, and is Heidegger not falsifying the whole issue of analyzing van Gogh's paintings by dreaming up a fantastic scene that has no reference whatsoever to the "things" van Gogh painted? "Schapiro tightens the picture's laces around 'real' feet. I underline: '*They are clearly* pictures of the artist's *own* shoes, not the shoes of a peasant.'"[10] Heidegger, on the contrary, is making an attribution to the shoes—he says they are peasant shoes—which is *not essential* but merely accessory or detachable. That is, Heidegger is simply fantasizing and projecting his fantasy on to the shoes that he sees. "Everything that comes down to the 'peasant' world is in this respect an accessory variable even if it does come massively under 'projection' and answers to Heidegger's pathetic-fantasmatic-ideological-political investments."[11] In other words, the "analysis" of Heidegger purposely sets aside the mimetic priority of valorizing the image as icastic in order to take up a simulacrum or phantastic allusion that has no "proper" reference. Therefore, Heidegger's analysis approaches the kind of doubling that Derrida has no-

10. Derrida, *The Truth in Painting,* p. 313.
11. Ibid., pp. 311–12.

ticed in Mallarmé's *Mimique*, a miming that reflects no reality but
produces instead "reality effects," because mimicry does allow for "a
difference without reference, or rather a reference without a referent
. . . a ghost that is the phantom of no flesh, wandering about without
a past, without any death, birth, or presence." If we read this back
into "Restitutions" and its remarks on the famous Heidegger passage
in "Origin of the Work of Art" on the peasant's shoes, we imme-
diately discern that far from being a metaphysical tribute to an au-
thentic völkisch existence in which blood and soil are fused, the pas-
sage is setting up a simulacrum or double that is estranged from
"death, birth, or presence." In short, "there is no simple reference."[12]
Whereas Schapiro wants to bring the shoes into the open so that they
can be exposed as referentially concrete and historically recoverable as
belonging to the artist, Heidegger wants to bring them into a very
different kind of openness in which the mimetic tradition is left be-
hind so that a less metaphysical region can come to appearance. This
region, in Derridean terms, is that of the "double séance": it is a
region where there is no longer any model, in Schapiro's sense, and
hence, properly speaking, no copy. Moreover, "this structure . . . is no
longer being referred back to any ontology or even to any dialectic"
(p. 207). Derrida cautions further: "Any attempt to reverse mim-
etologism or escape it in one fell swoop by leaping out of it *with both
feet* would only amount to an inevitable and immediate fall back into
its system: in suppressing the double or making it dialectical, one is
back in the perception of the thing itself, the production of its pres-
ence, its truth, as idea, form, or matter" (p. 207). The operation that
occurs in *Mimique* is not comprehended within the dynamics of the
truth as *veritas* but, rather, entails the comprehending of truth as a
truth-effect. This operation, Derrida notes, is a staging or framing
that has no requirement to conform or resemble something present.
But how can such a stage stage? Derrida maintains that in Mallarmé
this can occur only through a rethinking of difference in terms of
what he calls the veil or hymen. In addition to much else, the veil
marks the *différance* between "image and thing, the empty signifier
and the full signified, the imitator and the imitated." The veil abol-

12. Derrida, *Dissemination*, p. 206.

ishes the "difference" between "difference and nondifference" even as it intercedes in order to establish a gap or space between them.

In the van Gogh paintings the image of the shoes operates like the veil or hymen in Mallarmé's *Mimique.* The shoes are themselves a "double session" and, as such, are Derrida's fetishized gynocentric rendition of Heideggerian *aletheia.* For Derrida the question is not whether there is truth in art, but how the truth is de-monstrated in the context of, say, Mallarmé or van Gogh. Like Heideggerian *aletheia,* the shoes are dis-appropriative, a pair whose *dif-ference* forces even Heidegger to make a unified phantastic projection that supports a "subject" or wearer. Indeed, the need for "a pair of shoes" ties Schapiro and Heidegger together. Yet, this sutured "thing" also divides Heidegger and Schapiro because they cannot agree on the identity of the shoes: the question of to whom or what they belong. The pair/nonpair of shoes calls into question, therefore, the difference between the icastic and the phantastic, the representational and the mimotological. At a psychoanalytic level they also produce a dis-appropriative moment by taking up sides on gender: the one shoe gynocentric, the other phallocentric.

Because the shoes are not what Derrida in "The Double Session" considers a present around which is gathered a unity of temporal relations—van Gogh painting his shoes on a particular time on a particular date in history—they need to be thought out in terms of "a series of temporal differences without any central present" (p. 210). Derrida suggests this orientation to the shoes in "Restitutions" by discussing them as a series that both brings into relation and holds apart identity and difference, as if these shoes were veils, one substituting for another without ever taking priority, without ever collapsing into a real referent or "truth." This amplifies and transposes Heidegger's conception of *aletheia* as *Un-Verborgenheit* by mediating the question of appropriation and disappropriation with a rather aggressive de-monstration of mimetological *mise en abyme* that lifts the referent without removing reference:

> The referent is lifted, but reference remains: what is left is only the writing of dreams, a fiction that is not imaginary, mimicry without imitation, without verisimilitude, without truth or falsity, a miming of appearance without concealed reality, without any world behind it, and

hence without appearance: *"false appearance. . . ."* There remain only traces, announcements and souvenirs, foreplays and aftereffects which no present will have preceded or followed and which cannot be arranged on a line around a point, traces "here anticipating, there recalling, in the future, in the past, *under the false appearance of a present."* (p. 211)

In "Restitutions" lifting the referent by interrogating the pairing or divisibility of the shoes concerns the parergonal, because divisibility or mimetology is the frame for a phantasmic or de-monstrable content whose reality effects are everywhere. Derrida touches on this rather squarely when he notes that "What's at stake here is a decision about the frame, about what separates the internal from the external, with a border which is itself double in its trait, and joins together what it splits."[13] These remarks play with a double reference to the frame of the painting as well as to the shoes themselves. It is the frame of the painting that separates the internal from the external, and so on, even if, at the same time, the figure of the "pair" of shoes is mimicking the frame by means of operationalizing a "double session" that similarly deconstructs the difference of interiority (what is proper or attachable to the shoes) and exteriority (what is merely outside, or detachable from the shoes). What one has, then, is the deconstruction of the difference between what frames and what is framed with the result that the painting by van Gogh becomes an abyssal mimetology (i.e., the double in its trait) of frames on/within frames. The shoes themselves accede to a phantasmic series that obeys the abyssal law of the double trait, of the shoe as hymen, or, in terms of the notorious Heidegger passage on the peasant woman, rhapsodic hymn.

For the rhapsodic Heidegger passage on the peasant woman's shoes and the silent call of the earth is a hymn, though, too, a hymen. This is why it is a woman who is wearing the shoes and not a man: it is the Heideggerian hymen, covering, or veil of the Parmenidean "goddess truth" that is being disclosed. "In the stiffly rugged heaviness of the shoes there is the accumulated tenacity of her slow trudge through the far-spreading and ever-uniform furrows of the field swept by a raw wind. On the leather lie the dampness and richness of the soil. Under the soles slides the loneliness of the field-path as evening falls. In the

13. Derrida, *The Truth in Painting*, p. 331.

shoes vibrates the silent call of the earth, its quiet gift of the ripening grain and its unexplained self-refusal in the fallow desolation of the wintry field."[14] One can easily imagine the leather, the furrows, the gift of ripening grain, and an unexplained self-refusal as pertaining to a gynocentric scene that is itself divided or parceled out along the hymen's border as explained by Derrida in "The Double Session," which is to say, the hymen as that which is always already penetrated ("in the shoes vibrates . . . its quiet gift of the ripening grain") and never violated ("its unexplained self-refusal"). Yet, as we have noted, the shoes themselves are double sexed, meaning that they are both masculine and feminine. In Heidegger's passage, the feminine aspect of the shoes is being constituted as hymen and hymn. But such a reading is, without doubt, entirely phantastic, projected, and, as such, discountable, removable, detachable—hence the ex-centricity of the hymen, which is to say, its negligibility. In this sense, we could say that the hymen achieves a certain Heideggerian release in Being, say, the region of the hymen, the region of the unrepresentable (indeed, even the obscene) in which a hymn comes to pass in the aftermath of mimesis.

Yet if releasement is the region of the unrepresentable, of the hymen and the hymn, is it not as close as we are likely to get to a taking up once more of the truth in art? Or of "the goddess truth" that Parmenides spoke of in his hymn, "The Way to Truth"? Surely Derrida has preferred to speak of this in terms of the hymen as mimetological detachment and reattachment, disappropriation and reappropriation. For him the shoes are a radical unstable "figure" that stages this mimetological double session of Heideggerian *aletheia* in which is anticipated the return of the aesthetic and its redirection within borders—in Derrida's sense, the mimetological border of the hymn/hymen. That the aesthetic returns is beyond doubt, for "there is" the hymn that in positing its de-monstration of truth has always already redirected the hymen within its proper borders.

≫

In the catalogue *Richard Long* R. H. Fuchs recalls, "In Nepal, where there are many villages throughout the valleys, [Long] made a work

14. Martin Heidegger, "Origin of the Work of Art," in *Poetry, Language, Thought* (New York: Harper and Row, 1974), p. 34.

by brushing the footpath to leave a dusty line clear of leaves and twigs. Remoteness does not mean the absence of other people." And he notes further, "During a twelve day walk in Ladakh, the Buddhist part of Kashmir and a mountainous land of footpaths, [Long] respectfully walked lines upon the existing footpath, 'Walking within a walk, along the line of shared footprints.'"[15] Walking the paths of others, the walks of Richard Long take on an abyssal structure reminiscent of the mimetology of the "double session" or, as is worked out at length in "Cartouches" from *The Truth in Painting*, a reading of Titus-Carmel's "Pocket Size Tlingit Coffin" series in which a model is constituted as both intrinsic and extrinsic to the structure of which it is supposedly a part. For Derrida the series remains "without example," although it never does so entirely. "That which [the example] it [the series] expels, discounts, or defalcates, it also keeps in its own way, and exhibits the remains of it, it *raises it up* onto this pedestal, the stela, throne, or rostrum of its catafalque (*ex cathedra*, once it has climbed up into the pulpit it keeps silent)."[16] The model is therefore affirmed even as it is usurped by the drawings and forced to withdraw. Therefore the model is both posed and de-posed and the series manifested as an interplay of posing and de-posing that is, predictably, quite undecidable. The result is that "Titus-Carmel cadaverizes the paradigm. Hounding its effigy, feigning the feigning of it in a series of simulated reproductions, he reduces it, he transforms it into a tiny piece of waste, *outside the series in the series*, and henceforth no longer in use. He does without it ((*no*) *more* paradigm, (*no*) *more* coffin, one more or less), he puts an end to it."[17]

Certainly one could make a similar argument for the "brushed paths" and, in general, the "walks" that always pose and de-pose what Derrida calls the model, paradigm, cartouche, or example. In fact, one could probably make a similar argument for serial work by Sol LeWitt, Andy Warhol, Mary Kelley, Joseph Beuys, not to say van Gogh, whom, of course, Derrida does take up. But what would be missing from such an account is how the aesthetic is restored or rehabilitated.

15. Fuchs, *Long*, p. 133.
16. Jacques Derrida, "Cartouches," in *The Truth in Painting* (Chicago: University of Chicago Press, 1987), p. 194.
17. Ibid., p. 198.

Let me return, then, to the brushed paths. From a Heideggerian perspective the brushing of the path is a letting-be-seen (*sehen lassen*) or unconcealment of the *Feldweg*, the "thereness" of the path, which discloses that there is and has been walking, that someone has passed along the pass, and that the pass is the silent or still abiding trace or track of beings who have come to pass as passing. Hence like Derrida in the beginning of "Restitutions," one must face up to the fact that "Well, we've got a ghost story on our hands here all right," meaning that the specters of others who have passed are suggesting themselves in the brushing aside of leaves and twigs that have covered the path. This also means that Long is entering that abyssal structure that Derrida sees in Titus-Carmel's coffins; moreover, it means that, as in the case of the coffins, we may well notice the approach of something abject that Derrida addresses as cadavers, excrement, and ghosts. In Long's "brushed path" these phantoms are kept in abeyance, though one could project them into the scene from "outside."

Indeed, such a projection would come about at the moment someone brushes the path, at that moment the veil of leaves and twigs is lifted. Only then do we remember the others who have come before, both living and dead. To develop Derrida's notion of projection a little bit further, let us recall that all this could be read back into Claude Lanzmann's *Shoah*, a film that could be interpreted as a cinematic version of the "brushed path." That is, the traces or track of those who have gone before involves a hallucinatory apparatus of imaginary projection in which the absent returns to tell the story of crossing, walking, marching, staggering, and so on. By making people "come back" to where they once walked, Lanzmann lifts the veil—and the land, as it were—helps in narrating a terrifying history that has been covered over in a way similar to the paths of Nepal, that is to say, by the mere passage of time and change. Of course, the weight of Lanzmann's horror—the horrifying story he seeks to unconceal by brushing the leafy paths to Auschwitz—is absent from Long's "A Line in Nepal" in which the brushing of the path formalizes the forgetting of history, its sweeping aside, as it were, and the coming of a clearing in which the passage or turn from beings to Being is made wherein a restoration of beauty becomes thinkable once more. However, this restitution becomes thinkable only because something heavy has been

lifted, because the phantoms do not return, even though the road has been cleared or prepared for them.

Derrida, I think, would not want to miss this restitution or return of the dead. He would find it very problematic if in brushing the path a veil were lifted that had the structure or stricture of an undecidable strip or stripping that is both violable and inviolable. Here, of course, we approach the structure of the hymen in its Sadean manifestation of a body or covering that remains intact and virginal no matter how many times it has been raped or otherwise tortured. In other words, when Long brushes the path in Nepal, he guarantees the forest path's inviolability and its Heideggerian regioning, opening, or clearing in which we are released from representationality and, too, from the stories that those ghosts who have gone before have to tell. For Long the lifting of the veil is necessarily a releasement from ghosts, from the metaphysics or, better yet, phenomenology of those specters who haunt consciousness. To lift the veil in this way is to disclose the earth or path as yet a more authentic veil, as veil or hymen of a Truth incapable of suffering molestation. If we may substitute the word "earth" for "woman," we can quote from Derrida's *Spurs* as follows: "Earth [woman], inasmuch *as truth*, is skepticism and veiling dissimulation."[18] That is, the earth, too, in our perception, may be capable of dissimulating in a mimetological fashion only because it can never, in our consciousness, know anything of what Derrida calls "castration."[19] The brushing of the path, then, suggests a mimetology of veiling or dissimulation in which the veil is always being lifted in order that it affirm itself all the more as an inviolable truthful covering. However, this lifting always and already suggests violation, as well, since something is being disrupted, penetrated, uncovered, denuded, or stripped— what we might call the rape of the earth. Even if the brushing is

18. Jacques Derrida, *Spurs* (Paris: Flammarion, 1976), p. 47. Italics are mine.

19. Here, of course, a whole area called environmental ethics comes into view insofar as that ethics must engage the double and undecidable logic of the veil in correspondence with the articulation of the notion of woman as Derrida describes it in the context of Nietzsche and Heidegger in *Spurs*. The earth, in particular, is a figure of that which is always already violated and inviolable. And our actions with respect to the earth are, in every case, determined by this double session. To examine environmental policy, discourse, and the management of environmental catastrophes in these terms would be essential as a precondition for any rigorous understanding of how we conceptualize our relation to the land.

delicate, Long's "brushed paths" would appear to activate this dy-
namics of the veil as discussed in "The Double Session" and "Spurs."

However, the brushing of the path in Long also suggests both the
eradication and revelation of evidence or traces of where the human
has come to pass. Derrida, in addressing the expropriated shoe that
has been left behind on the *Feldweg*, notes that "there is persecution
in this narrative," as if to say that what gets left behind on the path is
always indicative of human conflict or travail.[20] Indeed, when Long
brushes the path, it is not to expose such conflict or, when it occurs,
human joy, but to clear away the traces of the human, as if to brush
or sweep humanity aside so that a "region" can come to appearance
as the granting of a hymn or ode to beauty. This would correspond to
Derrida's hint that Heidegger has put persecution carefully aside with
his metaphysics when speaking of the shoes and unconcealing the
clearing of Being in the *Feldweg*. For Heidegger in remembering Being
prefers to forget beings, and this, Derrida is saying, raises certain
problems in the context of German history, and particularly, as Phi-
lippe Lacoue-Labarthe explains in *Heidegger, Art, and Politics*, when
Heidegger opts to forget the dead.[21]

Such a problematic cannot be said to express itself in the same way
within the career of Richard Long whose historical and cultural con-
texts are so remote from those of Heidegger. Nevertheless, I wonder if
in lifting the veil by brushing the path of Nepal, Richard Long does
not walk in the footsteps of others in order to forget beings? The
photograph of the line, like the vast majority of other photographs by
Long, is devoid of people. And, no doubt because of this, such photo-
graphs are also devoid of nightmare, hallucination, and of phantoms.
It is as if in detaching us from beings by an attentiveness to the era-
sure of the trace, Long has cleared the way for the return of the
aesthetic in the persistence of that which has withdrawn from the
human. The brushed path could be said, then, to be the formalization
of this retreat even as it exposes Long and the viewer to the traces
(i.e., the erasure or effacement) of those who have passed through the
region. If this is so, then we can say that Long has successfully per-
formed what the discussants in "A Dialogue on Language" have pro-
posed: a dropping of the metaphysical and a redirecting of the aes-

20. Derrida, *The Truth in Painting*, p. 274.
21. Philippe Lacoue-Labarthe, *Heidegger, Art, and Politics* (Oxford: Blackwell, 1990).

thetic within certain borders or boundaries that concern a trace that unveils itself as the erasure of the trace. But if what is given in this effacement and clearing is gracious, it also is a hymn that comes from the side of the inhuman, what Heidegger elsewhere calls the "Unmenschlich." It is at this juncture, then, that the truth in art manifests itself as what Heidegger has called *aletheia* insofar as *aletheia* is but another way of naming that graciousness that redirects the aesthetic.

Although traditionalists accuse Derrida of having advanced an antihumanism, the fact is that "Restitutions" is quite reluctant to relinquish the human and its attachments to the metaphysical. Recall Derrida's opening remark in "Restitutions": "well, we've got a ghost story on our hands here all right." And recall his insistence that what makes Heidegger's reading of van Gogh so powerful is its very capacity to project a hallucination, to imagine something supplementary to the figure, to situate parergonally the image of the shoes in terms of a phantasmic scene. In other words, what characterizes the reading of Heidegger is a desire to pull the whole enterprise of "The Origin of the Work of Art" away from the inhuman, away from those lines I quoted earlier from "A Dialogue on Language" in which the aesthetic returns after metaphysics has been dropped and left behind.[22]

In "Restitutions" Derrida demonstrates that metaphysics is not some "thing" that can be merely cast aside, but an appropriation or correspondence implicating the relation between beings that comes to pass in the very dis-appropriation (i.e., the detachment or unlacing) of a Kantian (or, if one prefers, a Cartesian) understanding of the work. Although Derrida is suspicious of the correspondence with phantoms—speaking of Heidegger's famous passage on the peasant woman's shoes he says, "I had always found this passage of Heidegger's on van Gogh ridiculous and lamentable" (p. 292)—he rehabilitates them as a detachable projection or "accessory" that at once dismantles a realist or mimetic understanding of van Gogh even as it clears the way for a restitution or reattachment to human spirit. Hence, the shoes reveal "Vincent as a peasant woman" (p. 370). And Derrida asks, "Are they [the shoes] a ghost (a piece of ghost, a phantom member)? In that case are they the ghost of van Gogh *or the ghost of the other I* of van Gogh, and what does that *other I mean*

22. Derrida, *The Truth in Painting*, p. 292.

then?" (p. 373). Such questioning of gender, subjecthood, and the return of the dead rehabilitates, albeit in very radical terms, an existential analytic in Heidegger that Derrida initially dismissed as ridiculous and lamentable. That is, Derrida is willing to reanimate and wrestle with those parergonal ghosts who are attempting to appropriate or arrogate the shoes. He remains open to a reencounter with the metaphysical (the phantasmatic) as a means for critiquing Heidegger and the Kantian tradition. This reencounter could be said to mark a returning or coming back of an existential problematic whose metaphysics is accessory to its having been left behind. In Derrida, then, what emerges is a restitution of the human, a deconstructive restitution that reverses the Heideggerian turn from beings to Being.

For Richard Long and Martin Heidegger, the setting aside of metaphysics results in a reencounter or reappropriation of beauty situated in the emptiness of a space from which the human has been expunged. Like Anselm Kiefer's empty charred landscapes, the paths of Richard Long remind us of how alien earth is to the human and the extent to which the land is restored to beauty in the absence of human Dasein. Long's photographs, moreover, reinforce this difference or distance between the earth and ourselves as if it were a truth without which art could not be. Hence the photographs often are of worlds utterly remote from our experience, worlds that show the traces of the wanderer largely in terms of their impermanence or transience. In such regions, where the extraterrestrial itself is suggested, the human is precisely that which does not abide. Rather, what abides is the Being of what remains after humankind as passed through. As "Die Sprache" suggests, Heidegger identifies such an orientation to the restitution of beauty with the "bidding call of stillness" [den heißenden Ruf der Stille] through which Being is disclosed.[23] Derrida hears the ghosts that tell of persecution and destruction, whereas Heidegger and Long are attuned to silences through which one is released into the frameworks of beauty and grace, that regioning of truth in which "everything is in the best order only if it has been no one's doing." Still, even if in Heidegger and Long one can identify a movement from beings to Being that Derrida reverses in "Restitutions," are not all of these figures returning to Kant: to an aes-

23. Heidegger, *Poetry, Language, Thought*, p. 209. *Unterwegs zur Sprache*, p. 32.

thetics driven back within its boundaries? That is, even if one attempts
to think the future or beyond of metaphysics and aesthetics, is this think-
ing not, in any case, determined by the dif-ference of beings and Being
that is expressed not merely by the way in which beauty or the aesthetic
undergoes restitution but rather by the way in which that restitution is
itself "bounded" by the horizons of the human and the inhuman?

In "Dossier de van Gogh" Antonin Artaud speaks directly to restitu-
tion for van Gogh. Speaking of the mentality that led to the detachment
of van Gogh's ear, Artaud writes, with himself, too, in mind: "Non, les
hommes n'ont pas de mental, mais ils n'ont jamais pu se résigner à
laisser cette fonction stupide intégralement aux animaux, de même qu'ils
n'avaient à l'origine pas de sexe, ce qui ne veut pas dire qu'ils étaient des
anges non plus, car le corps dit de l'ange fut à l'origine plus insipide, et
sommairement simple, que celui de certains chimpanzés."[24]

Between these registers, of course, the restitution of the human is
suspended, spectral, detached—concealed as a rift in the inhuman
within the fold of a double session of angels and apes. Not so removed
are Francis Bacon's studies of van Gogh, in which we detect the simian
faces of van Gogh, the cinders of van Gogh . . . the incineration of van
Gogh . . . of van Gogh's holocausts . . . of van Gogh's nights . . . of the
vans of van Gogh . . . the places of a terrifying and monstrous truth
from which the walking but annihilated figure in the landscape hails us
. . . *as though she had never been* . . . who flashed between us, through
us, her face wet with tears and distorted, in her hands something . . .
maybe her shoes?[25]

24. Antonin Artaud, "Dossier de van Gogh," in *Œuvres complètes* (Paris: Gallimard,
1974), 13:155. "No, people have no mentality, nor have they been able to resign themselves
to leave this stupid function wholly to the animals, just as originally they had no sex,
which is not to say that they were no longer angels, since the angel's body was originally
more insipid and summarily more simplistic than certain chimpanzees."

25. Laura Mullen, *The Tales of Horror* (unpublished poem), p. 73. "This Actually Oc-
curred, who flashed between us, through us, her face wet with tears and distorted, in her
hands something . . . maybe her shoes? I think she may have been barefoot, or in her
stockings—there was no sound of heels on concrete, as she came down heavily—and she
was running, really, moving quickly, but her shuddering in-drawn breaths were not for
that, but because she was screaming, screams without words in them, just screaming, loud
enough to hear from a distance as she came toward us, and in the distance, as she went
away again, until the darkness and the silence took her back *as though she had never been.*
. . ." The passage also appears in "A Pretty Girl Is Like a Melody," *Denver Quarterly* 26, no.
2 (Fall 1991): 43.

4 Forces of Gravity

Commentators have often noticed that Paul Celan has estranged or orphaned his words from the discourse on which they depend for their existence and meaning. Yet, the very same critics have always managed to find ways in which to gather up these disincorporated words within a coherently narrated interpretation that restores them to meaningful utterance. That this restitution of meaning is inevitable and perhaps even the desired effect of a reading of Celan I will not challenge. In fact, more than likely I am fated to repeat it. Nevertheless, I think it is helpful to begin rather than end an analysis with the insight that Celan had quite likely thought about writing poetry from the perspective of Heideggerian disappropriation—a disincorporation of words from language that might fall under the rubric of *Versagung*. In this, Celan rather closely follows René Char, a poet he translated at length, and whose comparative example is illuminating.

This chapter explores the significance of a disincorporation of language from the standpoint of what Heidegger in "The Nature of Language" called the neighborhood of poetry and thought. By referring to a neighborhood, Heidegger was attempting to formulate a conception somewhat different from our usual definition of a place common to dwellings and dwellers who live in close proximity to one another. He was approaching a notion of proximity and place akin to what one finds in the poetry of Celan and Char where place is strange or alien to what is human. In rejecting the metaphysical conjunction of poetizing and thinking in his lectures on Hölderlin, Heidegger rejected an essentialist understanding of truth that presupposed a direct corre-

spondence between place, word, and thought. In particular, Heidegger rejected the Nazi idea that because Hölderlin was a German poet whose relation to place was considered authentic (racially, culturally, politically), his poetry expresses a truth in art that is reflected in the direct correspondence of poetizing, thinking, and being. Heidegger's interpretation of fatherland in Hölderlin's poetry is a direct attack on this assumption and is intended not only to demystify but also to repudiate a crude political appropriation of Hölderlin for propagandistic purposes. Celan and Char, who poetically instantiate Heidegger's conception of place, went further than Heidegger by conceiving the neighborhood where poetry and thinking are disincorporated as an extraterritorial, if not extraterrestrial place. In so doing, however, they encounter the return of a fascist conception of truth that Heidegger tried to repress and discard. That this inevitable return of the repressed manifests itself differently in Celan and Char suggests to me that one has to be prepared to accept a philosophically insightful heteronomy in the return of even a very politically suspect and corrupt notion of truth.

᪣

It was in 1963 that Paul Celan published a short poem, "Was Geschah?" in a collection entitled *Die Niemandsrose*. Although it is only a very short lyric, it is exemplary of the development in modern poetry whereby the word detaches itself from the narrative that engenders it.

> Was Geschah? Der Stein trat aus dem Berge.
> Wer erwachte? Du und ich.
> Sprache, Sprache. Mit-Stern. Neben-Erde.
> Ärmer. Offen. Heimatlich.
>
> Wohin gings? Gen Unverklungen.
> Mit dem Stein gings, mit uns zwein.
> Herz und Herz. Zu schwer befunden.
> Schwerer werden. Leichter sein.

Of course, there is balance and closure suggested by the poem's rhyme scheme: ABAB, CDCD. Moreover each stanza begins with a question

and each ends with words or phrases that require interpretation to be understood even in the most basic sense. In the first stanza the words "Offen" and "Heimatlich" are enigmatic and require a term, such as "Sprache," for context. In the second stanza the references to heaviness and lightness ("Schwerer werden. Leichter sein") also make little sense unless we attempt to construct a narrative or context, something that Michael Hamburger does in his translation of the poem into English.

> What Occurred? The boulder left the mountain.
> Who awakened? You and I.
> Language, language. Co-earth. Fellow planet.
> Poorer. Open. Homelandly.
>
> The course? Towards the unsubsided.
> Your course and mine was the boulder's flight.
> Heart and heart. Adjudged too heavy.
> Grow more heavy. Be more light.[1]

Certainly the translation has the virtue of connecting words by establishing narrative coherence. For example, the boulder is given a course in the English translation, something it does not have in the German original. After all, "Wohin gings?" does not transparently translate into "The course?" And the English line, "Your course and mine was the boulder's flight," forces the German original's "Mit dem Stein gings, mit uns zwein" into identifying the trajectory or course of the boulder with the fate of the "Du und ich." No doubt, once Hamburger gets his way with the English, he reaps the benefit of having that second stanza make considerable narrative sense. Because the course of the "du und ich" is identified with the boulder's flight, the condensation, "Herz und Herz" suddenly fits, as the you and I are swept along as if they were boulders crashing down a steep slope. They would pick up momentum, become heavier, and then become more light, as they would be like rocks ricocheting off stone cliffs on their way down into the abyss.

Interestingly enough, the narration of a fall in stanza two still does not entirely resolve stanza one. After all, what are we to do with words like "co-earth" or "homelandly"? Maybe the "co-earth" refers

1. *Paul Celan: Poems*, ed. and trans. Michael Hamburger (New York: Persea, 1980), pp. 168–69 (bilingual ed.).

to the couple and "homelandly" to the condition to which the couple wishes to incline or from which the couple has come. Whatever the case, Hamburger has adjusted the first line of stanza one so that at least it accords with stanza two. For as one may notice, "Der Stein trat aus dem Berge," is not very faithfully translated by "The boulder left the mountain." That is, Celan's original stresses a very peculiar personification in which a stone steps or walks out of the mountain. Hence a more literal translation might be something like, "What happened? The stone trudged out of the mountain." However, even if one uses a word like *trudged*, one still has the problem of making a counterintuitive statement, because stones cannot walk around on their own. Obviously, this must have bothered Hamburger, too, because he prefers a more inanimate locution, like leaving, to an animate locution like stepping or trudging. This choice, not surprisingly, is fateful because it contributes to a central strategy in the translation that emphasizes the course of the stone's fall and its narrative potential for binding all of the poem's elements. In other words, Hamburger has intuited a gravitational pull in the poem that produces a plot or trajectory where, in fact, there might not be one at all. Despite this, I am not so sure one can entirely fault Hamburger for noticing a physics of falling bodies in the poem if not that of a course, movement, or direction, that has the structural function of gathering all the words into a determinate and inevitable relation. After all, hasn't the translator intuited an important clue to the generation of the poem's meanings, namely, that it may reflect a gravity in the Newtonian sense that has the function of fate or destiny?

A good comparative example comes from René Char's *Feuillets d'Hypnos,* a collection of fragments, which Celan admired and translated in its entirety. "(#204) Ô vérité, infante mécanique, reste terre et murmure au milieu des astres impersonnels!" A highly unstable line with shifting resonances and senses, Celan translated it into German as "Wahrheit, du mechanische Infantin, bleib Erde und Geflüster inmitten der unpersönlichen Gestirne!" In English: "O truth, mechanical infanta, stay earth and murmur amidst the impersonal stars."[2]

2. René Char, "Feuillets d'Hypnos," trans. Paul Celan, in *Gesammelte Werke* (Frankfurt am Main: Suhrkamp, 1986), 4:540–41 (bilingual ed.). See also René Char, *Œuvres complètes* (Paris: Gallimard, 1983), p. 224. English translation by Cid Corman, in *Leaves of Hypnos* (New York: Grossman, 1973), unpaginated.

Most likely, Char also wants us to hear the mechanical infanta as a mechanical infant or child and the stars as disasters "des astres" so that the line might be saying "O Truth, you mechanical child, stay earth, murmuring amidst impersonal disasters." Here again there is a question of constructing a narrative that satisfactorily incorporates all the terms into an entirely coherent proposition. Because this line stands entirely alone, we do not know to what or whom the mechanical infanta or infant refers, or why she should be of the earth, let alone what it should mean for this "infante" to murmur in the midst of impersonal stars. Even more mysterious, perhaps, is the question of what any of this has to do with the abstract and metaphysical term that supposedly subsumes everything that follows its invocation "Ô *vérité.*" It is as if all the terms in this line fall away from the truth in the same manner that the stone detaches, stands apart, or falls away from the mountain in Celan. So that in both instances there is an expropriation or disincorporation of the word as if language were falling away from itself in slow motion. There is, then, a disenfranchisement or divorce of language reflected in how the words roll away from one another as if they were under the influence or spell of a mysterious gravitational force of separability.

Yet, in both Celan and Char, there is also the illusion of a gravitational force that pulls the elements together. Celan's reference to "Mit-Stern" is a self-evident example that underscores the pairing of elements like "Herz und Herz" or "Sprache, Sprache." In the line from Char's "Feuillets": "Ô vérité, infante mécanique, reste terre et murmure au milieu des astres impersonnels!", we can take the word "mécanique" to mean mechanical not so much in the context of a machine, but rather in the context of Newtonian forces relative to the astronomical laws of movement and equilibrium. Indeed, were we to read "mécanique" that way, the line could be grasped more straightforwardly in terms of the following paraphrase—truth, you princess of Newtonian mechanics, remain geological and astronomical. In this reading, truth would necessarily remain of this earth insofar as the earth's mechanics is already that truth which hums in the heavens. Apparently, gravitation in such poems is working to push and pull the elements. Instead of thinking of truth as a content or structure, we might have to consider it a force that gathers and disperses poetic elements in unpredictable ways.

৵৹

No doubt, for both Celan and Char the detachment/reattachment of words from a body of language or poem suggests a separability that is clearly symptomatic of a renunciation or rejection of a traditional notion of art. After all, by separating the word from the poem, Celan and Char do violence to the assumption that the parts of a work of art serve to sustain the totality of its form in order to bring about the formal embodiment or expression of a truthful idea.[3] Hence Celan and Char challenge an essential metaphysical relation between *Dichtung und Denken* (poetizing and thinking) that requires a formal correspondence between words, thoughts, and things. Like many modernist poets, Celan and Char have been eager to challenge principles of reason and order, whether discursive or poetic, that have traditionally grounded a formal or artistic correspondence between poetizing and thinking. For in the work of Celan and Char words irrationally pull away from the region of thought as if the gravity of the thinking were not powerful enough to keep the words in their proper orbits. It is not so much that the words are willful and insist on their independence, because that would suggest that the words are of another mind than that of the formal elaboration of thought that is intended to keep them in line. Rather, it would be more accurate to say that the words are of no mind at all and that they simply spin off, fall away from, or detach from the region where they are poetically gathered or constellated.

René Char was, no doubt, a major influence on Celan even if his work lacks the tonal gravity or sobriety typical of Celan. We will come back to this at the very end of this chapter where we can see Celan supplying a certain gravity—the gravity of the literal truth—to a poem by Char. Thematically, however, the gravity of falling bodies is everywhere to be seen in Char's collected works. For example, his frequent reference to meteors signals a dropping of words out of a constellated sky in which celestial bodies are symbolically correlated to one another. Elsewhere this dropping or falling is correlated to rain. In "Le Jonc ingénieux" (The Ingenious Reed) Char writes, "J'en-

3. In Hans-Georg Gadamer, *Wer bin Ich und wer bist Du?* (Frankfurt am Main: Suhrkamp, 1986), mention is made of Otto Pöggler's thought that in Celan the word is not *in* the poem (p. 141).

tends la pluie même quand ce n'est pas la pluie / Mais la nuit [I hear the rain even when it is not the rain / But the night]," a line that suggests a precipitation or raining down that is more primordial than rain, namely, a tendency to fall away that is inseparable from the regioning Char calls *la nuit*.[4] For Char there also are moments when the word drops out of thought as if it were a feather, a gift from heaven, both remarkable and obscure. Although it is tempting to search for metaphorical or allegorical meanings in the plumage, the fact is that in Char more often than not such images float free of the word, as if they were deposited somewhere else than within the language of the poem. "Comment me vint l'écriture? Comme un duvet d'oiseau sur ma vitre, en hiver [How did writing come to me? Like a bird's downy feather on my window, in winter]."[5]

The feather is, one might say, a disembodied image that has been detached from *signifiance* and, as such, no longer accedes to a higher order of intelligence, beauty, and truth. Rather, in many of his poems the pulling away of the image from language is shown within language to be merely accidental and residual, an estrangement from thought that does not transcend the strange and, as such, is alien in its purity: an estrangement of pure visibility. Here may be an explanation for why Char's poetry has been illustrated by so many major artists, among them, Braque, Miro, Picasso, and Matisse: they all celebrate the liberation or setting free of the image from the word that Char paradoxically brings about *within* the language of the poem. That the image is not *of* language but ejected, as it were, and hence exterior to it suggests that in Char's poetry the image comes to be where the truthful correspondence of word and thinking breaks off. As we will see, this puts Char directly in the way of Heidegger's thinking on poetry.

No doubt, Char is hard to appreciate unless one reorients oneself to his strangely antimetaphorical metaphors where the conjunction between two terms is jettisoned or expelled at the very moment of its being suggested. For example, in "Sept Parcelles de Luberon" ("Seven Tracts of Luberon") we are in the first stanza initially drawn to the

4. René Char, collected in "La Flûte et le Billot," in *Œuvres complètes*, p. 552.
5. René Char, "La Bibliothèque est en feu," in *Œuvres complètes*, p. 377. "Duvet" is literally a bird's down: the eider-down of a swan. "Fluff" would have implied that the snow is blanketing the window.

second term of a correspondence in which children apocalyptically
fall out of aging heavenly suns.

> Couchés en terre de douleur,
> Mordus des grillons, des enfants,
> Tombés de soleils vieillissants,
> Doux fruits de la Brémonde.
>
> Dans un bel arbre sans essaim,
> Vous languissez de communion,
> Vous éclatez de division,
> Jeunesse, voyante nuée.
>
> Ton naufrage n'a rien laissé
> Qu'un gouvernail pour notre cœur,
> Un rocher creux pour notre peur,
> Ô Buoux, barque maltraitée!
>
> Tels des mélèzes grandissants,
> Au-dessus des conjurations,
> Vous êtes le calque du vent,
> Mes jours, muraille d'incendie.[6]
>
> [Tucked in the painful earth,
> Cricket eaten, children
> Fallen from aging suns,
> Soft fruits of Bremonde.
>
> In a beautiful uninfested tree
> You yearn for communion,
> You burst of division,
> Youth, storm cloud seer.
>
> Your shipwreck has left nothing
> But a rudder for our heart,
> A hollow crag for our fear,
> O Buoux, mistreated skiff!
>
> Such spreading larches,
> Above the pleas,

6. "Sept Parcelles de Luberon" opens *Le Nu perdu*, in *Œuvres complètes*, p. 421.

> You are the residue of the wind,
> My days, a wall of fire.]

If we naturalize the perspective in the first stanza, the children are but fruit that has ripened and fallen from a tree; they sleep on a dolorous earth, infested with insects. A pastoral stirring, therefore, resonates with something supernatural that is as irrational as it is unrelated. Whereas Char makes a link between the children and the fruit, it cannot be said that they really substitute for one another, something that is reinforced elsewhere in the poem where the presence of the fallen is traversed by numerous incompatible identities: "voyante nuée," "le calque du vent," but also, a shipwrecked sailor ("Ton naufrage n'a rien laissé"). As in so much of his poetry, Char's correspondences are aggressively antimetaphorical in that they link entities in order to suggest the futility of imagining them together within the same domain. Hence we notice that the poem is itself like a cloud out of which there is a dropping or precipitation of incompatible singularities: the children falling from the stars, the fruit fallen from the tree, the one who is shipwrecked, the seer, the trace of a puff of wind.

The influence of Char on Celan is detectable in "Was Geschah?" with respect to the exodus of the stone, that is to say, the dropping out of an entity that is not answerable any longer to the correspondences suggested by the poem. In Celan this points to an almost imperceptible disturbance in which a violent dis-location or "un-neighboring" of entities is taking place. But whereas in Char such a dislocation would point toward a liberation wherein entities enjoy an uncompromisable glory or sublimity detached from truthful correspondences, in Celan the dislocation of entities lingers in the painful truth of the "Unverklungen" where there is little for painters to celebrate, because the unsubsided is a remainder that does not come into its own as a pure image or vision uncompromised by a relation to language.

❧

It is well known that after the Second World War both Celan and Char became personally acquainted with Martin Heidegger and wrote poetry that in retrospect appears to be responsive to a Heideggerian

poetic. Relevant to a reading of Celan and Char is Heidegger's point in "The Nature of Language" that a poem should be thought of as other than a singular domain (form, work, experience) in which thinking and poetizing are unified by a truthful correspondence. While questioning the metaphysical constitution of the poem as an entity whose essence is "jointure"—the unification of thought, word, and object—Heidegger remarked that scholarly analyses are suspect: they use a calculative hermeneutic that relies on *veritas*, a purely mimetic and obvious correspondence between thinking and poetizing. Long before Michel Foucault, Heidegger noticed that translating art into a bureaucratic or "critical" discourse requires grounding in a truth that is the discursive effect of institutional norms and practices. Heidegger noticed further that behind the technological impulse of instituting critical methods in order to automate the teaching/interpretation of literature, there was the metaphysical presupposition that poetry and thought are neighbors and that the neighboring of the two on one another is essential to the meaning and truth of the poem. Heidegger expresses his reservation as follows: "Because we are caught in the prejudice nurtured through centuries that thinking is a matter of ratiocination, that is, of calculation in the widest sense, the mere talk of a neighborhood of thinking to poetry is suspect."[7]

Heidegger's seminar of 1934–35, *Hölderlins Hymnen "Germanien" und "Der Rhein"* is radical if only because Heidegger rejects everything poets have traditionally practiced, for example, the use of rhyme, tropes, conventions, mise en scène, and genres to forge an essential belonging of words within a singular domain—the verbal structure that is the poem—whose ground is the unity of a language that establishes national, cultural, and ethnic identities. In turning to Hölderlin, Heidegger imagines a poet who has effectively broken with this poetic tradition, because Hölderlin heard a ground tone that conceals or withholds from us a correlation whereby we can metaphysically ground ourselves in the neighboring of thought and poetry, the proximity of the poet's moods, conceptions, and voices to that of language in its national, cultural, or ethnic manifestations.

This *philosophical* reading of Hölderlin rejected the crude metaphysics of the Nazi propagandists who had elevated Hölderlin in sta-

7. Martin Heidegger, "The Nature of Language," in *On the Way to Language*, trans. Peter D. Hertz (New York: Harper and Row, 1971), p. 70.

tus at the expense of the more cosmopolitan Goethe who was thought
to be decidedly less German, even though Heidegger would eventually
come back to posit a *political* endorsement of the conclusion that
Hölderlin is quintessentially Germany's most *German* poet. Whether
the philosophical rejection undermines the political allegiance to a
shared conclusion is unresolvable, though it has to be said that what
Heidegger meant by "German" is *not* what the Nazi Party had in
mind. Whereas many now assume that Heidegger's politics was detri-
mental to his philosophical thought, one may argue that Heidegger's
politics demanded a philosophical justification that pushed him to go
much further than he otherwise might have in challenging fundamen-
tal poetic principles whose embarrassing propagandistic caricatures of
the 1930s had roots in both Roman and Ancient Greek civilizations:
hence Heidegger's inquiry into how Hölderlin dismantled the con-
junction of poetry and thought.

None of this would matter if Heidegger's immediate historical proj-
ect of conceptually reforming National Socialism did not have an-
other destiny, one that gravitates to the wayward logic of what Jacques
Derrida has called *destin-errance*: the inevitable misrouting or disloca-
tion of a message. That is, just as a word in Celan and Char gets
expelled or ejected from its proper domain, in Heidegger there is a
corresponding philosophical *destin-errance* in which something falls
outside of the lecture's circuit. This is quite relevant to Heidegger's
discussion of fatherland in "Germanien" where the destiny of the
analysis gets waylaid or misrouted in the poetry of Char and Celan,
both of whom rejected Nazism and yet personally wished to acquaint
themselves with Heidegger. Celan, who felt awkward about the ac-
quaintance, notices the curious *destin-errance* of that relation in the
poem "Todtnauberg" when he wonders about the names in Heideg-
ger's guest register that preceded his. After all, Celan knows that as a
Jew he falls outside of the company, circuit, or circulation of the
proper name, "Heidegger," despite the fact that he has gravitated to
the still cistern of Heidegger's *Heimat*. While "Todtnauberg" com-
memorates the neighboring of poetry and thought, it also drives them
apart by addressing a place otherwise-than-truth that cannot ground
the relation.

We will come back to "Todtnauberg." For the moment consider
how Heidegger's consideration of *Vaterland* is key to his later thinking

about the neighborhood of thinking and poetizing. According to Heidegger, *Vaterland* in Hölderlin does not refer to an essential home wherein the German language discloses its proper essence as German. Rather, the fatherland is a region counter-essential to a metaphysical notion of *Heimat*. This is why, instead of saying the fatherland metaphysically grounds language, Heidegger points out that the fatherland is the region of Being, an identification directly correlated with truth as *aletheia*. The ground of being is an essencing of truth that we perceive poetically as a "ground tone" that withholds or denies us any originary or primordial unity allowing the German people to gain immediate access to the "popular." Heidegger's implication is clear: one should *resist* the National Socialist temptation to make an immediate correspondence by way of a translation of the ground tone into the popular voice of the people. "The fundamental attunement is then not what could be immediately made 'popular.'"[8]

The ground tone is the truth of poetry heard by one who has listened to Being by putting his ear to the ground of the fatherland. It is a tone that, far from affirming the truthful correspondence or identity of the German people in any popular sense, breaks with human expression, and, as such, with the popular condition and voice of a people collectively aspiring to a unified national subjecthood. What Hölderlin heard when he listened to the ground tone was not a unifying or collective call that brought a people into existence as Germans, but a fundamental difference, contradiction, or alterity that is not assimilable to any direct expressive correlation between the ground tone of the Fatherlandish—that is to say, of Being—and the collective being of a people. Heidegger praises Hölderlin because he heard that the *Volk* are not essentially grounded or legitimized in a crudely metaphysical notion of *Heimat* that justifies in advance their historical destiny as a collective or socialist popular entity. This extends to what Heidegger calls the "Bildzusammenhang unserer Dichtung," the relation or connection between image and word. It would be mistaken, Heidegger writes, to think that image and word are so directly correlated that the one explains the other; rather, the truthful connections between image and word that give way to the unification of an imag-

<hr>

8. Martin Heidegger, *Gesamtausgabe*, vol. 39: *Hölderlins Hymnen "Germanien" und "Der Rhein"* (Frankfurt am Main: Vittorio Klostermann, 1980), p. 119. "Die Grundstimmung ist daher nichts, was unmittelbar 'populär' gemacht werden darf."

ined or projected construction conceal and cover up a ground tone
that refuses consolidation, if not presentation. "Here a new perspec-
tive is opened on the essence of truth [das Wesen der Wahrheit] that
is proper for such a poetry, and accordingly on the essence of an
originary founding of poetic language."[9]

Essential to what opens itself in this apperception of the essence of
truth is what does not come forth as familiar to truth, namely, a
silence or not-showing that is exposed in what Heidegger calls the
openness of beings. "If the essence of truth is to be found in the
disclosure of beings, then concealment and veiling are established as a
proper means of disclosure."[10] The essence of truth is mysterious, or
geheim, because it is the "concealed preservation of authentic Being."[11]
It is the mystery, in other words, that holds itself back in the openness
or region of Being, driving apart those truthful metaphysical connec-
tions which would establish the poem as a direct representation of the
fatherland through the depiction of that region's natural beauties
through the use of arresting images. *In short, mystery, which one would
presume to be the most metaphysical of metaphysical philosophemes, is
ironically a spiritual conception that is here beyond metaphysics because
mystery is here thought of as counter-essential to the metaphysical.*

Indeed, it is in light of this appearance of mystery on the hither
side of the metaphysical that the following passage on German father-
land ought to be considered because it is cast in a metaphysical rheto-
ric that is not at all what it appears to be, given that the metaphysics

9. Ibid. "Hier eröffnet sich ein neuer Blick in das Wesen der Wahrheit, die einer sol-
chen Dichtung eignet, und demzufolge in das Wesen der ursprünglich stiftenden dichter-
ischen Sprache."

10. Ibid. "Wenn das Wesen der Wahrheit in der Offenbarkeit des Seienden zu suchen ist,
dann erweist sich die Verborgenheit und Verhüllung als eine eigene Weise der Offen-
barkeit."

11. Ibid. "Das Geheimnis ist nicht eine jenseits der Wahrheit liegende Schranke, sondern
ist selbst die höchste Gestalt der Wahrheit; denn um das Geheimnis wahrhaft sein zu
lassen, was es ist—verbergende Bewahrung des eigentlichen Seyns—muß das Geheimnis
als ein solches offenbar sein [The mystery [or secret] is not a barrier [or limit] situated
beyond truth, but is itself the highest form of truth; for in order to allow the mystery to
truly be what it is—concealed protecting of authentic being—the mystery must be dis-
closed as such]." Here "das Geheimnis" is yet another name for truth as *aletheia*, although
it is being theorized as constitutive of the dynamic of the concealment or forgetting of
truth that must, in some respect, come out of hiding. This mystery holds itself back in the
openness or unconcealment of Being, where it discloses the divisibility of truth along the
postmetaphysical lines discussed in *Parmenides* (see Chapter 1).

of fatherland is curiously postmetaphysical, thrown ahead of the very suspect metaphysics that threatens to reabsorb it.

> *Fatherland is Being [Seyn] itself,* which supports and joins from top to bottom the history of a people in so far as it is a *Dasein*: the historicity of its history. Fatherland is not an abstract and supratemporal idea; to the contrary, the poet sees fatherland historically in an original sense. That this is so is evidenced by the fundamental metaphysical reflection of being and persistence that the poet founds, hence withstanding the passing away that the Fatherland had designated from the outset. The latter does not play the externalized role of an obvious case to illuminate a passing away and a becoming in the passing away; rather, the Being [Seyn] of Fatherland, that is, the historical Dasein of the people [Volkes], is experienced as the only and true Being from which the fundamental position towards beings as a whole arises and achieves their jointure.[12]

The fatherland is not an idea, conception, or transcendental abstraction, but the primordial ground of the historicity of a people wherein that historicity is held back by the poets from the collective assertion of a national political will. The fatherland is therefore a mysterious ground that keeps to itself the destining of the being of the Germans as the essencing of a truth that is falsified and perverted at that moment the Germans turn their backs on the "Seyn des Vaterlands." The understanding of metaphysics is indeterminate in that for Heidegger the fatherland is a metaphysical region or neighborhood that is nevertheless counter-essential to metaphysics and, as such, postmetaphysical. For example, the primordial Saying to which Fatherland gives rise in Hölderlin is undecidably divided in terms of "where saying returns to unsaying, the unsaying to saying and to that which is to

12. Ibid., pp. 121–22. "*Das 'Vaterland' ist das Seyn selbst,* das von Grund aus die Geschichte eines Volkes als eines daseienden trägt und fügt: die Geschichtlichkeit seiner Geschichte. Das Vaterland ist keine abstrakte, überzeitliche Idee an sich, sondern das Vaterland sieht der Dichter in einem ursprünglichen Sinne geschichtlich. Daß dem so ist, dafür liegt der Beweis darin, daß die grundsätzliche metaphysische Besinnung des Dichters auf das Sein und Bleiben, das die Dichter stiften und so dem Vergehen standhalten, von vornherein auf das 'Vaterland' bezogen wird. Dieses spielt hierbei nicht die äußerliche Rolle eines naheliegenden Falles, an dem das Vergehen und das Werden im Vergehen beispielhaft beleuchtet werden könnte, sondern das Seyn des Vaterlandes, d.h. des geschichtlichen Daseins des Volkes, wird als das eigentliche und einzige Seyn erfahren, aus dem die Grundstellung zum Seienden im Ganzen erwächst und ihr Gefüge gewinnt."

be said [wo das Gesagte auf Ungesagtes, das Ungesagte auf Gesagtes und zu Sagendes weist]."[13] The Saying to which the Fatherland gives rise is, like *aletheia*, not conducive to a metaphysics of presence, but is, strictly speaking, beyond metaphysics. It is therefore not to be confused with the regressive metaphysics of authentic speech and *Heimat* dictated by the Nazis. For whereas such terms point to a simplistic metaphysics of presence and identification whose historical destiny forecloses a philosophy attuned to the question of Being, Fatherland in Heidegger suggests an overcoming of the metaphysics of presence and identification whose historical destiny is not that of political action in the here and now, but the destiny of the destining of Being, such as Hölderlin intuited in his writing about the German people's proximity with respect to the gods. In contrast, the fascist understanding of *Heimat* or *Boden* underwrites merely a direct political correspondence between thinking and poetizing. This is something that Celan also disrupts by pointing to the heavens and their stars for yet another way of figuring the counter-essence to the metaphysics of *Heimat* and *Boden*. Yet, if Celan's invocation of the extraterritorial parallels Heidegger's deconstruction of fatherland as a philosopheme of truth, Celan, unlike Heidegger, strategically chooses to recall a suspect understanding of truth in the very postmetaphysical move that invalidates it.

❧

TODTNAUBERG

Arnika, Augentrost, der
Trunk aus dem Brunnen mit dem
Sternwürfel drauf,

in der
Hütte,

die in das Buch
—wessen Namen nahms auf
vor dem meinen?—

13. Ibid., pp. 127–28.

die in dies Buch
geschriebene Zeile von
einer Hoffnung, heute,
auf eines Denkenden
kommendes
Wort
im Herzen,

Waldwasen, uneingeebnet,
Orchis und Orchis, einzeln,

Krudes, später, im Fahren,
deutlich,

der uns fährt, der Mensch,
der's mit anhört,

die halb-
beschrittenen Knüppel-
pfade im Hochmoor,

Feuchtes,
viel.

[Arnica, eyebright, the
draft from the well with the
starred die above it,

in the
hut,

the line
—whose name did the book
register before mine?—
the line inscribed
in that book about
a hope, today,
of a thinking man's
coming
word
in the heart,

woodland sward, unlevelled,
orchid and orchid, single,

coarse stuff, later, clear
in passing,

he who drives us, the man,
who listens in,

the half-
trodden wretched
tracks through the high moors,

dampness,
much.][14]

"Todtnauberg" suggests that Celan probably viewed his 1967 visit to Heidegger's *Hütte* as a penetration by an outsider whose effect was to disrupt the *Heimat* of the philosopher, hence disturbing the truthful ground on which poetry, language, and thought corresponded. Commentators on the poem have stressed a biographical reading and are in general agreement that the poem consists essentially of two parts, hopeful symbols of restitution ("Arnika," "Augentrost," "Brunn," "Stern," "Buch") culminating in the poet's call for a thinking man's coming word in the heart, followed by bitter disappointment and gloomy ruminations.[15] Celan approaches Heidegger's retreat under the

14. Paul Celan, "Todtnauberg," in *Paul Celan: Poems*, selected and translated by Michael Hamburger (New York: Persea Books, 1980), pp. 240–41.

15. J. D. Golb's "Celan and Heidegger: A Reading of 'Todtnauberg,'" *Seminar: A Journal of Germanic Studies* 24, no. 3 (September 1988): 255–67, fills in the allusions and word plays. Arnika and Augentrost are connected to old German folklore about the summer solstice and Johannistag. They are the plants out of which magical potions are made and are probably connected to astrology, symbolized by the star on the well. Golb believes that the star inscribes the Jews into the landscape in that it can be considered a Star of David. The "Buch" is the visitor's register in Heidegger's studio among whose names Celan's was not destined to be but arrived there, anyway. It may be a *Zauberbuch*, if not a book that stands for Celan's own books. The Orchis is associated with the summer festival of Johanni, "above all those involving *Liebeszauber*." Golb suggests that these plants are "a pair of testicular aphrodisiac plants." Hence motivation for "Krudes." Another suggestion: the person driving Heidegger and Celan out of the forest may well be Hölderlin.

See also Sighild Bogumil's "Todtnauberg," *Celan-Jahrbuch* 2 (1988): 38–51. Bogumil asks: What would it mean for the heart to speak "with" us? Does one think *with* the heart, in proximity to the heart? Is thinking near the heart? For Bogumil this question concerns the distinction between the human and inhuman and Heidegger's overcoming the human—the Cartesian subject. Celan understood that for Heidegger "seinem Ausdruck im Sagen [his expression in Saying]" is to be found in "des Heilen [healing]." "Celans herz aber, das herz der deutschen Geschichte, ist wund . . . [However, Celan's heart, the heart of German history, is [a] wound . . .]" (49). Because Heidegger had placed thought beyond the hu-

auspices of hopeful talismans, signs Heidegger's guest register, and has misgivings as he walks with Heidegger in the vicinity. The inscription in the register is taken as a request for Heidegger to break his silence about the Shoah so that the different ethnic identities and histories of Celan and Heidegger may be bridged and a dialogue or conversation may begin. But the hope for a hopeful sign from Heidegger that would break the stillness is in vain, even if the astrological portents of a mutual conjunction, much like that cast in a horoscope, point to the taking place of a "destinal interlocution."[16] As in so many astrological forecasts, however, the destiny of heavenly bodies has little to do with the destiny of human beings. Therefore, the walk, conversation, and drive out of the forest degenerate into something crude, destitute, and depressing, even to the point of awakening thoughts of Nazi death marches during the Second World War. What was to be a fateful and momentous interlocution has utterly failed.[17]

As J. D. Golb has pointed out in a lengthy and penetrating analysis of the poem, everything in "Todtnauberg" is presented in the absence of Martin Heidegger, the poem's "absent topic":

man, he also placed it beyond life and death, where no coming word of a thinking man could come to the heart. Bogumil's reading suggests an impasse that requires a restitution of metaphysics at the hitherside of its having been overcome.

16. The phrase is used by Véronique Fóti in *Heidegger and the Poets* (Atlantic Heights, N.J.: Humanities Press, 1992).

17. John Felsteiner describes in *Paul Celan: Poet, Survivor, Jew* (New Haven: Yale University Press, 1995) how Celan had already in 1959 expressed considerable ambiguity toward Heidegger. "A *contretemps* with Heidegger in 1959 had more obvious cause. Patent Heideggerisms marked Celan's 1958 Bremen speech, and that year he also sent Heidegger poems by his friend Klaus Demus. 'They are the poems of one who esteems you,' Celan said, signing himself 'In sincere gratitude.' But soon afterward Heidegger 'had a curious wish,' as Ingeborg Bachmann described it. 'For a Festschrift on his seventieth birthday he requested his publisher get a poem from Paul Celan and one from me. And we both said no'— though Celan's friend René Char, among others, agreed" (p. 149). At the University of Freiburg on July 24, 1967, Celan gave a poetry reading. "Heidegger, for his part, had sent his books to Celan and wanted to meet him. 'I know everything of his,' he said in 1967 [. . .] Heidegger attended this reading, and though Celan shrank from having a joint photo taken beforehand, the philosopher gave him a copy of his book *Was heißt Denken?* and invited him for an outing the next day. 'I know about his difficult crisis,' Heidegger had told a colleague. 'It would be salutary to show Paul Celan the Black Forest'" (p. 245). In both of these biographical vignettes it is clear that Celan had strong misgivings about Heidegger and that their meeting could not be anything but awkward. If the quotation about the Black Forest is correct, it would certainly be another instance of Heidegger's insensitivity to Jews. After all, the Black Forest could hardly mitigate the horrors that haunt Celan's thinking.

Not only does the text *gravitate* towards and away from a central silence, but its entire temporal movement is punctuated by a series of silences connecting the fragments with each other. The fragments give rise to a sense of the silences around them because we wait for something that— like the poem's central meeting—doesn't come, and this is a quintessentially Heideggerian strategy: one of his ways of suggesting, throughout his meditations on poetry, language, and thought, both a closeness to and distance from an opening to Being. Inversely, by fracturing (in the manner of a film slowed to a series of stops) the record of his experience into a series of predicateless stative moments, Celan makes each an autonomous existential unit, on the edge of its Heideggerian silence. The poem is thus transformed into a static system of reflexive reference, on the fringe of the vegetative silence towards which it moves.[18]

Golb is right to invoke the gravitation of words and phrases toward and away from the central silence of Heidegger's "retreat"—his retreat or Hütte in the Black Forest, as well as his retreat from the meeting with Celan that took place even as they encountered one another. Indeed, as the speaker in the poem, Celan himself gravitates toward the retreat that is Heidegger's woodland shelter only to be repelled or kept at a distance by the thinker. Here, as in "Was Geschah?", there is a noticeable conflict between forces of attraction and repulsion that are both personal, if not intimate, and impersonal, if not unaccountable. Just as the inert elements begin to speak with an eerie intimacy in "Was Geschah?", in "Todtnauberg" the script of the poet in the hut's register of visitors says something from the heart that is meant to draw a response or thought from the thinker's deepest philosophical wellsprings. What the notation asks for is nothing less than an acknowledgment of something that orbits the thinking of Heidegger that is repelled or repulsed by the relationship of the thinker to the place of thinking or, more aptly perhaps, the place of philosophy. At the beginning of "Todtnauberg" it is clear that the poet is quite aware he is making a pilgrimage on consecrated ground. It is for this reason that he notices the relation of place to a mythical or folklorish past, as in the case of the medicinal, magical plants or fairytale-like well with its star. Everything portends a magical or mystical conjunction between the thinker and the poet as if the very place was to be the

18. Golb, "Celan and Heidegger," p. 264. Italics are mine.

"ground" on which the two would gravitate together, whatever their own past inclinations may have been.

But if there is to be a fateful conjunction, it is not in this place or at this time that one is to come about, because Celan experiences the philosopher's mysterious distance, remoteness, and repulsion. To anticipate a later discussion, it is as if there were a psychology of moons at work in which entities are attracted and repulsed by mysterious forces that cannot be entirely verbalized. In "Todtnauberg" the entity that attracts and repels Celan is not even visible in the poem, but holds sway as an absence in the poem, as if it were some kind of "dark Other." No doubt this entity is "Heidegger," although it is also a hidden "thing" of much more astronomical proportions and, as such, more oppressive and difficult to grasp.

If we return for a moment to "The Nature of Language" we will recall that for Heidegger the neighborhood or truthful conjunction between thinker and poet is what one needs to call into question. In fact, Celan pays homage to this view in "Todtnauberg" by seeing to it that the thinker is absent. Yet even if Heidegger is not there in the poem, his thinking is. Therefore it is not as if an interlocution or correspondence between the thinker and the poet has been entirely missed. There is, after all, a discernment by the poet of a Heideggerian withdrawal or retreat that is neither counterproductive nor counter-essential to an encounter or dialogue with the poet. No doubt, Celan himself must have been familiar with "The Nature of Language" in which Heidegger explicitly stated that "we should become familiar with the suggestion that the neighborhood of poetry and thinking is concealed within this farthest divergence of their Saying. This divergence is their real face-to-face encounter."[19] Essential to the encounter, therefore, are divergence, distance, remoteness. And therefore what is a "real face-to-face encounter" is precisely what avoids the nearness of interlocution that assumes a mystical or metaphysical conjunction such as that portended at the beginning of "Todtnauberg." In other words, the reason behind Heidegger's distance—his absence in the poem—is that he is putting into practice what he wrote in "The Nature of Language" by means of concealing or withdrawing himself as the metaphysical persona of the philoso-

19. Heidegger, "The Nature of Language," p. 90.

pher in order that his philosophy or thought can emerge into the place where the *sujet supposé savoir*[20] has disappeared. This "clearing" away of a metaphysical notion of the philosopher for the sake of the philosophy is to be identified with a destruction that contradicts the dominant expectation of the coming word of the philosopher.

The double movement of withdrawal and emergence enacts a Heideggerian *aletheia* requiring concealment in order "to come to presence in the unconcealed."[21] But if this truth comes forth in the silence or renunciation of the philosopher—his refusal to atone for his symbolic complicity in the Shoah in whose concealment something is shown nevertheless—this truth also comes to pass as Celan, the poet, who effects a withdrawal from the neighborhood of poet and thinker. Recall that in "The Nature of Language" Heidegger noticed that "to say . . . means to show: to make appear, set free, that is, to offer and extend what we call World, lighting and concealing it."[22] As if in direct response, Celan writes a poem that is itself in withdrawal or retreat from a Saying that would manifest itself as an interlocution with the thinker. Therefore, just as the philosopher conceals himself from the poet to the point of absenting himself from the scene of their encounter in order to disclose the truth of his thought, the poet similarly draws away from the encounter with the thinker in order to unconceal something in "Todtnauberg."

It would appear that Todtnauberg names the place of the truth in art since it is the place or neighborhood that does not succumb to a metaphysics of binding poetry and thought. "*Aletheia*," Heidegger wrote in *Parmenides*, "is against concealment because it comes to presence in the unconcealed for the sake of a sheltering." In "Todtnauberg" Celan has implicitly glossed what Heidegger meant by sheltering as the exposure or clearing of a place that is fatherlandish in its refusal to capitulate to the metaphysics of the *heimatlich*. Sheltering means a place or abode that preserves the truth of the face-to-face encounter of poet and thinker—more generally, of poetry and thought—as *aletheia*, thought of here as the advent of an unconceal-

20. The well-known locution is Jacques Lacan's from his 1960s seminars concerning truth and mastery.

21. Martin Heidegger, *Parmenides*, trans. André Schuwer and Richard Rojcewicz (Bloomington: Indiana University Press, 1992), p. 133.

22. Heidegger, "The Nature of Language," p. 93.

ment that destroys the neighborhood where poetry and thought are metaphysically linked. "Todtnauberg" itself is dialect for "Tod-nun-berg" whose etymology points to the clearing or destruction after which a hill comes into view.[23] Perhaps, then, "Arnika," "Augentrost," "Sternwürfel," "Hütte," "Buch," "Wort," "Waldwasen," "Orchis und Orchis," "der Mensch," and "pfade in Hochmoor" are the things left over in the aftermath (the truth) of the withdrawal or clearing of Saying in Heidegger's neighborhood or *Heimat*. These are not things that any longer belong to a world in which the correspondences or connections between things are self-evidently given in advance.

Whereas we might have expected the poet to have withdrawn from Heidegger by retreating in the pathos and ethos of the poem—indeed, this is assumed by several of Celan's commentators, Hans-Georg Gadamer among them—there is no poetic Saying into which to retreat. This world is not hospitable for either the poet or poetry, it not being a world at all. "Todtnauberg" is akin to what in *Parmenides* is a field of oblivion (the forgetting of being in its metaphysical sense). There concealment and withdrawal are evident as a necessary destruction preparing the way for the unconcealment of truth, the baring of the things themselves as beings that stand forth in the Ab-grund where Being is held back. In this sense "Todtnauberg" can be considered fatherlandish, its primordial relation to Being disclosed as alien to commonplace notions of dwelling, inhabiting, and abiding that presuppose that the essence of one's being consists in the givenness of one's relation to place (i.e., nativism, racism, patriotism).

Yet, as "Todtnauberg" underscores, this fatherlandish place is, as in Hölderlin, dangerous and inhuman. Heidegger develops this in *Parmenides*. Initially he says of the Ancient Greek *polis* where poet and place are brought into relation that, "Th[is] essential abode gathers originally the unity of everything which, as the unconcealed, comes to man and is dispensed to him as that to which he is assigned in his Being."[24] Yet Heidegger cautions that the word *aletheia* introduces a conflicting essence: "the frightfulness, the horribleness, the atrociousness of the Greek *polis*": "If now, however as the word indicates, *aletheia* possesses a conflictual essence, which appears also in the oppositional forms of distortion and oblivion, then in the *polis*, as the

23. The source is Sighild Bogumil, "Todtnauberg."
24. Heidegger, *Parmenides*, p. 90.

essential abode of man there has to hold sway all the most extreme counter-essences, and therein all excesses, to the unconcealed and to beings, i.e., counter-beings in the multiplicity of their counter-essence."[25] In "Todtnauberg" Celan has indeed stepped into the fatherland. Not surprisingly, he has located the counter-essential in words such as *Waldwasen, Krudes, Knüppel-pfade*, and *Hochmoor*. They are what remains to be said of the conflictual essence in whose excesses counter-being is disclosed. In *Parmenides* Heidegger had referred to this excess of counter-being as a frightful, horrible, and atrocious homelessness. Hence the absence of Heidegger's coming word could be equated with the truth of counter-being concealed in the *Heimat*, a fatherlandish, evil counter-being. Celan, who equates this evil with the Shoah, imagined the locution Todt-nun-Berg from the perspective of liquidation as a laying waste. Here the fatherland attains the condition of an extraterritoriality, a place otherwise-than-human. That this extraterritoriality concerns the extraterrestrial and what Lacan called a psychology of moons becomes relevant at this point.

≈

In 1953 Jacques Lacan presented *Le Séminaire II: Le Moi dans la théorie de Freud*, in which a principal theme is repetition and the death drive. At one point, Lacan asked an intentionally childish question: "Why is it," he wondered, "that the planets don't speak?" Having dumbfounded his audience, Lacan supplies his own response.

> We aren't at all like planets, that's something we can have a sense of whenever we want, but that doesn't prevent us from forgetting it. We always have a tendency to reason about men as if they were moons, calculating their masses, their gravitation. That isn't an illusion peculiar to us, us scientists [*savants*]—it is quite especially tempting for politicians. I am thinking of a work which has been forgotten, though it wasn't that unreadable, because it probably wasn't written by the author

25. Ibid. "Here lies concealed the primordial ground of that feature Jacob Burckhardt presented for the first time in its full bearing and manifoldness: the frightfulness, the horribleness, the atrociousness of the Greek polis. Such is the rise and the fall of man in his historical abode of essence—νψιπολις, απολις—far exceeding abodes, homeless, as Sophocles (*Antigone*) calls man. It is not by chance that man is spoken of in this way in Greek tragedy. For the possibility, and the necessity, of 'tragedy' itself has its single source in the conflictual essence of *aletheia*."

who signed it—it had the title *Mein Kampf.* Well, in this work by the said Hitler, which has lost a great deal of its topicality, relations between men are spoken of as being like relations between moons. And there's always the temptation to construct a psychology and a psychoanalysis of moons.[26]

In discussing a speech that has withdrawn from Saying (*parole vide*) Lacan makes a political identification that is only latent in Heidegger, Celan, and Char. Fascism, Lacan tells us, predicates itself on a psychology that presupposes something in place of communication, namely, a Newtonian physics that translates into a gravitational pull between mute and obscure bodies. At one point, after repeating his query about why the planets don't speak, Lacan answers it yet another way by reasoning, "because Newton shut them up." That is, there was once a time when the planets did, in fact, speak, as in the writings of Paracelsus and Giordano Bruno, where the planets and constellations still had something to say to humanity. However, Newton quieted this interplanetary chatter by making all heavenly bodies obey the silent law of gravity. That is, by shutting the planets up, Newton introduced the truthful law of an implacable and unappeasable silent force. Lacan comments that as a model for science this is not problematic; as a model for social behavior, it is disastrous. To put one's faith in the truth of gravitational pull is the fatalism of a politics that calculates relationships according to a statistics of "heavy bodies" or "masses" governed by an inexorable logic or automatic process (call it the death drive) over which no one has any control and over which one can have no real understanding other than that such a force is bigger than we are and that its effects can be measured in terms of the inanimate.

26. Jacques Lacan, *Seminar II: The Ego in Freud's Theory and in the Technique of Psychoanalysis, 1954–1955,* trans. Sylvana Tomaselli (New York: Norton, 1988), p. 235. For an interesting confirmation of Lacan's intuition, see Erich Auerbach's discussion of the Roman soldier-historian Ammianus Marcellinus who wrote during late Antiquity (Erich Averbach, *Mimesis,* trans. Willard R. Trask [Princeton: Princeton University Press, 1953], pp. 50–76). Much of "The Arrest of Peter Valvomeres" is an allegory directed at National Socialism. "Ammianus' world is somber: it is full of superstition, blood frenzy, exhaustion, fear of death, and grim and magically rigid gestures. [. . .] In Ammianus' scene [the arrest of Peter Valvomeres] there is no objectively rational relationship whatever between the authorities and the rebels, let alone a human relationship based on mutual respect. There is *only a physical relation based on magic and brute force.* On one side there is a *pure mass of bodies, stupid* and full of effrontery, like a crowd of juvenile delinquents, and on the other, *imposing authority,* fearlessness, instant decision, flogging" (pp. 56, 52; italics are mine).

In other words, fascism could be defined as a politics in which communication is replaced by invisible forces akin to the unanswerable truth of a gravitational pull.

In Celan's "Todtnauberg," certainly, the seemingly autonomous forces of withdrawal and emergence essential to the manifestation of truth in poetry and thought are entirely conditioned by an extraterritorial silence, absence, or missed interlocution that conforms rather well to Lacan's insight. Again, in "Was Geschah?" there is a question of whether "Sprache, Sprache" or "Du und Ich" really speak to each other despite a vocative presence. We might ask further whether the phrases "Schwerer werden, Leichter sein" are really related to "Herz und Herz"? Is it not but an illusion that "Du und ich" answers "Wer erwachte"? And how can one prove otherwise? One asks oneself: are all these particles beginning to communicate, or are they only in mute proximity and only suggest a communication where there is none, thanks to the forces that bring them together? Are we within the structure or form of an utterance or outside of it? For example, in the *Unverklungen.* Do we achieve speaking? Or are we merely suspended in force fields? No doubt, one may have to ask whether such force fields do not raise the question of history and Lacan's suggestion that the National Socialists invented a politics of planetary subjectivity in order to exempt themselves from it and, hence, from their actions. In what way, we have to ask, does Celan address this exemption?

There is some thinking about this in Derrida's *Shibboleth* when the discussion turns to the question of the concentrated or of concentration. Already in Lacan the point was made that the Nazis achieved planetary silence by means of statistical concentration. The logic seems to be that if one makes something dense or compressed enough gravity will start to take over on its own. This, as Lacan well understood, was a version of Le Bon's theory of group psychology that played such an important role in *Mein Kampf,* Le Bon's idea being that concentration and force are mysteriously allied. In Derrida's reading of Celan the assumption is that the poetry addresses this where the concentration of dates generates autonomous forces. "I understand the word *concentration,*" Derrida writes, "which can become a terrible word for memory, *at once* both in that register in which one speaks of the gathering of the soul or of 'mental concentration,' as, for example, in the experience of prayer . . . and in that other dimension

in which concentration gathers around the same anamnetic center a multiplicity of dates, 'all our dates' coming to conjoin or constellate in a single occurrence or a single place."[27]

Derrida argues that in Celan's poetry, one cannot ever "speak of a date" or ask "what is a date?" because the practice of writing or generating the date breaks such metaphysical conceptions and has to be reconsidered in terms of a concentration of the signature or, as Derrida also puts it, the cipher. Like the stone, the cipher is a thing, and it, too, will speak, even though it must succumb to forces beyond its control. Concentration *of* and *on* the date as cipher led Celan to wipe out its mention in the published versions of his poems, what Derrida calls a "force or structure of self-effacement." And in terms of this liquidating force or form of effacement the date withdraws from signification even as it destines or sends something that assures a commemoration beyond communication:

> The date effaces itself in its very readability; it must efface in itself some stigma of singularity in order to outlast, in the poem, what it commemorates; in this lies the chance of assuring its spectral return.

> A date is a specter. But the spectral return of this impossible recurrence is marked in the date in the sort of ring or anniversary secured by a code such as the calendar. (pp. 318, 317)

Derrida predicates the analysis of fate in Celan on the astronomical device of the calendar that generates dates according to sidereal forces and movements—in Lacanian terms, the silence of the planets. Derrida is arguing that without the trait of this silence—the trait of the date's withdrawal, silencing, effacement, liquidation, exemption—there can be no speaking, no commemoration, no spectral voices, such as the one or ones we hear in "Was Geschah?" Moreover, without this trait the historical would not be broached, the date never ciphered as history, because history is nothing if not an appointment or rendezvous with the specter, a "date" or "dating" with the dead who are concentrated or compressed into an annular structure. Derrida's commentary suggests that the sidereal law of a date's annual repetition is inseparable from a repetition of the death drive, the repe-

27. Jacques Derrida, "Shibboleth," in *Midrash and Literature* (New Haven: Yale University Press, 1986), p. 313.

tition of a truth of effacement that is as indifferent and implacable as any purely physical force. "And since this annulment and the annulation of return partakes of the very movement of dating, what must henceforth commemorate itself is the annihilation itself of the date, a kind of nothing—or ash" (p. 318).

Another way of putting this would be to say that the ashes of the dead are astronomical in terms of both their number and their incalculability. And it is this one has to grasp along the way to comprehending Celan's Shibboleth, which, according to Derrida, is the constellation of the date. "What is gathered and commemorated in the single time of this 'in eins,' at one poetic stroke? And is it a matter, moreover, of *one* commemoration? The 'all in one,' 'all at once,' seems to constellate in the uniqueness of a date, but is this date, in being unique, also one?" (pp. 318, 319). After all, even in its most localized occurrence the date would mark an astronomical number of events (a "constellated series") whose anniversary cannot yoke them together even as it attempts to signify a "multiple singularity" (p. 321). The date as Shibboleth, Derrida says, is the sign of membership to a series of events that is itself aporetic in that it really cannot sign for them or gather them together as a determinate structure. In this sense, the Shibboleth approximates even as it revises what Heidegger called the logos.[28] That the date is both appropriative and disappropriative in a Heideggerian sense is obvious, given Derrida's analysis, and, of course, there is the hint that the date ought to be considered not only as an analogue to Heideggerian logos but also as a truth in Celan's poetry akin to Heideggerian *aletheia* insofar as the date is the region or neighborhood in which remembering and forgetting, poetizing and thinking gravitate toward and away from one another in what is a constellated art. Whereas for Heidegger the place or "regioning" of the poet and the thinker is perhaps most fateful—one thinks of Todtnauberg—for Celan it is the temporality "given" by the date.

28. "Shibboleth" revises Heidegger's analysis of the logos. Whereas for Heidegger language would be the gathering letting-lie-before of what is present in its presencing, for Derrida the Shibboleth is the gathering letting-lie-before of the specter that eternally returns in its absencing. Derrida's "Feu la cendre" examines what kind of being ashes have; it revises Heidegger by introducing a concept of oblivion (Holocaust) that Heidegger was unwilling to think. See Martin Heidegger, "Logos," in *Early Greek Thinking* (New York: Harper and Row, 1975), and Jacques Derrida, "Feu la cendre," trans. Ned Lukacher as *Cinders* (Lincoln: Nebraska University Press, 1991).

ℒ

As a book of fragments, René Char's *Feuillets d'Hypnos* is also some-thing of a constellation motivated by what Char called "la fantaisie de ses soleils." Char wrote that the project of his political resistance was to overcome this verticality in which the astronomical rules individ-uals, something that he found difficult given the seduction of an eter-nal nothingness in whose indifference he woke to the beauty of days. In the openness of the sun's dawnbreaking Char tied together the verticality between earth and star with the horizontality of day-to-day life. Here, too, there is an opportunity for a psychology of moons in which the planets are silent because, as Lacan said, they have no mouths. Hence in #31, "L'adoration des bergers n'est plus utile à la planète [The adoration of shepherds is no longer of use to the planet]"; in #57, "La source est roc et la langue est tranchée [the source is rock and the tongue is severed]"; in #134, "Nous sommes pareils à ces poissons retenus vifs dans la glace des lacs de montagne [We are like those fish impounded alive under the ice of mountain lakes]"; and in #126 direct reference to nazism: "Entre la réalité et son exposé, il y a ta vie qui magnifie la réalité, et cette abjection nazie qui ruine son exposé" [between the reality and its disclosure there is your life which magnifies the reality and this nazi abjection that ruins its disclosure].[29] In this last example the distinction between magnifying reality (making it more present, substantial, weighty) and ruining its disclosure (its representation, or, speaking for itself) touches more directly on Lacan's insight about fascism being a psychology of moons.

At one point in his seminar, Lacan remarks that such a psychology is encountered in patients who not only insist they don't have a mouth but that they have no stomachs either and "what is more that they will never die. In short, they have a very close relationship to the lunar world."[30] Lacan explains that such people live in an eternal nothingness of sustained indifference and that the truth of their being has been achieved at the cost of magnifying their realities while di-minishing their ability to speak. Hence they become like moons, be-ings who are otherwise-than-human and not of this world. Is this

29. Translations by Cid Corman, *Leaves of Hypnos*, save for #126, which I modified.
30. Lacan, *Seminar II*, pp. 237–38.

what happened to Heidegger, too? That the discourse on Being silenced him? Consider, for example, his meditation on the "peal of stillness" in *Unterwegs zur Sprache*. But notice, too, that "Todtnauberg" falls short of broaching this question, because it is itself operating in the vicinity of this psychology.

In "René Char and the Force of Poetry," Georges Bataille noticed that in Char there is an inclination for limitlessness or plenitude that Bataille shared. "If I want to raise myself and attain the heights, I tell myself that the opposite—degradation, debasement—is no longer without its charms." Here the debasement of victims can already be imagined. But Bataille continues, "In truth this comes from my fear of limiting myself to a defined possibility—which does not only lead me away from another, equally narrow one—which separates me from the *totality* of being, or from the universe which I cannot renounce."[31] Bataille, who had thought at length about a psychology of fascism, found it within himself just a few years after the liberation of France. Not wanting to be cut off from *total* being, the universe, he says quite frankly that his aspiration is not to confine his existence, "distinct from the rest of the world," because living in that neighborhood is "sordid." Rather, he would choose "sovereign existence." To achieve sovereignty, however, he must first raise himself above commonplace ordinary human existence to a level of action that is *not answerable to anything* except the "present moment" of an unfettered life: "No one can, by any displacement, enslave the truly and fully sovereign being: the only thing that concerns him is to exist in that instant, without expecting its plenitude to depend on anything and without undertaking anything whose result counts for more than the present moment, without any will or intention except the *empty space*" (p. 129; emphasis added). These remarks are addressed to Char, because Bataille sees in him a kindred soul whose writing represents a "genuine elevation" that takes him "beyond the concern to make of a flow of thought a confined object that accommodates the principle of utility" (p. 129). Unlike the poet who joins poetry and thought, Char attains poetic sovereignty by not allowing himself to be "limited" by this crucial conjunction. Instead of working within the space where

31. Georges Bataille, "René Char and the Force of Poetry," in *The Absence of Myth*, trans. Michael Richardson (London: Verso, 1994), p. 129.

poetry meets thought, Char unrestricts the space of such an encoun-
ter by attaining a plenitude that relies on what Bataille called empty
space—unfettered freedom, unlimited place, total being. "Once the
spirit gains some elevation, everything slips away as *far* as the eye can
see" (p. 130). Addressing Char's *À une sérénité crispée*, Bataille writes
that "this book calls for the negation of our limits, it brings back
those it disturbs to the totality they have denied. 'But,' [Char] says,
'who will re-establish this immensity around us, this density which
really was made for us and which, on all sides, not divinely, bathed
us?" (p. 131). This accession to plenitude is "a leap beyond what is
possible" and hence "the distressing contrary of what we are" (p. 131).
Plenitude "is also what we lack, that alone by which we restore our-
selves to totality and that alone by which totality restores itself: *so
death delivers us to a totality which requires our absence no less than
our presence*, which not only composes the world so naively expected
of this presence, but suppresses first its necessity and then the mem-
ory and traces of it" (p. 132; emphasis added).

In Bataille the suspicion that fascism is merely a lunar psychology
born of megalomania is sanitized so that the sordidness of an egotisti-
cal madness gives way to an egoless excess at the service of a desire for
ontological plenitude. If Bataille might not have contested that total-
itarianism is, in either instance, the politics of this astronomical sub-
jectivity, he also would have argued that totalitarianism remains sov-
ereign to the extent that no dictator, madman, or poet can ever
achieve it—even in death. That aside, we are left with the possibility
that a psychology of moons was the project of fascism and surrealism,
politics and art and that the border line between egotistical political
megalomania and egoless artistic sovereignty might be harder to dif-
ferentiate than we might hope. After all, they're both in the neighbor-
hood of the astronomical.

Char, who responded to remarks by Heidegger on Rimbaud in a
text entitled "Réponses interrogatives à une question de Martin
Heidegger," said that poetry is a work that precedes action and there-
fore cannot be restricted or bounded by an event, and that this repre-
sents the violence of the poet who overturns or destroys before the
fact of a political takeover. Rimbaud, Char says, was precisely such an
avant-garde poet. "La poésie ne rythmera plus l'action, elle en sera le

fruit et l'annonciation jamais savourés, en avant de son propre paradis [Poetry is no longer the rhythm of action, it will be its never savored fruit and annunciation in advance of its own paradise]."[32] However, Char adds, such a poetry preceding and exceeding action is always to be thought of as inherently manifesting a call for counter-action to any action and as such is to be considered a resistance or refusal that is more like a natural force than a self-conscious act. Unlike an action, the poem is not restricted by notions of activity, eventfulness, or occurrence; rather, it has a sovereignty that comes from the fact of a plenitude that is always already anterior to the acts of poetizing and thinking.

In the "Feuillets d'Hypnos" #168 Char writes,

Résistance n'est qu'espérance. Telle la lune d'Hypnos, pleine cette nuit de tous ses quartiers, demain vision sur le passage des poèmes.

[Widerstand ist nichts als Hoffnung. Wie der Mond über Hypnos: voll heute nacht in jedem seiner Viertel, morgen Vision über ziehenden Gedichten.]

[Resistance is only hope. Like the moon of Hypnos full tonight in all its quarters, tomorrow vision upon the passage of poems.][33]

Does the full moon of Hypnos (in Celan, the moon *over* Hypnos) govern the vision of poetry? Is one's resistance to the lunar just as much a mere hope? Or is the moon itself a force of resistance, one that can be detected in the passage of the poems? Indeed, do the three statements have anything to do with one another, or are they just in a mysterious conjunction? Immediately following this fragment is another, #169: "La lucidité est la blessure la plus rapprochée du soleil [Lucidity is the wound nearest the sun]." Celan concentrated it into the more forceful, "Klarsicht ist die sonnennächste Wunde." Is this clarity opposed to the fullness of the moon's light? In Celan's translation, the wound is not just closest to the sun ("la plus rapprochée") but is a "sun-nearest-wound," one fused to, if not obliterated by, the sun. Following Char's dedication to Albert Camus, we discover that

32. Char, *Œuvres complètes*, p. 736.
33. The translations are by Cid Corman. Hypnos, of course, is the Greek god of sleep, associated here with planetary silence.

Hypnos in taking hold of winter, dressed himself in granite, hence becoming identified with the earth. Hypnos, then, is less a personification of any one celestial body than a name that names cosmic conjunctions. Among these is Hypnos's transformation from granite into fire during winter's sleep. A Hyperion or solar god, he changes from stone to a concentrated burn-all or holocaust. Although it would be controversial to associate Hypnos with a solar symbol like the swastika, one could infer the parallel, since in the burn-all of Hypnos an extraterrestrial space is opened up that is internal and external to history where burning is no longer answerable but exercises itself as a terrifying lucidity of truth (e.g., repetition of the death drive, whose cinders fall coldly to earth). In #171, "Les Cendres du froid," Char writes, "sont dans le feu qui chante le refus [The ashes of cold are in the fire that sings refusal]." Celan's translates: "Die Asche der Kälte: sie ist im Feuer, das Absage singt." We can imagine to what Celan was correlating these ashes that in Char pertain to a lucidity of cosmic proportions of which there can be no knowledge, because its cinder vouchsafes only a decomposition without limit, an incineration without end. That is, whereas in Celan the ashes re-member the past, in Char the ashes cannot speak because the fire has refused them a mouth. That this refusal of the fire is a song only adds insult to injury.

Whereas it would appear that in "Feuillets d'Hypnos" Char's words have no mouths with which to speak, Celan in poems such as "Was Geschah?" is giving his words a tongue with which to ask, "What happened?" In Celan the planets and the rocks do have mouths. Perhaps this is why he is so disappointed when he gets no answer in "Todtnauberg" from Heidegger who behaves like a planetary body that is answerable to no one. Celan, in other words, resists withdrawal into the facticity of an indifferent cosmos, something that becomes clear in his translations of Char. This refusal to accede to a psychology of moons occurs, for example, in the translation of "La Carte du soir" ("The Chart of Evening") where Celan loans Char a lyrical voice reminiscent of "Todesfuge." It is here that Celan interjects a literal truth whose force jettisons the leaves of Hypnos out of a cosmic dream of total mobilization, indifference, and annihilation. Suddenly, as if waking it from a hypnotic spell, Celan forces Char's very disembodied

poem into speaking the literal truth of the beloved's ashes. Given the
gravity of Celan's down-to-earth translation, readers of Char may be
shaken, even to the point of asking, "What happened?":

221 *La Carte du soir*

Une fois de plus l'an nouveau mélange nos yeux.
De hautes herbes veillent qui n'ont d'amour qu'avec le feu et la
 prison mordue.
Après seront les cendres du vainqueur
Et le conte du mal;
Seront les cendres de l'amour;
L'églantier au glas survivant;
Seront tes cendres,
Celles imaginaires de ta vie immobile sur son cône d'ombre.

 (pp. 228–229)

221 *Die Karte des Abends*

Wieder vermengt das neue Jahr unsre Augen.
Die hohen, wachenden Gräser. Sie haben nur *eine* Liebe: das
 Feuer und das Gefängnis, in das man die Zähne schlägt.
Nachher: die Asche des Siegers
und der Bericht vom Bösen.
Nachher: die Asche der Liebe,
die Heckenrose mit ihrem fortlebenden Totengeläute.
Nachher: deine Asche,
die imaginäre Asche deines unbeweglichen Lebens auf seinem
 Schattenkegel.[34]

34. Char translation by Cid Corman. The Celan translation is mine. "Prison mordue" is
rendered "crazy prison" by Corman (*mordu du cinéma* in French would mean "crazy
about the cinema"); Celan relates it to *mordre*, "to bite." The *Schattenkegel* mentioned by
Celan is not only an umbra but a nine pin and, as Renata Wasserman suggested to me,
may refer us to the casting of a human shadow. Char's *cône d'ombre* is a far more abstract
and astronomical locution.

221 *The Chart of Evening (Char)*

221 *The Chart of Evening (Celan)*

Once more the new year blends
　our eyes
Tall grass keeps vigil which loves
　only fire and the crazy prison

Later will be the victor's ashes

And the tale of evil
Will be the ashes of love;
The eglantine with its knell
　surviving;
Will be your ashes,
Those imaginary ones of your
　life immobile on its cone of
　shadow.

Once more the new year
　confuses our eyes.
The tall, growing grasses. They
　have only *one* life: the fire and
　the prison whose teeth bite
　into one
Afterwards, ashes of the
　victorious
and the news from Evil.
Afterwards: the ashes of love,
the eglantine with its surviving
　funeral tones
Afterwards: your ashes,
the imaginary ashes of your
　motionless life on its umbra.

5 The Radiant Suspensions of Julien Gracq and Maurice Blanchot

In a short article on Marguerite Duras's *Détruire, dit-elle*, Maurice Blanchot writes, "Leucate: Leucade: le brillant du mot 'détruire,' ce mot qui brille mais n'éclaire pas, fût-ce sous le ciel vide, toujours ravagé pas l'absence des dieux [Leucate, Leucade, the brightness of the word 'destroy,' is a word that shines but doesn't enlighten, even under an empty sky, which is always ravaged by the absence of the gods]."[1] One wonders: Is Blanchot pointing to an aspect of fiction and film that is not often taken into account, namely, the extent to which the manipulation of light by an author or director serves as a running moral commentary on ethical truth as the truth in art? For example, in plays such as Aeschylus's *Agamemnon*, poems such as Dante's *Divine Comedy*, and novels such as Thomas Hardy's *Tess of the D'Urbervilles* lighting is not just something that shines onto a mise en scène, but it is also integral to what is said, as if light were a metaphysical Sovereign law that adjudicates moral distinctions. Hence in the forest scene where Tess is about to be raped, the fading moonlight and the increasingly dark shadows of the Chase articulate a moral order that suggests conscience exists outside of subjectivity as a limit to what is thinkable or permissible, a limit that discloses itself in an interplay between light and dark that is unambiguous. Where limits are exposed, we are able to imagine a running moral commentary that allows us to judge characters and actions according to transcendental laws that we all are supposed to know and uphold in advance. In

1. Maurice Blanchot, "Détruire," in *L'Amitié* (Paris: Gallimard, 1971), p. 135. "Destroy," in *Duras by Duras* (San Francisco: City Lights, 1987), p. 132.

many literary works, of course, authors greatly ambiguate the limits of interpretability as in the case of Goethe's *Elective Affinities* or Nathaniel Hawthorne's *The Scarlet Letter*, where one has good reason to suspect that the author has started to manipulate lighting in such a way that it becomes estranged or alien to the very moral code it supposedly is trying to communicate, as if the lighting belonged to an inscrutable moral order estranged from the human. In plays such as Samuel Beckett's *Catastrophe* or Eugène Ionesco's *Exit the King* the lighting enjoys sovereignty and is itself a main character, perhaps violent and mad, whose actions are answerable to no one: hence our perception of outrage and absurdity in these works.

This chapter considers two narratives in which lighting effects are more highly abstracted in order to achieve what would appear to be a zero degree of signification—a neutrality that shines without enlightening and therefore holds back the disclosure of an ethical truth in art. In particular, I will consider Julien Gracq's novel *Au château d'Argol* (1939) and Maurice Blanchot's *récit* "Le Dernier Mot" (1936), works compatible with the later films of Marguerite Duras. In fact, in a review of Duras's film, *Détruire, dit-elle*, Blanchot retroactively discovers a name for that atmospheric neutrality in whose radiant suspensions a destruction unanswerable to the symbolism of moral truth comes about. It is the word uttered by Duras's Alissa when she says "détruire," a word that Blanchot calls a "mot étranger" (an "alien word"), *set apart*, in which Sovereignty ("la souveraineté même") appears and disappears.

Not only is there a question of truth concerning lighting effects in art whose veiling and unveiling resists a metaphysics of ethical clarification (the ethos of narrative), but this truth also concerns a partitioning of violence. Particularly in the fiction of Blanchot and Gracq, the partitioning or apportioning of violence attempts to overcome a metaphysics of difference. That is, the political distinction, legislated by laws, between those on whom one practices violence and those whom one will protect from violence concerns a partitioning or apartheid that would not be reducible to the kind of difference that expresses itself as an absolute (differences of race, culture, ethnicity, gender), what in Blanchot would be called a "mot d'ordre." Indeed, it would be most difficult to imagine such an anarchic violence if in the narratives of Julien Gracq and Maurice Blanchot we did not see how a

partitioning of violence involves a departitioning of its metaphysics, *the truth of the law of division as the truth in art.* As Derrida's "Le Dernier Mot du racisme" suggests, even such a deconstruction of metaphysics would in no way abolish apartheid: it would transform it in terms of an apportioning or allocation of violence that implies a dismantling of the law on which society differentiates friends from enemies. In both of the examples from Gracq and Blanchot this elementary "truthful" distinction between friend and enemy is everywhere blurred as if the law that partitions violence were anarchic and disrupted from the very beginning. Of course, departitioning violence in order to deconstruct the limits of difference for the sake of a violence as yet to be fully disclosed may or may not have been intended as a critique of fascism. After all, it could represent a postmetaphysical fascism that takes violence to ever new heights. As Jeffrey Mehlman has pointed out, both Blanchot and Gracq are politically ambiguous.[2] Gracq's Germanophilia and his strong endorsement, if not emulation, of Ernst Jünger has to be considered alongside Blanchot's rightist politics of the 1930s. Yet Gracq's affiliation with surrealism and his own wartime experiences do not suggest any sort of direct alliance with fascism per se. Blanchot, for his part, demonstrated a shadowy aloofness during the war, but despite some anti-Semitic references in his prewar writings, he had already during that time expressed his dislike for National Socialism. In writings that postdate the war, it is evident that Blanchot strongly repudiates genocide.

Whereas it is tempting to read the fiction of Gracq and Blanchot in order to objectify aesthetics in relation to politics, one should take into account not only personal political ambiguity but also a resistance to construct "truthful" metaphysical objectifications in which art and politics are wedded. Still, we should be aware that in this

2. Jeffrey Mehlman, *Legacies of Anti-Semitism in France* (Minneapolis: University of Minnesota Press, 1983), suggested that at some point in his novelistic career Julien Gracq sensed strong affinities with German culture and, in particular, the writings of Ernst Jünger. Mehlman does not miss the chiastic turning in which, just as Gracq's work points us in the direction where German culture and politics become quite sovereign, just so Jünger's fiction points to a direction where French culture becomes supreme. Such acknowledgments, however, are the result of perceptions that determine but do not embody meanings. The line that demarcates the border between France and Germany comes into view for both Jünger and Gracq in such a way that its identity as line is, according to Mehlman, displaced and historically proliferated. We could add that the line has been radiantly suspended so that its authority has been expressed according to the dictates of heterogeneity.

resistance, destruction is being advanced as a partitioning related to the very political/aesthetic juncture that the fiction attempts to exceed. If Gracq and Blanchot create luminous radiant suspensions in which an objectified relation to the moral, the religious, and the political is sacrificed, they do it in order to achieve an experience of destruction that obliterates even as it conserves the "truth" of such relations— even to the point of a partitioning or discrimination of violence that exceeds the protocols of a metaphysical differentiation that would establish itself as the truth in art. This is evident in (1) how both authors use lighting effects to stage acts of violence against women who occupy a place as ready-made victims—operative within and outside of a metaphysics of violence—in whose beauty the horror of their destruction is concentrated; and (2) how the achievement of a violence beyond the metaphysics of violence is itself divided or partitioned *après coup* by Blanchot in a critique, written shortly after the Second World War, of Gracq's fiction.

ॐ

Written by Gracq when he was only 27 years old, *Au château d'Argol* was clearly influenced by the symbolist dramatic poem *Axel,* by Villiers de L'Isle-Adam. No doubt one should read Gracq's tour de force as a deliberate exacerbation of symbolist conventions, among them the predictable use of light symbolism. In Gracq's novel we find such symbolism. However, the lengthy descriptions of light that filter through the novel's scenography are so excessive and at times elusive that one wonders whether they have become an end in themselves. Notice, for example, the following description:

> Les rayons jaunes du soleil couchant touchaient alors cette cuirasse de métal sanglant et en tiraient de puissantes harmonies: les masses florales d'un rouge mat y paraissaient presque des blocs de ténèbres, emblèmes d'une mélancolie solennelle et glorieuse. Cependant de cruels éclairs glissaient sur ces murs avec la passée des nuages, des flaques d'une lumière grasse, louches et gluantes, se posaient sur la table, sur le sertissage délicat des glaces, et l'éclat de ce métal dur, de ces parois hostiles forçait l'âme à se réfugier au centre d'elle-même et semblait concentrer la pensée en une pointe de flamme aiguë et pénétrante comme une lame d'acier.

[The yellow beams of the setting sun now shone full on this cuirass of incarnadined metal and called forth rich and potent harmonies: the dull red of the massed flowers appeared almost as blocks of darkness—emblems of a solemn and noble melancholy. But as clouds passed by, cruel flashes glided over the walls, pools of unctuous light, viscous and dubious, fell on the table and on the delicate bezels of the mirrors; and the hard brilliance of the metal, of these hostile walls, forced the soul to take refuge in its own centre and seemed to concentrate all thought in a point of flame, sharp and penetrating as a steel blade.][3]

No doubt, we may be reminded of *Axel*, wherein sparkling mists, radiant jewels, flashes of sunlight, and the gleaming of Axel and Sara's suicide cup are all manifestations of a superhuman transcendence or sublimation of sexual love. However, whereas in the symbolist poem the characters are self-conscious of shimmering radiance as an index of their self-abnegating spirituality, in Gracq's radiant lapidary descriptions we notice that consciousness is suspended in the manifold brightenings and darkenings of light even as a certain Sovereignty comes to pass in the "puissantes harmonies [potent harmonies]," the "cruels éclairs [cruel flashes]," the "blocs de ténèbres [blocks of darkness]," and the "flamme aiguë et pénétrante comme une lame d'acier [point of flame, sharp and penetrating as a steel blade]." Although such Sovereignty may appear to be only intermittent, one finds that, in fact, the whole novel can be read as a record of the most nuanced and complex lighting effects, as if the focus of this novel were not the characters and their actions but the atmosphere—how scenes and personages are illuminated. Moreover, whereas the lighting effects in a novel such as Goethe's *Elective Affinities* can be read as signs of an inscrutable moral conscience outside of subjectivity per se, in Gracq it would be difficult to establish that effects of lighting have anything to do with right and wrong, good and evil, the spiritual and the debased. In other words, in Gracq the light is not judgmental even though it is clearly Sovereign.

In a passage such as "Des meurtrières horizontales jaillissaient ici des nappes de lumière continues qui divisaient la hauteur de la salle par des cloisons immatérielles et mouvantes, et en cachaient presque entrèrement le plafond [through the horizontal loopholes surged con-

3. Julien Gracq, *Au château d'Argol*, in *Œuvres complètes* (Paris: Gallimard, 1989), p. 14. *The Castle of Argol*, trans. Louise Varèse (Norfolk: The Direction Series, undated), p. 12.

tinuous sheets of light that divided the apartment in height by imma-
terial pulsating partitions almost entirely concealing the ceiling]," the
Sovereignty of the light's sheeting actually darkens or conceals as
much as it brightens or discloses (pp. 14/13). Like the brightness that
Blanchot sees as a shining that does not enlighten, the luminescent
interplay in Gracq's novel breaks up images and scenes into a differen-
tial counterpoint of lights and darks to which no ethical or symbolic
importance is necessarily attributed. Whereas in Villiers de L'Isle-
Adam we can expect an interplay of lights and darks to reveal truths,
flag moral judgments, or underscore themes, in Gracq the lumines-
cence is not indexical or allegorical. Rather, it falls neutrally on the
represented things themselves, as if the light were pointing to some-
thing without actually going so far as to signify anything in particular.

In thinking about this peculiar literary phenomenon, one might
consider Edmund Husserl's *Logical Investigations*, in particular a pas-
sage from the sixth investigation, in which we are told that "although
perception is responsible for the relation of my word to *this object*, my
meaning does not lie in perception." We should recall that such a
view differs drastically from that of Locke or Kant, for whom mean-
ing lies precisely in how perceptions are fundamentally linked to the
various mental faculties. Husserl, on the contrary, insists that "when I
say 'this,' I do not merely perceive, but a *new act of pointing (of this
meaning) builds itself on my perception, an act directed upon the latter
and dependent on it, despite its difference. In this pointing reference, and
in it alone, our meaning resides*. Without a perception—or some cor-
respondingly functioning act—the pointing would be empty, without
definite differentiation, impossible in the concrete." In other words,
there is a difference between perception and indication, even if indi-
cation is dependent on there being perception. "Perception accord-
ingly realizes the possibility of an unfolding of my act of this-meaning
with its definite relation to the object. . . . But it does not, on our
view, itself constitute this meaning, nor even part of it."[4]

Because the lighting or luminescence in Gracq's *Au château d'Argol*
does not constitute meaning by way of pointing to determinate oppo-
sitions that flag moral, psychological, or metaphysical values, it could
be said to enable us to realize the possibility of an unfolding of an act

4. Edmund Husserl, *Logical Investigations*, trans. J. N. Findlay (London: Routledge &
Kegan Paul, 1970), 2:683, 684.

of reference or "this-meaning," even though it would not necessarily
constitute or embody meaning. We could hypothesize, then, that the
interplay of lights and darks constitutes a heteronomous pointing that
precedes the act of indicating any definite relationship to an object.
Luminescence in Gracq, therefore, would belong to a phenomenologi-
cal aspect of perception that is merely anticipatory to any definiteness
of intention and therefore could be identified as a radiant suspension
within which perception is determined even as it does not yet embody
a distinct meaning that is ready to hand. In addition, I want to sug-
gest that this lighting in Gracq has yet another curious feature in that
it is Sovereign or absolute. This is made very clear by Gracq in terms
of the castle of Argol, the woodlands of Storrvan, and the resplendent
bay nearby where Albert, Herminian, and Heide come near to com-
mitting collective suicide. Indeed, the light's Sovereignty or Truth is
expressed in multiple and heterogeneous manifestations, detached
from any rule of brightening and darkening, or blazing and fading.
The presence of light itself approaches what Blanchot has called, in a
récit by that name, "la folie du jour," a madness of day in whose
indeterminate and insane modulations of tone a Destruction comes
about (not entirely unlike the Heideggerian understanding of truth as
Lichtung or oblivion of truth), that is Sovereign and yet indefinite,
given that the light's madness precedes concretized perception.

We may recall that *Au château d'Argol* concerns a lover's triangle.
Albert, who has bought the vast domain of Argol, has walked up the
mountainous region to claim his estate. And, aside from the porter,
he is soon accompanied by his close male friend Herminien, a de-
tached and enigmatic trickster, who has brought along one of his
many mistresses, Heide. She is inviolate and neither of the men make
love to her, even though she ravishes them with her apparent beauty
and her seductive disposition. Apparently, the so-called double life of
the two men—their fascination for each other—is so strong that each
must refuse to take the woman for himself given that the consequence
of this action would be to shatter the men's specular relation with
each other. Heide, who is far from being disappointed, enjoys what to
her and her companions is an ecstatic revelation of her sexuality. At
one point, alone in a forested setting with Albert, she sinks to the
mossy ground. "Under the light silk of her dress the palpitation of her
breasts was barely perceptible. She loosened her hair and let it spread

like a pool around her on the grass. She stretched out her arms and the warm muscles trembled with the ardor of an enchanted life. At last she turned her eyes toward him and let a viscid glow filter through them even like the veil of blood it traversed." What follows this description is clearly her experience of lying before him like a "wholly submissive slave" [esclave entièrement soumise]:

Il lui semblait tantôt qu'une masse de métal fondu, d'une dévorante chaleur, naquît de ses seins houleux et insupportables, et comblât les cavernes de sa chair des coulées d'un feu liquide, et tantôt qu'elle s'enlevât tout entière avec une délirante légèreté vers le ciel bleu et lointain qui l'aspirait comme un puits de lumière fraîche au-dessus de sa tête entre les cimes des arbres. Et telle était en elle l'explosion de la vie qu'il lui paraissait que son corps sous la chaleur de fournaise allait s'entrouvrir comme une pêche mûre, sa peau dans toute sa massive épaisseur s'arracher d'elle et se retourner tout entière vers le soleil pour épuiser les feux de l'amour de toutes ses artères rouges, et sa chair la plus secrète s'arracher aussi depuis le fond d'elle-même en lambeaux convulsifs et jaillir dans ses mille replis comme un drapeau claquant de sang et de flamme à la face du soleil dans une inouïe, dernière, et terrible nudité. (pp. 38–39)

[It seemed to her at times that a mass of molten metal of a consuming heat was born from her swelling tortured breasts, and filled the caverns of her flesh with floods of liquid fire; at others, deliriously light she felt herself lifted and inhaled by the blue and distant sky which was like a well of cool light through the tops of the trees above her. And such was the explosion of life within her that it seemed to her that her body in the consuming heat was about to open like a ripe peach, and her skin in all its massive thickness to be torn from her, turned inside out toward the sun to exhaust the fires of love in all her red arteries, and that her most secret flesh as well would be torn out of her very depths in quivering shreds, and burst through all her thousand recesses like a banner of blood and flame flashing in the face of the sun in a final inexpressible and terrible nudity.] (pp. 51–52)

Immediately following this description, the narrator flatly remarks that "mais, quoique son coeur pesât la miséricorde d'un tel abandon, Albert y restait insensible [although his heart weighed all the compassion of such a surrender, Albert remained insensible]" (p. 37 / p. 52). In other words, her fireworks don't seem to have anything to do with

him, even though they are on the verge of blanking out even the sun with their terrible nudity. And yet, it is this terrible nudity of Heide that will rather speedily drive both Albert and Herminien quite mad, so mad, in fact, that they will commit a kind of double murder, a serial killing of the same woman. Rather than pursue this double dying, I want to point out that Heide's terrible nakedness concerns her being taken up or assumed by the heavens in a Sovereign moment that is as utterly destructive as it is ecstatic, that moment represented by an explosion in which her body—in fact, her most secret flesh—is flayed and turned inside out, her solarized blood beating in concert with the sun's rays. No doubt a close inspection of the passage, itself a foreshock of the slayings to come, shows that light, heat, fire, flame, and sun are closely associated with the terrible nudity that is the woman's body. And yet, these images merely anticipate and do not cross the threshold of reference, that act of pointing, that would make them metaphors. In fact, there is not even very much linkage between the images of luminescence, although they certainly evoke one another and suggest a persistence or Sovereignty as powerful as Heide's sexual feelings, if not equivalent to them. That is, even if these images of brightness do not necessarily cross the threshold of reference to the woman's body, they certainly do reflect the intense madness to which Heide's passions have been driven. Yet, this correspondence, I would like to argue, is taking place at a perceptual level that in and of itself does not consummate the act of reference precisely as Albert himself will not consummate the sexual attraction that he and Heide feel for each other.

It is here, in this abeyance of the sexual act, so reminiscent of the passion between Sara and Axel in the symbolist drama, that I would like to suggest another hypothesis which is based on my suspicion that there is something politically suggestive about the relationship of violence and chastity in *Au château d'Argol.* Because this relation is mediated by the pyrotechnics of light, let me access it through a work that has much explanatory power in relation to Gracq's fiction, namely, an essay written in the early 1930s by Georges Bataille entitled "La Structure psychologique du fascisme." This essay is intriguing in the context of Gracq because it brings into relation questions of perception, Sovereignty, violence, heterogeneity, and excess. Specifically, Bataille understands fascism in this essay not merely as a politics, but

as a mode of perception that invokes what he calls an entire set of higher forms (*formes supérieures*) that violently exceeds even as it includes. Such perception "fait appel aux sentiments traditionnellement définis comme *élevés* et *nobles* et tend à constituer l'autorité comme un principe inconditionnel, situé au-dessus de tout jugement utilitaire [makes an appeal to sentiments traditionally defined as *exalted* and *noble* and tends to constitute authority as an unconditional principle, situated above any utilitarian principle]."[5] At the same time, the Sovereignty of such perception is founded on heterogeneity: "Les éléments *hétérogènes* provoquent des réactions affectives d'intensité variable . . . et il est possible de supposer que l'objet de toute réaction affective est nécessairement *hétérogène* (sinon généralement, du moins, par rapport au sujet) [*heterogeneous* elements will provoke affective reactions of varying intensity and it is possible to assume that the object of any affective reaction is necessarily *heterogeneous* (if not generally, at least with regard to the subject)] (pp. 346–47 / p. 142). The castle of Argol, the forest of Storrvan, and, later, the very wide avenue that cuts through the landscape, are very much exalted, noble, and higher forms that constitute authority and Sovereignty as an unconditional principle of truth situated above anything utilitarian. Hence in Gracq the wide avenue, particularly, is mysterious precisely because it has no use value. Similarly, the castle and forest are utterly detached from utilitarian aims. Of course, all this is reminiscent of the symbolist play *Axel.* However, in Gracq it is significant that the interplay of lights and darks lack symbolic or moral purpose and correspond quite well to what Bataille is calling the heterogeneous. Most interesting is that this heterogeneity in the novel is, in fact, an accompaniment to violence, as we noted in the passages above describing Heide's passionate sacrifice of herself to Albert, a sacrifice, of course, to no end and, as such, as useless as it is excessive. In short, something like a pure expenditure has taken place and is represented as violence, what Bataille in his essay on "heterogeneous fascist action" identifies with madness and delirium, which characterizes the heterogeneous itself. Bataille summarizes by saying that "La souveraineté politique apparaît en premier lieu comme une activité sadique claire-

5. Georges Bataille, *Œuvres complètes* (Paris: Gallimard, 1970), 1:350. *Visions of Excess: Selected Essays,* trans. A. Stoekl, C. R. Lovitt, and D. M Leslie, Jr. (Minneapolis: University of Minnesota Press, 1985), p. 145.

ment différenciée [political sovereignty initially presents itself as a clearly differentiated sadistic activity]" (p. 352 / p. 146). Upon reflection, we could say that such activity is almost everywhere present in *Au château d'Argol*, even in the most minor observations. For example, as Heide and Hermenien disappear into the forest, Gracq narrates, "l'œil d'Albert put suivre le long canon d'un fusil suspendu à l'épaule d'Herminien et qui brilla longtemps d'un feu cruel au travers des premiers rideaux de la forêt, où il reparaissait par intervalles avec l'éclat insupportable d'une épée nue [Albert's eye caught sight of the long barrel of a rifle slung over Herminien's shoulder, and he followed for a long time as it glinted cruelly through the curtain of forest trees, appearing and disappearing at intervals like the unendurable gleam of a naked sword]." (p. 61 / p. 86). It is this sword, another of those sovereign higher forms, that will be part of a serial killing in which Heide will undergo a double dying, first at the hands of Hermenien, then at the hands of Albert. It is by means of this double dying in which the two deaths put the homogeneity of a final spiritual solution into question that Gracq's novel most violently exceeds the homogeneous closure of the double suicide that ends the symbolist play *Axel.*

In exceeding this homogeneous closure, of course, Gracq has not only pointed to a Sovereignty that is heteronomous but also to one that goes beyond what Gracq in the prefatory note to the novel calls the symbolic point of view (*l'angle symbolique*). In other words, Sovereignty, for Gracq, is that heterogeneity of violence, detectable at the level of even very ordinary perception, that shatters the symbol as a determinate figure standing for or pointing to an idea. Hence Gracq, in taking distance from symbolism, would accede to a different notion of metaphysics, that is, a metaphysics beyond metahysics in which the givenness or truthfulness of things is liberated from a language of symbols that partition differences in a more or less static and predictable way. Indeed, this has already been evident in the contrast between Gracq and Villiers de L'Isle-Adam, though Gracq speaks to the issue quite directly in the prefatory remarks to *Au château d'Argol:*

> Il va sans dire qu'il serait par trop naïf de considérer sous l'angle symbolique tels objets, actes ou circonstances qui sembleraient dresser à certains carrefours de ce livre une silhouette toujours malencontreuse de poteau indicateur. L'explication symbolique étant—en général—un appauvrissement tellement bouffon de la part envahissante de contin-

gent que recèle toujours la vie réelle ou imaginaire, qu'à l'exclusion de
toute idée indicatrice la seule notion brute et très accessible, autour de
chaque événement, de *circonstances fortes* et de *circonstances faibles*,
pourra dans tous les cas, et ici en particulier, lui être substituée avan-
tageusement. La vigueur, d'elle-même convaincante, de "ce qui est
donné," comme dit si magnifiquement la métaphysique, dans un livre
comme dans la vie, devrait exclure à jamais toutes les dérobades de la
niaise fantasmagorie symbolique et nous inciter une fois pour toutes à
un acte décisif de purification. (pp. 4–5)

[It goes without saying that it would be too naive to consider from a
symbolic point of view such objects, actions, or circumstances as may at
certain crossroads of this book raise the always untoward silhouette of a
signpost. Symbolic explanation is in general such a ludicrous impov-
erishment for the teeming possibilities, whether real or imaginary, al-
ways abounding in life, in all cases, and here in particular, rejecting all
notion of an indicator, alone the primitive and easily accessible idea
surrounding each event, strong circumstances and weak circumstances
may be advantageously substituted. The vigour convincing in itself of
"that which is given," as metaphysics so magnificently puts it, in a book
or in life, should forever exclude all evasions of the silly symbolic phan-
tasmagoria, and incite us once and for all to a decisive purification.] (p.
144)

❧

Toward the end of Maurice Blanchot's *récit* "Le Dernier Mot," the
narrator comments:

Moi-même, je volais en morceaux et pourtant j'étais indemne. Je criai,
j'appelai cette fille. "Mon corps brûle," dit celle-ci. Elle entrouvrit son
manteau et me montra les taches de feu qui y dessinaient les premières
formes d'un vague langage. J'ouvris les yeux sur ce corps blanc et la
renvoyai. Par la glace, je voyais mieux de quelle chute les entassements
de rocher, place par place, perpétuaient le souvenir.

[I myself flew into fragments, and yet I was unhurt. I cried out. I called
to the girl. "My body is burning up," she said. She opened her coat a
little and showed me the marks of fire. They seemed to be forming the
first shapes of a vague language. I opened my eyes on this white body
and sent her away. By looking in the mirror I was better able to see how

the rock piles had fallen into their present shapes—and how they pre-
served the memory of the past].[6]

Whereas in Gracq's novel the world withdraws into radiant suspen-
sions that do not consummate the act of reference, in Blanchot's nar-
rative one detects radiant fissures that violently sunder established re-
lations and objectivities. This means that "Le Dernier Mot" may be
less indicative of predisclosive perceptions than of postdisclosive reve-
lations, which is not surprising, because the narrative is about last
things. However, as in Gracq, care has been taken to ensure that these
last things cannot be reduced to symbolic phantasmagoria. Moreover,
"Le Dernier Mot" substitutes strong and weak circumstances for an
easily accessible idea surrounding each event. Therefore, instead of
locating determinate occurrences, one will be required, as in Gracq, to
come to terms with forces. However, whereas Gracq's *Au château
d'Argol* is always careful to subordinate its forces to an unfolding of
events or actions that, however mysterious, constitute a plot that can
be retold, in "Le Dernier Mot" the forces are so violent that the story
as such is pulverized to the point of annihilation. To say that the
narrative deconstructs itself would only be to banalize the kind of
destruction that Blanchot must have had in mind.

Only if we ignore the narrative's dissolves, shocking transitions, and
unintelligible moments, can we hazard a story about a man who sud-
denly finds himself in the middle of a civil revolt and who, during a
short day, manages to cross the city while experiencing strange en-
counters, for example, at a library, near a river, in a schoolroom and,
finally, in a deserted plain leading to a mountain where he enters into
a black tower with a young woman he has simply run into on the
way. It is in the tower where he discovers himself flying into frag-
ments and sees the naked girl covered with marks of fire. The narra-
tion, which can no longer entirely support the difference between
what is inside and outside the tower, continues,

Partout devant moi s'étaient élevées jadis de splendides constructions et
c'est autant d'édifices effondrés que les pierres rappelaient dans leur

6. Maurice Blanchot, "Le Dernier Mot," in *Après Coup* (Paris: Editions de Minuit,
1983), p. 76. "The Last Word," trans. Paul Auster, in *Vicious Circles* (Barrytown, N.Y.:
Station Hill, 1985), pp. 51–52.

lourde stabilité. Je fis quelques pas dans la pièce. Il n'y avait rien d'autre que la chaise et une corde qui ébranlait une cloche au faîte de la tour. Timidement, j'entrebâillai la porte et regardai l'obscurité.

Laissez-moi entrer, dit la fille qui attendait. Ici, c'est la nuit complète.

Mais, bien que la chambre, elle-même privée de lumière, ne reçût que la légère phosphorescence du dehors, elle poussa un cri en y pénétrant et se couvrit les yeux.

Oui, dis-je, vous aussi, vous voyez ce maudit soleil qui brûle et n'éclaire pas. (p. 76)

[Everywhere in front of me there had once been splendid structures, and the heavy stability of the stones recalled those buildings that had now collapsed. I took several steps in the room. The only things in it were a chair and a rope for ringing the bell at the top of the tower. Timidly, I opened the door a crack and looked out at the darkness.

"Let me in," said the girl, who was waiting. "It's completely dark out here."

But even though the room was also without light, a weak phosphorescence came in from the outside, and she screamed and covered her eyes.

"Yes," I said, "you see it too—this terrible sun that burns and casts no light."] (p. 52)

As in *Au château d'Argol*, where Heide's body is turned inside out toward the sun and her most secret flesh torn out of her very depths, the young woman's naked body in "Le Dernier Mot" also has suffered exposure to a radiant suspension whose incandescence the narrator associates, in this case, with a terrifying black sun. In Blanchot, however, this terrible solarization is indistinguishable from the revelation of a new and vague language which is written on the woman's body and which compels the narrator to expel her from the tower. Following this the narrator himself undergoes a similarly ekstatic experience, when, upon seeing a constellation in the sky, he breaks a window with his bare hands:

Je cassai la vitre, mes mains se déchirèrent, le sang, goutte à goutte, coulait dans le ciel par cette déchirure. Il me semblait que mes yeux enfin s'étaient fermés. Ils me brûlaient, je ne voyais rien; ils me consumaient et cette brûlure me rendait le bonheur d'être aveugle. La mort, pensais-je. (p. 77)

[I broke the window, my hands were cut, my blood flowed drop by drop through this hole into the sky. It seemed to me that my eyes were finally closed. They were burning me, I couldn't see a thing; they were consuming me, and this burning gave me the happiness of being blind. Death, I thought.] (p. 52)

Whereas in Gracq the subtle differentiatedness or heteronomy disclosed by the interplay of light can often be associated with natural sidereal processes that ensure a sense of continuity and inevitability, in Blanchot the radiant constellation in the night sky or the woman's fiery body in the tower are the consequences of unnatural phenomena that follow from the retraction of what at the narrative's outset is called a *mot d'ordre*, the truthful watchword. More precisely, the radiant suspensions could be said to be linked to the retreat or oblivion of the *mot d'ordre, as if the lighting were itself a trace or trait of the truth's withdrawal or recess.* Indeed, we could go so far as to say that, as in Gracq, this lighting is also a predisclosive trait of destruction or oblivion, except that in Blanchot one encounters it *après coup*, which is to say, in the recess of the trait's recession. It is in this recess, hiatus, or suspension that the trait traces a rift in which destruction is achieved even as it is itself obliterated or withdrawn. Hence the narrator survives the *soleil noir*, the woman's burning body, and the white hole in the sky, all of which are differential traits of a destruction in recession.

What should not escape our attention, however, is that, as in more traditional literature, the lighting effects are intimately related to the question of language, because the session of the *mot d'ordre* or "regime of words" is being allegorically reflected in the radiant suspensions that the narrator experiences. It is here, of course, that one may wonder whether Gracq's novel is not, in fact, much more audacious with respect to its break with literary tradition, because his lighting effects, however much they appear to reflect the laws of a pastoral world, nevertheless stand clear of human utterance and transpire in a language, that as we shall see, is counter-essential to humanity. In Blanchot, however, this is not the case, since the mad clarity of day and the demented obscurity of night celebrate a revolutionary recession of the *mot d'ordre* that is socially determined and fateful for human utterance.

Recall that "Le Dernier Mot" opens with the narrator's comment

that "Les paroles que j'entendis ce jour-là sonnaient mal à mes or-
eilles, dans la plus belle rue de la ville; j'interpellai un passant [the
words I heard that day rang strangely in my ears. I hailed a stranger
on the finest street in the city]." The narrator then asks, "Quel est
donc le mot d'ordre? [Can you tell me what the watchword is?]" but
the stranger confesses ignorance and says, accusingly, "Votre langage
ne me plaît qu'à moitié. Êtes-vous sûr de vos paroles? [I'm not too
happy with your language. Are you sure of your words?]" (p. 57 / p.
39). In this way, the narrator discovers the unpleasant news that the
social and political contract underwriting communication has sud-
denly become defunct with the result that no one can be sure they are
using words in such a way that they are talking about the same thing.
The narrator, who has woken up to an anarchic world of civil revolt,
finds that there cannot even be what Jean-Paul Sartre in *L'Être et le
néant* would call concrete relations with Others, because the social
and political assumptions necessary for guaranteeing mutual under-
standing have suddenly evaporated with nothing to take their place. If
the narrator imagines that he can eventually deduce the new rules
necessary for establishing concrete relations with others, he will dis-
cover that every word he speaks is the very last word, a word belong-
ing neither to the language of truth that has just foundered nor to any
subsequent regime of truth that is as yet to come.

The full significance of this is critically elaborated only later in
Blanchot's review of Duras's *Détruire, dit-elle* when he argues that
Duras is correct in intuiting that "le dernier mot" has been spoken by
the character Alissa when she says "détruire" to Max Thor. The point
is not that Alissa is actually ruining or wiping anything out by saying
this, but that her word is among the last words that are taking place
in a hiatus or caesura, namely, the hotel bounded by vast forests into
which no one dares to venture. Although Alissa's words are still drawn
from the truths of a life she has known before, they are stripped of a
certain relation to the world and anticipate a terrifying moment of
mad clarity—in short, of destruction—for which there will be no
words or truths, either during the catastrophe or in its aftermath. The
interplay of dark and light, so strong in Duras's film, is not simply
ambient, but is, like the last word, a radiant suspension between a
regime that is over and a regime as yet to come. It is the trait of a
hiatus in which a law is withdrawn and unconditional destruction

occurs outside or beyond a language wherein one felt secure, protected, or at home. In Blanchot's narrative, as well, lighting is the trait of a violence that comes about in the demise of the *mot d'ordre*. It is the trait of truthful clarification outside of any order of truth that is unconcealed in the concealment of a regime of words; as such, this unconcealed trait not only stands forth but also apart, a condition that in the narrative by Blanchot is reflected in the fissures and abysses symptomatic of a setting apart that elicits a surprisingly heteronomous concentration of violence whose horror is discontinuous with anything imaginable in the world that one has known. Blanchot thinks that Duras's *Détruire, dit-elle* is an apt title for this condition.

In the gloss on Blanchot's narrative titled "Le Dernier Mot du racisme," Jacques Derrida calls Blanchot's last word, *le pire*, the worst. For it is a set-aside word without equivalent, a word that is always a question of *Sonderbehandlung* or, as Derrida himself puts it, *Apartheid*. This is what the stranger alerts the narrator to when he says he's not sure he likes the way the narrator is using language, since words now are set aside in such a way that they require special handling or delivery. Because the set-aside or last word is the trait set aside in the demise of a vocabulary which houses or shelters being, it rejects any relation to being-in-the-world. Rather, the trait discloses a setting apart or segregation without ontology, a partitioning or screening that, strictly speaking, is inhuman, and as such not recoverable within the imitative structure of a morally truthful equivalency between communicability and visibility, telling and showing. Therefore, whereas the traits of light mimic the differential traits of a regime of words in recession, there is also this partitioning or setting aside of the trait in whose Apartheid the mimetic and metaphysical correspondence between showing and telling is subverted.

It is in this sense that Blanchot's narrative is reminiscent of Jean Genet's *Les Paravents*, in which the screens or partitions articulate a visible world in which things work, according to Genet, to break down whatever separates us from the dead. Genet speaks of this breaking down in terms of an other Order that is concentrated, unencumbered by any social responsibility, wherein every audacity comes to pass. And he tells his director, Roger Blin, that he wants all the

costumes to be designed and sown by the partitioned, the inmates of insane asylums. The actors, too, must occupy a partitioned consciousness. "Ne permettez pas à un comédien de s'oublier, sauf s'il pousse cet oubli de lui jusqu'à pisser face au public. Il faudrait les obliger à rêver—ceux qui n'ont pas à parler—la mort de leur fils ou celle de leur mère bien-aimée [Don't allow an actor to forget himself unless he carries this forgetfulness to the point of pissing squarely in front of the public. You should force them to dream—those who have no lines—to dream about the death of their son or the death of their beloved mother]."[7] At the end of Blanchot's *récit* the tower may be nothing other than a partitioning of language that in isolation forgets and exceeds any responsibility to Being, let alone, to an Other. Anticipating Genet, the partitioning or screening of the word as last word means that the word is segregated from the very structure necessary to perceive what has happened. Whereas in both Genet and Duras such partitioning or Apartheid bears directly on the question of racism, in Blanchot's narrative the last word is not restricted to any particular zone of concentrated violence. Instead it is a general condition of one's political existence reflected in the demise of a perception that requires one to speak of a moment wherein nothing can be elevated to any higher form and in which the sovereignty of the last word is merely the accession to an absolute difference whose setting aside, screening, or partitioning belongs to a closing off where all words receive special handling. Moreover, the connection between what is seen and what is said is no longer simply a mimetic relation, but instead has to be considered in terms of a destructive clearing in which partitioning broaches the inhuman. In this context, one should consider the following lines from Genet's *Les Paravents* delivered by the character Lahussein: "Celui qui après moi la baisera ne verra jamais ses yeux quand elle regardait par en dessous la couleur des oranges dans le ciel [The one who fucks her after me will never see the eyes with which she looked up at the color of the oranges in the sky]."[8]

7. Jean Genet, *Lettres à Roger Blin* (Paris: Gallimard, 1966), p. 13. *Letters to Roger Blin*, trans. Richard Seaver (New York: Grove, 1969), p. 13.

8. Jean Genet, *Les Paravents* (Isère: L'Arbalète, 1961), p. 131. *The Screens*, trans. Bernard Frechtman (New York: Grove, 1962), p. 98.

૪

In "Le Dernier Mot" the question of mimesis directly bears on the question of politics. In his newspaper articles of the 1930s, Blanchot called for revolution against both the debilitating effects of capitalism and the encroaching menace of National Socialism. Nowhere in the articles I have seen do I recall any specific definition for what Blanchot might mean by revolutionary action. Yet, judging from "Le Dernier Mot" of 1936, I am wondering whether already at that time Blanchot was exploring a revolution that exceeded the democratic social contract theory of language proposed by someone such as John Locke as well as the structure of heterogeneity described by George Bataille in the context of fascism. That is, I am wondering whether one could not, in fact, hypothesize that with the retraction of an unspecified watchword and the advent of "Le Dernier Mot," Blanchot set out to explore a notion of destruction in whose wake fascist and capitalist practices of destruction are transcended even as they are being exercised in terms of a special action that is marked by the term, the last word.

It is while he was in the library that the narrator of "Le Dernier Mot" read a document from a so-called "third State":

> Il y eut un temps où le langage cessa de lier les mots entre eux suivant des rapports simples et devint un instrument si délicat qu'on en interdit l'usage au plus grand nombre. Mais, les hommes manquant naturellement de sagesse et le désir d'être unis par des liens défendus ne leur laissant aucune paix, ils se moquèrent de cette interdiction. Devant une telle folie, les personnes raisonnables décidèrent de ne plus parler. Elles à qui rien n'était interdit et qui savaient s'exprimer, gardèrent désormais le silence. Elles semblaient n'avoir appris les mots que pour mieux les ignorer et, les associant à ce qu'il y a de plus secret, elles les détournèrent de leur cours naturel. (pp. 59–60)

> [There was a time when language no longer linked words according to simple relationships. It became such a delicate instrument that most people were forbidden to use it. But men naturally lack wisdom. The desire to be united through outlawed bonds never left them in peace, and they mocked this decree. In the face of such folly, reasonable people decided to stop speaking. Those who had not been forbidden to speak, who knew how to express themselves, resolved to stay silent from then

on. They seemed to have learned words only to forget them. Associating them with what was most secret, they turned them away from their natural course.] (pp. 40–41)

No doubt, Blanchot's reference to a "third state" and the inner migration of the intellectuals who resolve to stay silent tempts one to start allegorizing on 1930s politics, though exactly what type of regime is being discussed may not be so easy to identify. It might well be a sinister and authoritarian society, akin to the Third Reich, which has such a subtle and intolerant notion of political correctness that those who understand the system purposely decline to participate out of protest. But the narrative might also be referring to a society so open and democratic, perhaps French society, that its specialized languages have become overly particularized and incapable of speaking in ways that could be universally understood, anticipating what Jean-François Lyotard would much later call a postmodern condition. Although the common people speak all they like, the educated have learned words only to forget they once had a common reference. One such symptom might well be jargon, wherein terms refer to secret or special meanings belonging to certain groups and hence turn away from their natural folkish course.

Whether in an authoritarian or in an open society it is clear that language has undergone a retreat from the kind of universally agreed-upon referentiality that could withstand the anarchy to come. In place of such self-evidently truthful (i.e., human) language, however, the narrator quickly encounters something nonhuman, echoes of barking dogs along the river:

Lorsque j'eus descendu l'escalier près du fleuve, des chiens de grande taille, des espèces de molosses, la tête hérissée de couronnes de ronces, apparurent sur l'autre rive. Je savais que la justice les avait rendus féroces pour faire d'eux ses instruments occasionnels. Mais moi aussi j'appartenais à la justice. C'était là ma honte: j'étais juge. Qui pouvait me condamner? Aussi, au lieu d'emplir la nuit de leurs aboiements, les chiens me laissèrent-ils passer en silence, comme un homme qu'ils n'auraient pas vu. Ce n'est que bien après mon passage qu'ils recommencèrent à hurler: hurlements tremblants, étouffés, qui, à cette heure du jour, retentissaient comme l'écho du mot *il y a*. "Voilà sans doute le dernier mot," pensai-je en les écoutant. (pp. 65–66)

[When I went down the stairway beside the river, some large dogs appeared on the opposite bank. They were similar to mastiffs and their heads bristled with crowns of thorns. I knew that the justice department used these dogs from time to time and that they had been trained to be quite ferocious. But I belonged to the justice department as well. That was my shame: I was a judge. Who could condemn me? Instead of filling the night with their barking, the dogs silently let me pass, as though they had not seen me. It was only after I had walked some distance that they began to howl again: trembling, muffled howls, which at that hour of the day resounded like the echo of the words, "*il y a*." "Those are probably the last words," I thought, listening to them.] (p. 44)

This howling is key to a transition from a mere lapse of the *mot d'ordre* that follows in the wake of a capitalist or fascist entelechy to a much more radical revolution: the turn to a very last word that steps beyond the human. This last word is the "*il y a*," which, as the narrator says, is still disclosive, though not in a mimetic sense. In short, the "*il y a*" is the truthful trait of a destruction of truth that makes the link between perception and language only for the sake of obliterating their continuity. In fact, the resistance of the *récit* to narrative summary is itself a performance of this obliteration, because the text we are reading is itself the last word. In this sense, everything in the story takes place beyond the human as such, and all the radiant suspensions function as a mute and inscrutable appearance of the "*il y a*" that has no stable identity even as it achieves a thereness that consumes the narrator and his female companion in a *Sonder-Destruktion*, a unique destructive series of events that fracture emotional responses to the point where they do not refer in any logical or mimetic manner to the influences of pleasure and pain, with the consequence of eradicating the difference between bearability and unbearability.

It is in surpassing the limit of life versus death that the narrator says to the young woman:

Au fond de mes yeux sans vue se rouvrit le ciel qui voyait tout, et le vertige de fumée et de larmes qui les obscurcissait s'éleva jusqu'à l'infini, où il se dissipa en lumière et en gloire. Je me mis à balbutier.

"Que voulez-vous dire?" cria la fille, qui me gifla. "Qu'avez-vous besoin de parler?"

Je me réveillai complètement.

"Il faut que je vous explique clairement les choses," lui dis-je. "Jusqu'au dernier moment, je vais être tenté d'ajouter un mot à ce qui a été dit. Mais pourquoi un mot serait-il le dernier? La dernière parole, ce n'est déjà plus une parole et, cependant, ce n'est pas le commencement d'autre chose. Je vous demande donc de vous rappeler ceci, pour bien conduire vos observations: le dernier mot ne peut être un mot, ni l'absence de mot, ni autre chose qu'un mot." (p. 77)

[At the core of my sightless eyes the sky opened up, and it saw everything, and the vestige of the smoke and tears that had obscured them rose up to infinity, where it dissipated in light and glory. I began to stammer.

"What do you mean?" the girl shouted. She slapped me in the face. "Why do you have to speak?"

I roused myself completely.

"I must explain things clearly to you," I said. "Up to the last moment, I'm going to be tempted to add one word to what has been said. But why would one word be the last? The last word is no longer a word, and yet it is not the beginning of anything else. I ask you to remember this, so you'll understand what you're seeing: the last word cannot be a word, nor the absence of words, nor anything else but a word."] (pp. 52–53)

Here once more the light bears on the word, except that now the last word is understood not to be a word at all, though it is also not the absence of words. Nor is it something else besides a word. Rather, the last word, like the light itself, is to be considered a trait or trace appearing in the recess of the word, a trait that is itself a holding apart, divergence, or difference which is irreducible, and yet not something identical to itself, either. Indeed, one might do well to consider this trait as what Heidegger in *Parmenides* called *Gegenwesen*, the counter-essence or bringing into essence by means of exposing concealed conflictual structures overlooked if not suppressed by metaphysical speculation.[9] In other words, the trait in Blanchot may be reminiscent of what Heidegger was exploring in terms of a partitioning of words by using prefixes such as *gegen-*, *ent-*, or *un-* (*Gegen-wesen*; *Ent-bergen*; *Un-verborgene*) that are not just prefixes, but also examples of the "last word" as trait of an irreducible difference or partitioning that is counter-essential to the presence it discloses. As in the Heidegger texts

9. Martin Heidegger, *Parmenides*, trans. André Schuwer and Richard Rojcewicz (Bloomington: Indiana University Press, 1961).

of the early 1940s, themselves written in a peculiar kind of hiatus of last words, Blanchot's narrative of 1936 posits a counter-essence that can be thought of as the trait of an essential destructiveness or partitioning that is not given or disclosed by any essentializing term, whether it be the word, the absence of the word, or anything else. So that destruction is, however essential, destined to exceed essence by means of its standing apart from a certain conception of destruction that is total or final, as if destruction could be separated, partitioned, or segregated from itself.

To return now to my earlier question concerning the traits of Blanchot's politics, I am wondering whether we couldn't identify his notion of revolution in the polemical articles with a revolutionary notion of destruction as that trait which is partitioned so that it stands apart as counter-essential, as, in fact, a last word outside any regime of truth, a last word given as an irreducible heteronomous difference prohibiting any continuity with, say, fascism or democracy. Still, this last word has to be considered, simultaneously, as a trait of what came before and of what is as yet to come. In other words, it is and isn't part of any regime. This differs from last words in Duras—*India Song* comes to mind—in which the characters make a point of living their disaster as if it were chic and became them. Blanchot also differs from Gracq, for whom destruction is an absolutizing and spiritualizing phenomenon, albeit beyond a metaphysics of discrete ideas, that culminates in an orgy of aestheticized violence.

In France, shortly after the Second World War, one could find in a journal like the *Cahiers de la Pléiade* that writers such as Drieu La Rochelle were being published in the company of writers such as Breton, Artaud, and Blanchot. In fact, it is in the second volume of these *Cahiers* that Blanchot published an article on Julien Gracq entitled "Grève désolée, obscur malaise" in which he forwards an ambiguous assessment of Gracq's use of epithets in *Au château d'Argol* and *Un Beau Ténébreux*. Interestingly enough, this article appeared in 1947, the same year Blanchot published "Le Dernier Mot."[10]

In the article Blanchot more or less follows Pierre Fontanier's au-

10. Maurice Blanchot, "Grève désolée, obscur malaise," *Cahiers de la Pléiade* 2 (April 1947): 134–37.

thoritative definition of the epithet as an adjectival construction of any sort whose role is not to complete or determine the substantive it modifies, but to give it a particular characteristic and render it more salient, sensuous, or energetic. Whereas adjectival constructions may be necessary or indispensable to determine a noun, the epithet has no utilitarian role of this sort; rather, it usually is redundant or trifling. Fontanier's test for the epithet is omission. If the adjective can be suppressed without changing the meaning of a sentence, then it is an epithet. When epithets are weak, vague, or amassed without care, they are a major flaw and render the writing insipid. But, Fontanier tells us, without judiciously selected epithets, one's writing will lack energy, precision, and, above all, elegance.[11] Pierre Fontanier's *Les Figures du discours* was published between 1821 and 1830 and is considered a classic. The most recent reprint has an introduction by Gérard Genette. Blanchot, whose own narratives are allergic to the adjective, agrees that epithets make for lugubrious and clogged sentences and contribute to a destruction or ruin of words.[12] Yet, he asks, is it not necessary to encumber language in order to disengage or liberate it in a certain way? Is not bad writing, to some degree, a necessity for serious writers? Blanchot notices that in Gracq the epithets do not designate but nuance and that they suggest a permanence or substantiality to which the adjectives are themselves foreign or, to draw on language used above, counter-essential. Yet this counter-essentiality, what is it if not that of force and coloration? Blanchot says that, in any case, adjectives in French are ill at ease with the language and function to banish accident or contingency, even though they can attain the truth of things only outside the circumstances that disclose that truth in its essentiality.

One wonders. Is the epithet akin to what elsewhere he has termed "le dernier mot," and would a reading of Gracq be possible in which the adjectives need to be seen as counter-essential or partitioned and,

11. The most recent reprint has an introduction by Gérard Genette (Paris: Flammarion, 1977).

12. At this point I wish to acknowledge Marie-Claire Ropars-Wuilleumier's perception in a remark addressing this paper that Blanchot's narratives practice an avoidance of the adjective and that they challenge visibility. Blanchot bears this out: "l'image—toute image—est attirante, attrait du vide même et de la mort en son leurre [the image, every image, is attractive: the image exerts the attraction of the void and of death in its falsity]." *L'Écriture du désastre* (Paris: Gallimard, 1980), pp. 192–93. *The Writing of the Disaster*, trans. Ann Smock (Lincoln: University of Nebraska Press, 1986), p. 125.

as such, estranged from the determination or determinability of the narrative that they serve? Blanchot suggests as much when he wonders why the sentences are so clogged with adjectives and why Gracq seems to incline toward a holophrastic speech as if language were being concentrated. In Gracq the epithets are not merely episodic, but suggest a liaison that cannot be broken because the phrases have congealed or hardened into indivisible blocks. After suggesting that the epithet in Gracq is symptomatic of a primordial confusion or inmixing which is originary or fundamental, he talks about what critics will only much later call decentering. "Le substantif a perdu son rang de soleil, de centre d'un système où les satellites étaient toujours menacés d'éclipse. Il ne vaut pas plus que le parasite qui vit à ses dépens [The substantive has lost its place in the sun, the center of a system where the satellites were always threatened by eclipse. It's not worth any more than a parasite that lives at its expense]."[13] Not only does the epithet decenter the noun, but that decentering establishes a heteronomy or primordial confusion which is now sovereign. There is no hierarchy any more, Blanchot says, and everything seems mixed together. Using another term that will become familiar to deconstructionists decades later, Blanchot speaks of the epithet in terms of *usure*, a usurpation of the adjective that by means of wearing and tearing pulverizes languages and makes all words equal. It is here, of course, that a certain and *truthful mot d'ordre* is withdrawn in the fiction of Gracq and that a democratization, or, as Blanchot says, equalization, of language occurs. It is this which is reminiscent of the state of language to which the narrator has woken up one day in "Le Dernier Mot," and perhaps one ought to wonder whether this narrative is what lies behind Blanchot's criticisms of Gracq.

Problematic is that throughout the review it is difficult to get a very exact bearing on Blanchot's reception of Gracq. In fact, the tone appears to be disapproving or, at the very best, reserved, even though at the very end Blanchot takes a turn that suggests that he finds Gracq to be of immense interest. Given "Le Dernier Mot," one might have expected Blanchot to have found enormous kinship in a writer such as Gracq, particularly since the epithets suggest a writing "hors d'usage." Not only that, but Gracq's detachment of lighting effects from

13. Blanchot, "Grève désolée, obscur malaise," p. 135.

symbolist practice should have intrigued Blanchot, who in his own way has tried to do something quite similar in "Le Dernier Mot." However, Blanchot did criticize Gracq for having used adjectives so extensively that the words no longer can respond to the desire to visualize forms, because the descriptions allow us to feel more at the expense of seeing less. Here, it is precisely the mimetic relation between what is shown and what is told that is at issue.

In a series of remarks that approach a parallel diagnosis of what Bataille called the psychology of fascism, Blanchot says that we are overcome by material impressions to whose sheer massiveness we are made passively submissive. We can no longer see or distinguish anything, because everything has become so indistinct, in a word, so heterogeneous, that all hierarchy breaks down. The irony, which Blanchot hardly need mention, is that Gracq's writing does this through a decidedly elitist use of a most artificial literary discourse. Consequently, what results is disorganized perspective and a concomitant detotalized vision. That we are made passive before this disarticulated spectacle suggests that such heterogeneity is nevertheless supremely powerful. Blanchot does not fail to note that before such a demise of form the sensibilities withdraw for the benefit of an indeterminate morass in which we have to engage in order to achieve knowledge. This morass, it turns out, is the indistinct fluctuation of the elements that force us to contemplate objects as so many vacillating qualities at once massive, unstable, and even ephemeral. It is here, of course, that Blanchot could have introduced the phenomenon of lighting effects in Gracq that are encased in the epithets and function to reinforce a menacing of configurations by means of destabilizing identities. In fact, Blanchot is referring to such lighting effects when he speaks of an "incohérence absolue," although he cautions that we don't succumb to it, because all the liaisons or relations established in the text create a unification or assembly through which we lose our distance and find that we are at the mercy of something that to us is the most foreign. What one discovers in Gracq is that the fluctuation of the elements—that is, of all that is most counter-essential, differentiated, partitioned, closed off, encased, congealed, or estranged—both reveals to us a predisclosive truth in the Husserlian sense noted earlier and at the same time suggests that behind everything there is a force that is transcendent and magical. Blanchot finds in Gracq, therefore, a

metaphysical recovery of atmospheric effects. Blanchot writes, "D'un côté, les rochers, la chambre, l'étang semblent receler une intention et cacher une disponibilité énigmatique. De l'autre, les hommes perdent leur liberté, ont des airs de somnambule en plein jour [On the one hand the rocks, pools, and rooms seem to conceal an intention and hide an enigmatic disposition. But on the other hand, individuals lose their freedom and have the demeanor of sleepwalkers in broad day]."[14]

Perhaps one could say that in Gracq there is a mystification of "le dernier mot" whereby the partitioned or estranged entities, among them epithetic radiant suspensions, undergo a special handling whereby they appear marvelous and beautiful, luminous and magical. It is here that the ugliness of "le dernier mot," as Derrida has so carefully exposed it, has been purified of any abjection or horror. Perhaps this is what Blanchot finds objectionable in Gracq, namely, that he treats the last word in the wrong way in order to convert horror into an idyll. But if this is conceded, then we have at issue nothing less than a difference or partitioning of a last word that Blanchot closely identifies in his own *récit* with a revolutionary notion of destruction that apparently Gracq failed to contemplate, a failure that is not without its political difference. In other words, Blanchot faults Gracq, on the one hand, for a literary destruction that is not destructive or radical enough, and, on the other hand, for a destruction that is far too destructive. According to this logic, Gracq is not destructive enough, because he fails to conceptualize the fiction as a species of last word, something that leads him to err by way of a magical or idyllic recovery that is totalizing; yet, for all that, Gracq is still too destructive, because of a relatively uncritical attraction to a kind of annihilation that Derrida calls apartitionality—a setting apart that is undecidable and, as Blanchot puts it, perceptually incoherent, so that in the end Gracq requires death to set some limits. At issue, then, for Blanchot is nothing less than *the truth of the last word,* a truth that Gracq overshoots in two directions. No doubt one could reply to Blanchot that even death has been internally partitioned in *Au château d'Argol* and therefore lacks closure and that Gracq's so-called incoherence may be a measure of the extent to which he succeeded much better than Blanchot in keeping lighting effects to them-

14. Ibid., p. 134.

selves so that, instead of mimetically reflecting the nonessentiality of last words, the words are put in the awkward position of being at the behest of a clarity or visibility whose presence fails to signify even as it envelops the scene with a not displeasing aesthetic that is otherwise-than-human. Of the not-entirely-dead body of Heide, the omniscient narrator of Gracq's novel relates the following, which suggests that perhaps the woman's naked body discloses a truth in art that transcends the segregated truth of "le dernier mot" in that from the outset every word is already too much "in use" or "in play," with the overall effect of surfeit and surplus that encumber language by a mingling that privileges entanglements where blood and water mix:

Parmi les longues touffes d'herbe qui flottaient tout près de sa tête dans les eaux de la source, il lui avait paru qu'en un éclair venait de s'imprimer au fond de son œil, parmi toutes les autres, *une* touffe indicible-ment différente, sur le mouvement ondulant, la matière particulière-ment soyeuse et déliée de laquelle *il n'y eût pas* à se tromper. Longtemps, cherchant en vain à fuir dans son désespoir au fond d'un abîme d'ombre et d'oubli, il tint ses yeux clos et comprima de ses mains serrées l'affreux bondissement de son coeur. Mais *déjà il savait.* En un bond il fut sur pied, et contempla le corps entièrement nu de Heide. Ses cheveux flottaient en longues vagues dans la source et sa tête rejetée en arrière, et noyée dans l'ombre où luisaient seulement les dents nues de sa bouche, faisait avec son corps un angle horrible et haussait vers le ciel ses seins gonflés et caressés par la lune avec l'élan d'une insoutenable ardeur. Du sang tachait, éclaboussait comme les pétales d'une fleur vive son ventre et ses cuisses ouvertes, plus sombre que les fleuves de la nuit, plus fascinant que ses étoiles, et autour de ses poignets ramenés en arrière, une corde mince avait pénétré dans les chairs où elle dis-paraissait entièrement au fond d'une minuscule entaille rouge, de la-quelle une goutte de sang filtra avec une lenteur insensée, roula le long d'un doigt et tomba enfin dans l'eau de la source avec un son bizarre-ment musical. (pp. 64–65)

[Among the long tufts of grass floating in the waters of the spring near his head, it seemed to [Albert] that, in a flash, there had been stamped on the retina of his eye, one tuft ineffably different from all the others, whose undulating movement and particularly fine silky substance made it impossible for him to be mistaken. In his despair he kept his eyes closed for a long time, seeking in vain to flee into the depth of an abyss of darkness and oblivion, while he pressed his hands tightly over the

appalling leaping of his heart. But he already knew. With a bound he was on his feet, was gazing down at Heide's completely naked body. Her hair was floating in long swirls over the water and her head, thrown back and lost in the shadows where only her bare teeth shone, was raised at an appalling angle to her body, lifting toward the sky her round breasts caressed by the unbearable ardours of the moon. Blood, like the petals of a living flower, stained and bespattered her belly and open thighs, darker than the rivers of the night, more fascinating than its stars, and around her wrists, tied together behind her back, a thin rope had penetrated the flesh and disappeared completely under a tiny red line from which a drop of blood oozed with an insane deliberateness, rolled down one finger and fell into the water of the spring with a curiously musical sound.] (p. 92)

6 Beyond Essence: Marguerite Duras's Aurélia Steiner Cycle

Aurélia Steiner, dite Aurélia Melbourne[1] is not the only film Marguerite Duras will make of Aurélia Steiner, not the only time Duras will tell Aurélia's story by way of a narration that is utterly unreliable even if every word speaks a truth seldom heard in literary or visual works of art, murmured rather than spoken, reflected rather than seen. "When I speak, I have a negative concern, I'm taking care not to move away from the neutral ground where all words are equal." If one accedes to the truth in Duras's film, it is in terms of a muted view of the Seine in which oily waters lap up around the footings of bridges or merely slap against the sides of things . . . a barge, a retaining wall, a small boat. Here the eddying waters have already flattened before a procession of endless bridges as if in anticipation of the dark openings and black toxins that have collected near the pontoons. While the arching darkness approaches, an ominous humming of motors can be heard, as if to suggest that something unpleasant and industrial is at hand. Then the sound subsides with an apprehension whose cause one cannot

1. *Aurélia Steiner, dite Aurélia Melbourne* and *Aurélia Steiner, dite Aurélia Vancouver* are films produced in 1979 by Marguerite Duras whose scripts are to be found in a volume titled *Le Navire Night—Césarée—Les Mains négatives—Aurélia Steiner—Aurélia Steiner—Aurélia Steiner* (Paris: Mercure de France, 1979). The three scripts titled *Aurélia Steiner* are referred to in conversation by Duras as *Aurélia Steiner Melbourne, Aurélia Steiner Vancouver,* and *Aurélia Steiner Paris.* As is not uncommon, Duras has produced works that cross various generic boundaries, in this case, prose poem, theater, film, and récit. In this chapter I focus on both the cinematic aspect of the Aurélia Steiner scripts and Duras's rethinking of these scripts in a volume entitled "Les Yeux verts," *Cahiers du Cinéma,* no. 312–13 (June 1980), translated by Carol Barko as *Green Eyes* (New York: Columbia University Press, 1990).

rationalize. A bright sky reappears, and famous buildings reassure us that the world is whole. The sound, it turns out, was just sound. The people who stand on the bridges appear as feeble shadows, anonymous outlines. "We shot *Aurélia Melbourne* against the light. The faces are erased, you see only their outline, the camera swallows them, the river takes them."[2]

The voice-over is deliberate and soft. Duras: "When I am speaking, I am Aurélia Steiner, if you will. What I'm careful about is less, not more. It is not to convey the text but to be careful not to get away from her, Aurélia, who is speaking. It takes extreme care, every second, not to lose Aurélia." To lose her between the vastness, the openness of the scenes, and the closeness of Marguerite Duras's mouth to the microphone would be to risk the destruction of the films, the failure to hold on to the voice of the one in whose name the name of Duras should never come to pass—"to stay with her, not to speak in my name."[3]

So that when we hear the following lines, we know they do not belong to Duras but to Aurélia with whom Duras is struggling so hard to keep within earshot, this inviolable voice.

> Vous vous souvenez?
> Ce mot. Cette contrée. Cette terre obscure.
> Vous disiez: Il n'en reste rien que ce chemin-là.
> Ce fleuve.
> Comment rejoindre notre amour. Comment?
>
> [Do you remember?
> That word. That country. That obscure land.
> You could say: There is nothing left but the road.
> That river.
> How to reunite our love. How?][4]

The space between these and other sentences is flooded. As if the sentences were broken dams. Reprise of *L'Amour*. Reprise of *Eden Cinéma*. Reprise of the sea in *Savannah Bay*. Reprise of *Un Barrage contre le pacifique*. Speaking of the toxic waters, "The peasants had been a little astonished. To begin with, the sea had invaded the plain for

2. Duras, *Green Eyes*, pp. 135, 119.
3. Ibid., p. 145.
4. Duras, *Aurélia Steiner*, p. 121.

thousands of years. They were used to it and had never imagined it could be held back. Then their misery had accustomed them to passivity, their one and only defense against the spectacle of their children dying of starvation, their crops being destroyed by salt."[5] As in the script for *Aurélia Steiner Melbourne* the sentences in *Barrage* are futile defenses against a periodic sterilization or poisoning that no one can hold back. In the villages of Cambodia, dying children are commonplace. There is no defense, no wall that can protect them from death by flooding. Hence everyone gives up, at it were, in advance:

> Écoutez.
> Sous les voûtes du fleuve, ce déferlement.
> Écoutez . . .
> Cette apparente fragmentation dont je
> vous ai parlé, a disparu.
> Nous devrions nous rapprocher ensemble de la fin.
> De celle de notre amour.
> N'ayez plus peur.
>
> [Listen.
> Beneath the arches of the river, this unfurling.
> Listen . . .
> This apparent fragmentation of which I have spoken, has vanished.
> We would be able to come together in the end.
> Of that of our love.
> Have no fear anymore.][6]

But what overcomes this apparent fragmentation? What closes it up? Aurélia calls such closure "le bruit de la mer" and "la caverne noire." In other words, she has entered into an openness or opening, what Maurice Blanchot has called a space that allows the poet to approach the unapproachable in order to be near that truth which exceeds speech, a truth akin to the sacred. "For Hölderlin, for the poet, death is the poem. It is in the poem that he must achieve the extreme moment of opposition, the moment where he is caught up in disappearing and, by disappearing, to carry meaning to the highest pitch of what can be achieved only through this disappearance."[7] Inexistence,

5. Duras, *The Sea Wall* (New York: Vintage, 1990), p. 42.
6. Duras, *Aurélia Steiner*, pp. 125–26.
7. Maurice Blanchot, *La Part du feu* (Paris: Gallimard, 1949), p. 132.

Blanchot says, is at the intersection of speech and the sacred. And in Duras this inexistence is nothing other than *das Offene*: "the sound of the sea," the "dark cavern," and also "the white square." "On the white rectangle the letters A.S. and a birthdate. You are seven."[8] Martin Heidegger has said of such openings, of such radiant suspensions, that in them the sacred and chaos have become one.[9]

"I think that at one particular moment Aurélia is on a bridge. To the left of the picture, there is a silhouette of a girl with long blond hair. The face is blotted out like the others. She has a very lovely shape, tall, thin." But all we see of her against the light is a smile. In fact, "she is broken into bits, scattered throughout the film," which is to say, that she is an afterimage, a residue of something. "She is still on the rue des Rosiers, first there, then somewhere else at the same time, always there, then, later, always somewhere else, here as well as elsewhere, in all Jews: she is the first generation, like the last."[10] Like the walls that cannot keep the water back, Aurélia Steiner is a particle or fraction of something that cannot hold out the forces that invade and destroy. And as such she is part of something that has been wrecked in advance, like a broken-down sea wall that has been inundated many times, but she is also, and at the same time, to be identified with that chaos we identify with the flood, a streaming radiant dissemination against the light: the harsh whiteness of the small rectangle . . . a face blotted out by the sun . . . a stroke of light on a figure's blonde hair. But too there is the white noise of the sea and alternately, the dark openings of the bridges, the black patches where oil has spilled on to the waters, the darkness between the plank beds at Auschwitz. It is into these openings, into this Open, that Aurélia has fled from her persecutors, this place that in and of itself is the place of persecution, or, as Blanchot says, of Death. No wonder that "it takes extreme care, every second, not to lose Aurélia, to stay with her." And yet, who is this "her"? Who or what speaks?

There are, after all, a great number of manifestations to consider. She is perhaps the granddaughter of forebears who were gassed during the Shoah, perhaps the daughter of parents who died in the

8. Duras, *Aurélia Steiner*, pp. 178–79. "Sur le rectangle blanc il y avait les lettres A.S. et une date de naissance. Tu as sept ans."

9. Cited by Blanchot in *La Part du feu*, p. 123.

10. Duras, *Green Eyes*, p. 119.

camps but who herself survived, perhaps a child who was saved from the Shoah in Paris, but whose parents did not escape murder. She may be a mad young woman born to a well-to-do family in Melbourne, Vancouver, or Paris, whose masochistic phantasy is to undergo vicariously what Hitler's victims experienced in the camps. No doubt, the name Aurélia Steiner is discontinuous with itself, a linguistic shifter that traverses a number of similar accounts, each of which could be viewed as a variant of the other. Dina Sherzer notes how serial composition by the new novelists has emphasized the construction of parallel or recurrent accounts that allow for "continuous discontinuous structures that combine extreme heterogeneity and cohesion." As one traverses the series, one encounters "correspondences, echoes, interferences, associations, and oppositions."[11] In Duras's Aurélia Steiner scripts, films, and commentary one could make a thematic recovery of such seriality by arguing that the series is characteristic of what Blanchot calls the open and of what Duras herself calls in English the "Outside," a term that points to *the beyond of that essence which would posit a truth identical to itself.* Indeed, as film, theater, *récit*, and interview, the Aurélia Steiner cycle commits itself to an eternal return to a truth that is forgotten or obliterated each time in the stark encounter with the Outside—the otherwise-than-human.

જી

In Duras's Aurélia Steiner films, scripts, and commentaries, one has the opportunity to consider a Nietzschean question of propriation and truth from the perspective of the beyond of essence as reflected in the thinking of Emmanuel Lévinas and his most important interpreter, Jacques Derrida. In particular, I am interested in how this propriation touches on questions of Jewish identity in relation to the Shoah, but in terms that explode or break open a usual understanding of identity as a truthfulness or certainty that requires a determinate difference or partitioning between interiority and exteriority, subjectivity and objectivity. Duras, of course, has gone as far as anyone in refiguring subjectivity beyond an essence. Hence there is no longer a subject for or in itself who could be said to encounter the truth of its

11. Dina Sherzer, *Representation in Contemporary French Fiction* (Lincoln: University of Nebraska Press, 1986), pp. 39, 30.

own identity, a truth whereby it can always find itself back. Yet in the Aurélia Steiner cycle this exceeding of identity and truth is contradicted by the return of an identity grounded in violence—the identity of being partitioned as a Jew. After all, throughout the Aurélia Steiner cycle the violence of the Shoah is essential to all the Aurélias and makes up the name's unitary trait. Despite this, the unification or essentialization of the Jew by the collective violence of a European community is something that is entirely foreign or alien to the person who is essentialized by it. Here we touch on a determining feature of racism: the imposition of essence or truth by violence. This theme relates to Chapter 5 in which the political was considered an apportionment of violence, one inherent in how Julien Gracq and Maurice Blanchot treated lighting effects in their fictions.

In developing the notion of an apportionment of violence, I want to consider Jacques Derrida's remarks on *sériature* in a paper on Emmanuel Lévinas entitled "En ce moment même dans cet ouvrage me voici." Derrida's essay not only allows me to point out some features about Duras's films, scripts, and commentaries that are otherwise difficult to glean, but it enables me to address some of the ways in which Duras is considering the Shoah as an apportioned subjectivity, a subjectivity of the victim that has internalized the violence of racism even as it radically estranges the understanding of essence that racism has tried to impose.

In itself, Derrida's essay makes yet another attempt to think beyond the Heideggerian impasse of the ontological difference. Whereas in "La Différance" Derrida was concerned with difference as undecidability, in "En ce moment même" he is concerned with the undecidability of identity and of the temporality that is given in any moment where identity is presumed. This follows from Lévinas's considerations in *Autrement qu'être, ou au-delà de l'essence* in which "temporality, in the divergence of the identical from itself, is *essence* and original light, that which Plato distinguished from the visibility of the visible and the clairvoyance of the eye." In close proximity to this statement, Lévinas also says that "the visibility of the same to the same [is] sometimes called openness."[12] This visibility of the same to

12. Emmanuel Lévinas, *Otherwise than Being; or, Beyond Essence*, trans. Alphonso Lingis (The Hague: Martinus Nijhoff, 1981), p. 30. Translation modified.

the same, moreover, comes to pass seriatum as a temporality Lévinas sees as both essential and as beyond essence:

> Does temporality go beyond essence? The question remains: are this night or this sleep which being would "quit" by means of time so as to manifest itself still *essence*, simple negations of light and wakefulness? Or "are" they an "otherwise" or a "hither side"? Are they according to a temporality beyond reminiscence, in diachrony, beyond essence—on this side of, or beyond, *otherwise than being*, liable of being shown in the Said, in order to be immediately reduced to it? Is the subject completely comprehensible in terms of ontology? That is one of the principal problems of the present research.[13]

Here Lévinas asks how there can be otherness within identity, a question analogous to Heidegger's asking whether there is untruth in truth. Night and sleep are dialectically and thematically opposed to light and wakefulness as, presumably, are death to life. The temporality of my existence is essentially determined by this difference. Its identity depends on it. However, night and sleep are something other as well. They are *the manifestation of otherness within identity* or that which is *beyond essence* and *otherwise-than-being*. But why? As Lévinas demonstrates, they are so because *they overflow their significance as themes* and hence the dialectic itself between night and light, sleep and wakefulness, life and death, blindness and insight. The instructive point in Lévinas's exposition is not that something other exists outside of identity per se but that this something other takes place as the Same. In other words, like Heidegger, Lévinas finds something counter-essential to essence within the essential itself.

Like Heidegger, Lévinas seeks to show that this otherness within identity has implications for a theory of temporality in that one can no longer subscribe to a simple notion of self-presence or presentness in the here and now (the *me voici*). Lévinas discusses how otherness takes place as the Same by considering temporal terms that retain or, as Lévinas says, protain time: terms such as "already," "still," or "at this very moment." In these terms the past can be seen as having been modified even as it is retained and does not change its identity. Retention is the manifold of the Same, therefore, within which difference

13. Lévinas, *Otherwise than Being*, pp. 30–31. Translation slightly modified.

or otherness may appear as the Same. Such retention is, for Lévinas, a returning to the Same in which the Same is both the Same and not the Same. Lévinas equates this eternal return with truth. But such a truth can arrive only in what Lévinas considers a moment that, in various texts, he delimits by the phrase Derrida will apprehend or take up, "en ce moment même."

Like Lévinas, Derrida considers how the retention of time reorients Heideggerian Saying by introducing questions of obligation, responsibility, exchange, performance, and morality. Jean-François Lyotard has explored Lévinas's concerns from some other philosophical vantage points in *Le Différend*, where nonidentity within the identity may become an occasion for silence, nonrecognition of the Other, and of what theologians traditionally have called evil.[14] Derrida, however, is less interested in the question of nonreciprocity or the refusal to recognize than in what happens to fall "outside" of Lévinas's field of vision or control—both in terms of what Lévinas passively allows to be situated on the outside or hitherside of the moment in which he comes to pass in his work, as well as that which Lévinas might be chagrined to discover on the outside despite all attempts to determine its very indeterminacy.

In discussing Lévinas, therefore, Derrida undertakes an analysis of textual recursivity in order to show curious serial effects of nonidentity within identity, effects that negate the structural principles on which a notion of essence (i.e., truth) depends: the unification of temporal moments, a notion of presence identical to itself as present, the idea of persistence as that which is the same, repetition of the same as the same rather than as difference, motility of the same as the same, and so on. For Lévinas and Derrida the beyond of Essence is a structural effect that breaks with the Aristotelian contradiction between identity and difference, an effect Derrida locates in what he calls the *sériature*, the repetition of the signature, which is at odds with an Aristotelian conception of time in which an identity is thought to consist of a temporality dominated by the presence of a historical now according to which past and future moments are to be synchronized. In Lévinas, phrases such as "en ce moment même"

14. Jean-François Lyotard, *Le Différend* (Paris: Éditions de Minuit, 1983).

break with this essentializing historical logic within which the signature as subject is written:

> But there must be a *series*, a beginning of a series of that "same" (at least two occurrences) in order for the writing that dislocates the Same toward the Relation to have a hold and a chance. E.L. would have been unable to make understandable the *probable* essence of language without that singular repetition, without that citation or recitation which makes the Same come [*venir*] to rather than returning [*revenir*] to the Other. I said a "chance" because one is never constrained, even when obligated, to read what is thus rendered legible. Certainly, it appears clear, and clearly said, that, in the second occurrence, the "at this moment" which determines the language of thematization finds itself, one cannot say determined any longer, but disturbed from its normal signification of presence, by that Relation which makes it possible by opening (having opened) it up to the Other, outside of the theme, outside presence, beyond the circle of the Same, beyond Being. Such an opening doesn't open something (that would have an identity) to something else.[15]

The "en ce moment même" that returns is, in being disturbed from its normal signification of presence, othered, opened up to something outside presence, "beyond the circle of the Same, beyond Being." But, following Lévinas, Derrida cautions that this Other is not simply something else. "Perhaps it isn't even an opening, but what bids (*ordonne*) to the Other, from out of the order of the other, a 'this very moment' which can no longer return to itself."[16] In such passages, Derrida assumes that we already know that the distinction between difference and identity is a fundamental structural principle for constructing notions of essence. And even the term *différance* (in which undecidability is introduced to dismantle the distinction between difference and identity) is not sufficient to discuss Lévinas's project, since for Lévinas the beyond of Essence is not strictly speaking beyond identity—beyond the identity/difference or self/other question—but

15. Jacques Derrida, "At This Very Moment in This Work Here I Am," trans. Ruben Berezdivin, in *Re-Reading Lévinas*, ed. Robert Bernasconi and Simon Critchley (Bloomington: Indiana University Press, 1991), p. 24. "En ce moment même dans cet ouvrage me voici" appeared originally in *Textes pour Emmanuel Lévinas* (Paris: J.-M. Place, 1980) and is collected in a revised version in Jacques Derrida, *Psyché* (Paris: Galilée, 1987).

16. Derrida, "At This Very Moment," p. 24.

situated within identity as something that breaks with the logic of the same as Same.

In the phrase "en ce moment même" Derrida will examine this surpassing of the same in terms of how two moments or occurrences are given, the one thematic, the other unthematic:

> You will have noticed that the two occurrences of "at this moment" are inscribed and interpreted, drawn along according to two different gestures. In the first case, the present moment is determined from the movement of a present thematization, a presentation that pretends to encompass within itself the Relation which yet exceeds it, pretends to exceed it, precede it, and overflow it. That first "moment" makes the other return to the same. But the other, the second "moment," if it is rendered possible by the excessive relation, is no longer nor shall it ever have been, a present "same." Its "same" is (will have been) dislocated by the very same thing which will have (probably, perhaps) been its "essence," namely, the Relation. It is in itself anachronic, in itself disparate, it no longer closes in upon itself. (pp. 23–24)

Here Derrida draws out the synchronization of two identical moments in which the one swears by the other *as its truth* even as the Relation between such moments exceeds their coincidence. "[The moment] is not what it is, in that strange and only probable essence, except by allowing itself beforehand to be opened up and deported by the Relation which makes it possible. The Relation *will have* made it possible—and, by the same stroke, impossible as presence, sameness, and assured essence" (p. 24). Certainly, if there is to be truth in Duras's art, it is a truth beyond truth that comes to pass in the advent of such a relation.

୬ଡ଼

Aurélia Steiner is the name or signature whose identity as truth is never bound to any one person or to any one moment even if she comes to appearance "en ce moment même." The name, therefore, broaches what Lévinas and Derrida call anachrony, repetition, difference, and identity. The voice that has returned to the world outside the camps and inhabits a temporality not of the Shoah is a voice that has either projected itself into the future beyond the times of the camps or has spoken retroactively from some point long after the

camps are barely imaginable. The script, therefore, is temporally divided and perhaps even folded over on itself, at once the same and not the same with itself. The name Aurélia Steiner is subjected to serial effacement, because it cannot be determined as having a singular identity or moment within which its call can be restricted. Aurélia Steiner names the woman dying under the plank beds in Auschwitz and also the young woman, who, long after the war, is calling herself the daughter of highly educated parents, the daughter born in the death camp, or the daughter of this daughter. In the following phrases, the fissuring and doubling of temporality is quite noticeable, because the lines describe the feelings of the Aurélia of the camp who has just lost her husband, though the text could just as easily comprise the remarks of another Aurélia, that of Melbourne or Vancouver, who is calling out to her own lover:

> Où êtes-vous?
> Que faites-vous?
> Où êtes-vous perdu?
> Où vous êtes-vous perdu tandis que je crie que j'ai peur?
>
> [Where are you?
> What are you doing?
> Where have you gone to?
> Where have you gone to while I cried that I was afraid?][17]

Such words speak the Shoah thematically even as they speak out of their difference in a way that makes the first moment, that of the camp, withdraw into an uncomplicated self-presence or self-presentation even as the second moment, spoken retroactively by the Aurélia of Melbourne, is peculiarly nonthematizable, because it is so utterly nondescript and adaptable to so many situations. The division between the name Aurélia, the Aurélia of Auschwitz and the Aurélias of Melbourne, Vancouver, Paris, *brings the thematic and the nonthematic into proximity as if to elude any determinate moment in which the name can be concretized or essentialized.* The first thematic moment is overshot or superseded by the second nonthematic moment that encompasses the Relation and yet exceeds or overflows it. That is, the text addresses a moment in Auschwitz whose thematic is that of the

17. Duras, *Aurélia Steiner,* p. 119.

father's slow death by hanging and the mother's grief, although this moment is shared, parceled out, or divided with a second concomitant moment from long after the war that resists localization and determinability. Although the first moment is necessarily recovered if not rendered entirely from the position of the second moment, that second moment does not, in fact, merely encompass the Relation—the genealogy of Aurélia Steiner Melbourne—but exceeds and overflows it. As Derrida says, "It is in itself anachronic, in itself disparate, it no longer closes in upon itself." And yet, for all that, it is the Same. Indeed, in the context of Duras, this deconstruction of identity can be viewed as a modality of the coming to pass of truth in art, because the deconstruction of the Same pertains so strongly to mimesis in film and text, what Heidegger thought of, precisely, as the condition of *veritas.*

Notice how such a deconstruction of identity (*veritas, rectitudo, certitudo*) relates to some of the cinematic features of the Aurélia Steiner films. For example, the filmed shots of the Seine address the thematics of the Shoah, something that is evident in Duras's comment in which she speaks of the way in which she imagines the Jews being carried away downriver like so much sewage. However, these shots are, at the same time, so utterly *unthematic,* nondescript, or neutral that they could just as well be the images taken by a tourist on holiday or the images in a bad travelogue. Maurice Blanchot has spoken of neutrality in Duras as something that bestows "an infinite emptiness where the word destroy becomes a non-privative, non-positive, neutral word which bears neutral desire."[18]

The water, bridges, and buildings in Aurélia Steiner Melbourne are, for all their cultural significance and presence, oddly remote and neutral, or, nonthematic. Blanchot is correct to have identified in this neutrality a consciousness of destruction (his comments pertain to the novel and film *Détruire, dit-elle*) although it is an understanding of destruction that is not literally or metaphorically represented on screen. Like the text, then, the visual mise en scène is also to a certain degree outside of the theme, outside presence, and beyond what Derrida calls the circle of the Same. Openings, therefore, like the dark cavernous passage ways of the bridges, do not open from something

18. Maurice Blanchot, "Destroy," in *Marguerite Duras* (San Francisco: City Lights, 1987), p. 130. "Détruire" appears in Maurice Blanchot, *L'Amitié* (Paris: Gallimard, 1971).

to something else, but are themselves part of a *sériature* that bids us "from out of the order of the other," as if the bridges, the Seine, the Notre Dame Cathedral, and the shadowy faces on the bridges, were themselves taking place outside the orders of difference and identity necessary to constitute that ethical relation in which the Jew and the non-Jew come into proximity.

This coincides with Lévinas's fundamental point that from a Jewish orientation the *truthful* ethical relation is always outside or *beyond essence*, because the relation to an Other precedes the construction of ontological and epistemological categories based on the metaphysical coincidence of beings and Being.[19] In Duras's film, we have the rather complex matter of there being two structural relations to bear in mind, the *first* a *thematizable* and dialectical relation that is of the Shoah and, consequently, of the difference between persecutor and persecuted, anti-Semite and Jew; and, the *second*, of a *nonthematizable* relation that we could call the neutral or open, after Blanchot, in which one is beyond the previous dialectic even as this moment has the capacity to lapse back into that thematic as its Same. If the non-thematic moment easily slips back into the thematized dialectic, it is because the nonthematic moment cannot maintain its neutrality absolutely but becomes temporally and historically polarized. Hence the very same bridges that we see today as neutral were, during the Occupation, present as part of that openness in which the destruction of the Jews took place. In looking at the Seine in its manifestation as the neutral or the merely banal, the ethical relation between anti-Semite and Jew is clearly suspended or forgotten. The dialectical or violent relation is overtaken by the neutral one. Yet this structural moment of the thematic and the nonthematic is overtaken by yet a third moment, namely, Blanchot's reminder that in Duras the neutral and the open is precisely where destruction occurs, so that, in effect, the difference between the two occasions, the one thematic, the other not, results in the iteration of an imperative—"destroy." All three of these moments concern comportment toward the Other; however, taken together they are, strictly speaking, exceeding essence in that collectively they defy the philosophical protocols of identification (truth) established within a metaphysical tradition.

19. In this regard, note my discussion of metaphysics in Chapter 1, where the question of the ontological relation between beings and Being is situated in the context of truth.

In the film *Aurélia Steiner, dite Aurélia Vancouver* the rocks, the felled trees, the serial numbers, the water all function as neutral, unthematic things plainly identical to themselves in which an ethical relation is simply dropped. Yet, in this particular film, some of these images also function to metaphorically or thematically mark the ethical relation of responsibility that their neutrality is excluding even while we are listening to the following remarks:

> My name is Aurélia Steiner. I am your child.
> You weren't told of my existence.
> You cannot give me any sign. Death prohibited you from seeing me; I know that. And I, I see your death like a fleeting illusion of your life, for example, that of an other love. It's the same to me. I found out about you on my own. This morning, for example, by the momentary dissolution of the sea's movement, that sudden shock without any evident object. I have found out about our deep affinity before the ordeal of desire.[20]

While the camera is tracking a lumber yard in which we see the logs with serial numbers and the letter D stamped for identification, the writing transposes what would have been a neutral or unthematic image into a thematic register. Therefore the logs become metaphors for the Jewish dead. Yet, even this thematic is not as stable as one might think, because Duras is also touching on Heidegger's way of seeing the Shoah as just another aberration akin to those one sees in the production of raw materials and foodstuffs. In other words, simultaneously a callous and unsympathetic attitude has surfaced. Instead of thematically supporting the text, the tracking shots purposefully exclude or neutralize the ethical relation between Jew and non-Jew by affirming things as merely present to themselves in the filmic now. In this example, we begin to glimpse the motility of var-

20. Duras, *Aurélia Steiner*, pp. 142–43.
Je m'appelle Aurélia Steiner.
Je suis votre enfant.
Vous n'êtes pas informé de mon existence. Vous ne pouvez pas me faire signe, la mort vous retient de me voir, je le sais. Et moi, je vois votre mort comme une illusion passagère de votre vie, celle, par exemple, d'un autre amour. Cela m'est égal. Je suis informée de vous à travers moi. Ce matin, par exemple, par cette disparition momentanée du mouvement de la mer, par cette épouvante soudaine sans objet apparent, j'ai été informée de notre ressemblance profonde devant le hasard du désir."

ious constructions that are to be sorted out in the moment we see and hear a sequence of shots in Duras's film.

Duras herself has pointed to the unsympathetic side of her treatment of her central Jewish figure(s):

> It's already almost forty years ago. She could not have been writing in '45. To do it, time has to pass over the horror. She is the leprous cat too, Aurélia Steiner is. That Jew, that Jewish cat. Moreover, in those days, you would cross a Jewish continent. During that journey on the river in the north, Aurélia is calling her lover who has disappeared in the charnel houses, the wars, the crematories, the equatorial lands of hunger. We are exactly in the center of an unknown city where the river cuts through. The river would drain off all the Jewish dead and carry them away. They would be talking about Aurélia everywhere. You would hear her name whispered under the bridges, she would be in everyone's memory those days. Yes, the river would carry them away in the funeral bark toward the singular end of the river, to be diluted in the sea, throughout the universe.[21]

We have, in this instance, a decided return to thematic materials with strong historical resonances. The river in Aurélia Steiner Melbourne reminds Duras of a sewer for the dead, a draining off or hemorrhaging that cannot be arrested or walled off, even if the shots of Notre Dame and the Louvre are shown in order to remind us of how some buildings have dreamed the grandiose dream of self-enclosure. In contrast to them the bridges remind us of liquidation, of invasion, of an alien and destructive force that the city has aesthetically incorporated so that we might forget its threatening presence. We recall that the dilapidated chateau in the film *Son Nom de Venise dans Calcutta désert* has a similar function, and Duras expects us to recall that French culture has always been permeable, a host to something lethal. Especially the bridges in *Aurélia Steiner Melbourne* raise the question of what it might mean to cross over the lethal, to pass over or by those who are transported by toxins. One thinks, for example, of an ecstatic transportation watched from above, an emotional transportation in which the Jew is being watched as he or she is drained away or hauled off as if punished by a sacred decree as old as the river itself, as inevitable as the seas that flood the plains of Indochina.

21. Duras, *Green Eyes*, pp. 119–20.

This, of course, is a powerful thematic and a troubling one, because it takes sides, as it were, with the anti-Semites for whom the Jews are to be bled off. Just as the mother hemorrhages to death after the birth of her child, the river leaks out of Paris with its bloody debris "at the very moment" a very young woman smiles to us on the bridge, who is herself transported, carried away, as it were—an Aurélia who is repeating or reinventing the life of someone called Aurélia Steiner who has died in Auschwitz but has given birth to a daughter who the young woman may or may not be. The husband is hanged for having stolen food, and through a small rectangle of harsh white light his corpse is hanging. Duras adds in *Green Eyes* that "this is the scene of a double death she would experience in her orgasm with strangers, that is, in a form of anonymous prostitution—the anonymity of the crematoria, of the camps" (p. 84). Aurélia, then, is memorializing her love for the dead within a single ecstatic embrace, an "en ce moment même," in which an Other—the lover? whom?—witnesses her coming into Being from beyond the plank beds even as the very moment in which she has the orgasm that moment is kept safe and secret within the very same moment she comes into being as a Jew. For Duras, however, this sexual circumscription of the moment is objectionable insofar as it is really a female type of circumcision that has cut something away from Aurélia's jouissance by means of remembering the past. Given such a self-mutilation of love, the genealogy of Jewishness circumnavigates the limits of passion:

> For me, it's not an insult when the black-haired sailor switches from the name Aurélia Steiner to the name Juden; he's letting himself be taken in, swept away by the strength of the curse that prevails over the race and the body of Aurélia Steiner; he isn't aware that he's no longer naming her but that he's calling her by the word that invokes her race and doing so, he enters into the vertigo of wild desire. This word becomes a word that takes him way beyond the limits of himself, an insane word, like those cried out in insane desire. This word fits Aurélia Steiner perfectly, her sexual pleasure comes with this word through which she completely rejoins the lovers of the white rectangle of death. (p. 85)

What occurs, then, is that the name itself is partitioned, cut away, circumcised, when Aurélia Steiner is caught "in a kind of coming and going between the inscribing and the wearing away of the name and

that's it, the racial, Jewish orgasm of Aurélia Steiner" (p. 84). No doubt one might wonder about this locution, the so-called "racial, Jewish orgasm" and ponder the objectionability of such a phrase, if not to say, Duras's construction of the Jewess as a figure for race in whose sexual pleasure persecution or liquidation necessarily comes about as an essential and defining element: circumcision of pleasure at the behest of an Other. No doubt, one could speak of a writing of the Jewish female body as the circumcision of pleasure, or, as Duras puts it, a racial, Jewish orgasm. Whatever this orgasm is, it obliquely addresses the well-known question, put to us by Hélène Cixous, of "Who am I?" in relation to "How do I feel pleasure?" For the racial, Jewish orgasm is precisely one that defines "who am I?" in terms of what it has cut away or cut out of itself in the service of providing a historical continuity that the world at large has broken by means of disclosing itself as the eternally banal and inoffensive, as if the Shoah never could have taken place there at all. In other words, in this example one continuity or identity, the world as banally present to itself, breaks with or excludes an other continuity or identity, the historical continuity of the Shoah with postwar society. The racial, Jewish orgasm, however, by cutting something away from itself, makes the connection possible whereby the orgasm's imaginary is the world of the extermination camp: "She is in the concentration camps, that is where Aurélia Steiner lives. The German concentration camps, Auschwitz, Birkenau, were continental locations, stifling, very cold in winter, scorching in summer, very deep into the interior of Europe, very far from the sea. It's there that she goes to write her story, that is, the story of the Jews of all time" (p. 123).

While the circumcision or partitioning of her pleasure—her racial, Jewish orgasm—remains a constant that traverses all manifestations of Aurélia Steiner, the violent unifying trait or signature that marks this cut comprises a *sériature* by means of which the Same is historically fissured, cut by that orgasm (the caesura of pleasure) within "a very same moment." Notice, for example, Duras's account given on the same page as that just previously cited:

The first generation—the grandparents—were gassed at Auschwitz. They were Aurélia Steiner's grandparents. When that generation was exterminated they already had children. From the beginning of the war

and even in the years preceding it, many of those children were sent away and entrusted to relatives who lived far from Europe, the aunts and the uncles of Aurélia Steiner's parents. The last Aurélia was therefore born abroad, in Melbourne and in Vancouver. I don't think she ever went back to Europe. (p. 123)

Both of these reconstructions take place or are given at *the very same moment* and each negates, effaces, or cuts out the other as if to cut something from Aurélia herself. In this sense, the circumcision of pleasure relates closely to the seriality of Aurélia's anonymous lovers, but, more widely as well, to the *sériature* or cutting up of these numerous retellings of her genealogy and of her life, that "stringed sequence of enlaced erasures," to quote Derrida, or what he has also called the *seriasure*, a partitioning that in Duras is the internalization of racism. *Seriasure*: "A *series* (a stringed sequence of enlaced *erasures*), an interrupted series, a *series* of interlaced interruptions, series of *hiatuses* (gaping mouth, mouth opened out to the cut-off-word, or to the gift of the other and to the bread-in-his-mouth) that I shall henceforth call, in order to formalize in economical fashion and so as not to dissociate what is not dissociable within this fabric, the *seriasure* (*sériature*)."[22]

&

In *Green Eyes* someone asks Duras, "Is she the same one in Paris, Melbourne, and Vancouver?"

Yes, she's the same one. At the same time. At every age. I can show you her photograph, as a child. I found her, Aurélia, at Neauphle. She was seven. She is not in the film but even so she was filmed. We didn't know how to film her with Pierre Lhomme, we didn't know how to capture her wildness. There is no difference between Aurélia's eyes and the sea, between her penetrating look and the depth of time. (p. 143)

In the rectangle of the photograph she remains static, self-identical, the Same. At every age. So that, somewhere, there is someone who truthfully corresponds to an image and a name. Someone who really and truly is Aurélia "en ce moment même" and who, in the frame-

22. Derrida, "At This Very Moment," p. 36. *Seriasure* in this case is the *sériature sous rature*.

work of a photograph, does not necessarily open something to something else or devolve into a series. That is, like the stones, the battlements, the pavements, Aurélia, too, is literal, impenetrable. Suspended in the photograph as in brackets, she is a singularity.

Yet, she nevertheless hails the Other from outside of the order of the Other, from that outside we know as the impenetrable. In this sense she exists *beyond the truth*, if not to say serial order, of Duras's Aurélias, who can say to themselves, behind whatever else they're saying, at this very moment in this camp here I am. For like the stone battlements she exists in a neutral clearing where something is only pending. Like the stones of *Aurélia Vancouver* she is merely "thereness," a "thereness" for this moment and within this photograph that, in fact, constitutes a horizon established outside of time: that horizon of Da-Sein (or Jacques Lacan's "Das Ein") in which the Jew appears like everyone or everything else. In the photograph, then, one only has the affirmation of stasis and continuity, a stasis that Duras does not insert into the films or the scripts but must keep "outside" or "exterior" to the work.

In this representation, therefore, an identity can be said to break with the Same even as it is posited as the Same itself. In other words, the photograph of the green-eyed girl is a radiant photographic suspension in which the violence between anti-Semite and Jew is sewn up in an image wherein the destruction is held in abeyance. To some extent, she is like a survivor in that "she can be only in places of this kind, where nothing happens except memory," the memory of the Same.[23] In this particular construction we find an interiority in which each moment is remembered even while it is not being absorbed in a universal time. Hence the photograph is but a supernumerary instant that resists incorporation into the whole that could be called Aurélia Steiner. Yet, for all that, the photograph overshoots the resistance in terms of its presence-to-itself, its presence as presence. In returning to herself as herself in the photograph, Aurélia Steiner accedes to a *forgetting* or *obviation* of the Other and an awakening to the Same—to the *truth* that is Aurélia Steiner.

In terms of the photograph, therefore, we see a *passage des frontières* in which an incessant *sériature* has recollected or gathered itself into a

23. Duras, *Green Eyes*, p. 120.

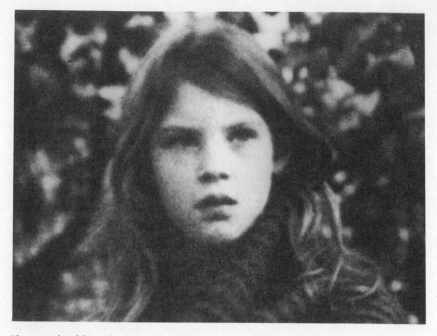

Photograph of "Aurélia Steiner," from *Cahiers du Cinéma*, 1980, reprinted in Marguerite Duras, *Green Eyes*.

unity of perception, the "me voici." The photograph, therefore, could be said to be an instantiation of the "en ce moment même dans cet ouvrage me voici," an instantiation in which the disaster of the "me voici" is safeguarded in terms of the Same—a nonrelation with the Other. In the films this nonrelation (or *apartheid*) repeats itself as the "*il y a*" of the bridges, the stones, the logs, the water, the lights, the sky, things overshot with a nonrelation we might call the inhuman— the irremissibility of an ipseity closed upon itself. Yet within this ipseity—this presence or existence of the girl who remains exterior and inviolate to the very *sériature* of which she is a part—and return of the same to the Same, one notices something else, too, namely, the trace of an other moment or nonrelation that exceeds it and ruptures any potential for absolute closure. If we consider the photograph as the inviolate or the impenetrable, as that which represents an absolute nonrelation that corresponds to the film's images of the outside, that outside also carries with it a reference to something that is noticed in Jean-Paul Sartre's *Anti-Semite and Jew*.

In making this turn, we repeat the Outside as something identical and yet different by positing it from the perspective of someone other than the Jew. Speaking of the anti-Semite, Sartre asks, "How can one choose to reason falsely? It is because of a longing for impenetrability. . . . There are people who are attracted by the durability of a stone. They wish to be massive and impenetrable; they wish not to change." The image of stone is mentioned on several occasions. "Choos[ing] for his personality the permanence of rock, he chooses for his morality a scale of petrified values." Or, "The anti-Semite is a man who wishes to be pitiless stone, a furious torrent, a devastating thunderbolt—anything except a man."[24] Here Sartre is addressing the question of the outside as that neutral Sameness in which a nonrelation comes to pass, except that here the Same is that of the fascist (the anti-Semite) who looks on others with a blank and pitiless attitude that in and of itself withdraws from any motivated or personal relation. The stone, therefore, represents a neutrality of the unmotivated in which disaster is always pending into whose anonymity the destroyer retreats. What was Sovereign in the radiant suspensions of Gracq and Blanchot becomes more politically explicit in Sartre and Duras.

In *Aurélia Steiner Melbourne* and *Aurélia Steiner Vancouver*, the stone suggests both impenetrability and Sovereignty. As in *Anti-Semite and Jew*, Duras considers the remoteness and distance of objects in a world that permitted the Shoah and contrasts this to the victim's individual experience. As in Sartre, the outside in Duras corresponds truthfully to the anti-Semite, to one who is not anyone in particular but who exists as a potential for violence once he or she seizes the opportunity to politically activate an identity closely associated with the natural (i.e., *Heimat*) and the pitiless (i.e., things in themselves). As mere beings, the anti-Semites are very much like Notre Dame Cathedral in that they simply are there as timeless, impenetrable neutrality, a neutrality or facticity that is Sovereign and that has the coldness and power to say, "destroy."

It is this obliteration, given alongside or in addition to the Nonrelation that appears in the face of the girl, that "destruction" accedes to the Same—the Same as partitioned, as otherwise-than-the-Same. This

24. Jean-Paul Sartre, *Anti-Semite and Jew*, trans. George Becker (New York: Schocken, 1963), pp. 18–19, 27, 54. Originally published as *Refléxions sur la question Juive* (Paris: Morihien, 1946).

Same, therefore, is dislocated by the very same thing, in this case the
very same concrete image disclosed outside, which is in an anachronic
relation: the disparate Relation of a Nonrelation that is serially given
as the Same. In this sense the "*me voici*" of Aurélia is posited in a
moment that is "not what it is, in that strange and only probable
essence, except by allowing itself beforehand to be opened up and
deported by the Relation that makes it possible."[25] This is the very
relation or truth that enables the coming to presence of the Same—
what gives or recollects itself as essence—to exceed its own horizon
by not simply stepping beyond the Same, but also by returning to the
Same as a separability or Nonrelation in whose iteration one can
think existence with "no exists." This, according to Lévinas, would
enable us to think of Interiority as an order "different from historical
time in which totality is constituted, an order where everything is
pending."[26] And this imminence—this sense of the pending as an ap-
proach of something disastrous—is what Duras characterizes as the
experience of the Same in whose advent the beyond of essence comes
into a certain clearing or cinematic luminescence wherein the Outside
(the partitioned) is radiantly suspended.

The Outside. . . . It is a Truth one has encountered all along in the
art of Duras: the sea in *Barrage*, the yachting in *Le Marin de Gibraltar*,
the murder in the street in *Moderato Cantabile*, the cellar window in
Hiroshima mon amour, the life outdoors of *La Femme du Gange*, the
vagrancies of Lola Valerie Stein, the tennis court of *Détruire, dit-elle*,
the open French windows of *Agatha*, the estuary of *Savannah Bay*, the
imagery of light in *Emily L.*, the deserted scenes in *Son Nom de Venise
dans Calcutta désert*. The outside is whatever interiority one has on
the hitherside of essence, a hitherside in which alterity is no longer
thinkable as such and alienation has been superseded, because terms
such as these imply merely a negated relation that could be undone,
the possibility of a way back.

In Duras's Aurélia Steiner films, the "*me voici*" is the dis-closure of
an exteriority or outside that is beyond solitude and despair, beyond
any ordeal of desire, because it is the revelation of that which is other-
wise-than-human, the face of what lies beyond essence. It is for this

25. Derrida, "At This Very Moment," p. 24.
26. Emmanuel Lévinas, *Totality and Infinity: An Essay on Exteriority*, trans. Alphonso
Lingis (Pittsburgh: Duquesne, 1969), p. 55.

reason that Duras can say of Aurélia, "Eighteen-year-old Aurélia Steiner, forgotten by God, sets herself up as equal to God face-to-face with herself."[27] If the truth of the "*me voici*" of Aurélia's face is not directly seen, this is because she accedes to God. That the divine is not disclosed indicates the disregard and obliteration of the very Law that such a sacrilegious act implies. Indeed, the impenetrable neutrality of the photographic image from *Les Yeux verts* suggests that such an obliteration of the law has occurred as the obviation or forgetting of the Other (God) for the sake of affirming a singularity: the signature/sériasure of Aurélia Steiner. Yet it also stands in opposition to such a forgetting or destruction that Aurélia identifies with the victims of National Socialism's war on the Jews, as if the ability to remember their fate matched a capacity only imaginable of the very God to whom she would equal herself. In either instance, her face is effaced and occulted—her countenance the trace of a destruction of which it cannot be said she has survived even if her life story comes after the fact of the Shoah's having taken place.

27. Duras, *Green Eyes*, p. 121.

7 Of the Eye and the Law

I begin by recalling a photograph that perhaps everyone has seen at one time or another. It was taken by National Socialist forces during the destruction of the Warsaw Ghetto and became part of the infamous *Stroop Report* that was used as evidence during the Nuremberg trials for documenting war crimes. A child, he cannot be much older than eight or nine years of age, is holding up his hands before what must be (they are off camera) weapons directly pointed at him. The child is wearing one of those hats for which we remember Jackie Coogan. There is no star on the child's coat. Unlike the well-fed soldiers in the background, and even one of these is obliquely pointing a rifle at the child, the boy with raised hands is not well nourished. His expression is serious, but not defiant. Certainly his face registers considerable anguish, much more than the arrested adults and other children in the background who appear to be somewhat bewildered. Unlike the others with raised arms, the child stands out from the group, alone and vulnerable in the foreground. His expression is so self-possessed that it suggests that only he intuits not only the moral perversity but also the extreme danger of this situation. Clearly, in the figure of this terrified child a decidedly moral conscience comes to appearance.

Since the Shoah, this photograph has become exemplary of a politics of apportioning violence that must never be repeated. Indeed, if truth comes to pass in this photograph, it is a literal truth captured by those who practiced inhumanity and derived sadistic enjoyment from it. Anyone who reads the captions to the photographs of the *Stroop*

Report should immediately be able to detect a perverse gallows humor that is entirely at odds with what is shown, something that is not surprising since revisionist historicism was always already at work during such "actions." Yet, it would be fair to say that after the war this particular photograph has not only survived this revisionism but has done so in a way that has served as a terrible indictment of those who committed crimes against humanity. Indeed, this survival or living on of a moment has become representative for countless other moments very much like it and has therefore served as an example that assumes an interrelation of existential horizons (the human, the inhuman), if not to say, the presencing of a subject who transcends himself and the temporality of a moment. In other words, there is a sense in which the photograph has lived on not only as courtroom documentation or evidence, but also as art. Hence the photograph has taken on an iconic significance akin to, say, the protest art of Käthe Kollwitz following the First World War.

We will recall from the discussion of Emmanuel Lévinas in Chapter 1 that such images are problematic in that they cannot complete the "task" posited by the situation that they represent. For the image is but a frozen moment, taking place in a present that is unable to "force the future." The image is therefore dominated by fate and is little else but an empty interval in which a figure, say, a child, is infinitely suspended and condemned. This is why Lévinas said of representations that they inherently display something inhuman and monstrous, for the inert temporal "meanwhile" can never change or give way to any salvation. For Lévinas, therefore, the work of art is objectionable because it is a survivor, a living-on that discloses the irremissibility of being—the truth in art as horror. Most likely, it is this truthful irremissibility of what Lévinas called "existence" in *Existence and Existents*—existence as "*il y a*" or horror—that appealed to the compilers of the *Stroop Report* for whom the child with raised hands expressed the inevitability of an apportionment of power in which a being-toward-death is as fated to occur as a stone is fated to fall down a steep mountain slope. No doubt it is this determination of death, already given in advance, that guarantees the closure of representation and the finitude of the boy with vulnerable knees who stands forth from the other victims. That this determination will later be rehabilitated as a truth in art counter-essential to what we are see-

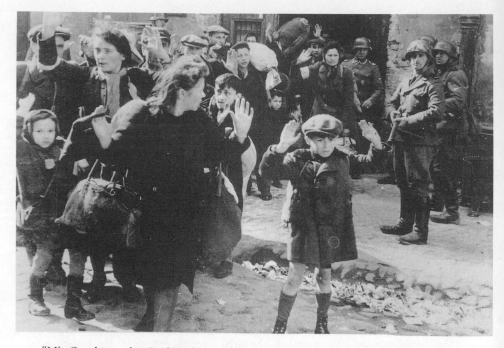

"Mit Gewalt aus den Bunkern herausgeholt [Pulled from the bunkers by force]." *Stroop Report*, Exhibit 275 of the International Military Tribunal, Nuremberg, 1946. Photograph courtesy of the YIVO Institute for Jewish Research.

ing is very much at issue in the following pages of this chapter, where I explore what I would like to call the otherwise-than-truth-in-art.

⁂

In 1960 Merleau-Ponty wrote in "The Child's Relations with Others":

> When we considered the child's imagination, it appeared likewise that we could not assimilate what is called the *image* in the child to a kind of degraded, weakened copy of preceding perceptions. What is called *imagination* is an emotional conduct. Consequently here again we found ourselves, as it were, *beneath* the relation of the knowing subject to the known object. We had to do with a primordial operation by which the child organizes the imaginary, just as he organizes the perceived.[1]

1. Maurice Merleau-Ponty, "The Child's Relations with Others," in *The Primacy of Perception* (Evanston, Ill.: Northwestern University Press, 1964), p. 98.

One might immediately wonder how we are to detect the way in which the Jewish child in the photograph imaginatively organizes or figures the perceived. No doubt this way of putting matters emphasizes an epistemological, if not psychological, mode of analysis, albeit one that is required, given the fact that it is difficult to view this photograph without imagining the child's situation from his point of view. In doing this, however, one invites a hermeneutic reconstruction of an interiorized consciousness or psychology of the child that risks the fatalism of the photograph's truth. In considering the phenomenological position of Merleau-Ponty we can avoid this, perhaps, by imagining a relation with an Other in which our being is not determined or conditioned on the basis of a representational or artistic framework through which an individual psychology of the subject or reconstruction of consciousness can be made. Not only would this bear on psychology but also on those categories through which we traditionally consider notions such as character, plot, or scene, narrative terms that not only give access to certain interpretations of agency and image but also, more generally, to history itself as a sequence of artful moral examples that presuppose the determinacy or finitude of being. In short, by way of Merleau-Ponty we may begin to rethink many of the concepts that underwrite our usual understanding of history, representation, and psychology insofar as a phenomenological approach may be capable of dismantling representations that mortgage their closure by means of borrowing from a temporality in which a pitiless death is fated. It is for this reason that I want to consider what a term such as Merleau-Ponty's "imaginary" might mean once we agree, however provisionally, with Lévinas that in the act of bearing one's face before the other, an undetermined concept of being is disclosed, *a concept not reducible to an interiorized notion of exemplary consciousness or psychology wherein subjecthood is recovered as a transparent historical and political reality.* Still, if we are to speak of a psychology or consciousness in this way, it would necessarily be one constituted in an exteriority of relationships in whose correspondences a photograph as trace comes into appearance even as it is left behind.

Let us return to the figure of the child in the photograph. It is striking to see how the child's raised hands and facial expression are outward signs of what Merleau-Ponty calls the imagination as emo-

tional conduct. In fact, it is precisely this "emotional conduct" that calls for interpretation. It is curious that the child's gesture and expression are peculiarly unchildlike, as if the child were acknowledging that he fits the role of someone who could be a threat to the Third Reich. In part, this is underscored by the photograph's composition, in which the child is seen as isolated from the group, an isolation or unprotectedness that suggests that he is being singled out for punishment. Indeed, whereas the other persecuted figures are standing near one another for support—some children peer at the camera from behind the adults—the composition of the photograph suggests that the child with raised hands in the foreground is incongruously taking on the brunt of something he cannot possibly understand. The incongruity between the person who is the child and the expression he bears, in addition to his unprotected isolation from the group and the violence he confronts, allows us to perceive a coming to appearance of an emotional comportment whose signs or traces are politically and historically made manifest even as the being of the child *as* child is undetermined with respect to its revealed image. Here, of course, one departs from an understanding of the figure that presumes an identification of being and appearance, an identification that presumes not only a psychologization of the figure but also an existential presencing of the kind presupposed by the *Stroop Report.* Indeed, from the perspective of the report, Sartre's apt pronouncement on the Nazis holds true: "Actually they take pleasure in protecting these few persons through a sort of inversion of their sadism; they take pleasure in keeping under their eyes the living image of this people who they execrate."[2] In other words, this photograph sets the child aside as one who is spared under gun point, as one who is protected through an inverse sadism wherein a sentimental notion of childhood plays a role.

2. Jean-Paul Sartre, *Anti-Semite and Jew* (New York: Schocken, 1948), p. 48. Jürgen Stroop, *The Stroop Report,* trans. Sybil Milton (New York: Pantheon, 1979). The photograph belongs to the "Pictorial Report" on the *Stroop Report,* Exhibit 275 of the International Military Tribunal, held in Nuremberg, 1946. Several photographs from the *Report* were widely publicized by the international media, this photograph being the most well known. There were fifty-four photographs in all, and thirty were captioned in Gothic script. Jürgen Stroop directed the destruction of the Warsaw Ghetto, and the deluxe leather-bound copy obtained by the U.S. 7th Army was a presentation copy given to Heinrich Himmler. In the report, the term "bunker" is a Nazi euphemism for any residence in the Ghetto, the implication being that the liquidation is part of a declared war between Jews and National Socialist forces.

However, the photograph does not entirely submit to such a gaze, since the figure of the child is so ambiguously situated that its expression or appearance transcends the very notion of childhood necessary for the anti-Semite to take pleasure in keeping a living image under his eyes by means of photography. Indeed, the photograph of the Warsaw child resists the reductive gaze of the Nazi camera eye by refusing to surrender to a commonplace mental construction of childhood, a refusal that accompanies its surrender to the undetermined: the Shoah. This resistance is nothing less than the imaginary resistance to being-in-the-world-as-a-child, a resistance that betokens the existential collapse of appearance and being. In fact, the child's appearance—his position and expression—might be said to overshoot the person that is the child, that is, to overshoot what in *Existence and Existents* Lévinas calls existence or irremediable being. What Lévinas can help us appreciate is the way in which an auxiliary appearance such as a photograph surreptitiously irrupts into the world and in so doing interrupts an event from a transcendental and ethical standpoint. Our consideration of the photograph, then, would mark a position from beyond or outside the event that nevertheless irrupts into the phenomenality of its historical unfolding. Whereas in Husserl one would attempt to reconstruct the intersubjective intentionalities of the represented agencies in the photograph for the sake of establishing how consciousness constitutes or objectifies meanings, in Lévinas one would turn to a transcendental phenomenon whose ethical irruption into history disturbs that synchronicity or unity that we ordinarily take as a precondition to interpret consciousness as self-identical with the meanings it constitutes. The photograph, then, in registering the unprotected isolation of the child and his peculiarly mature expression, manifests the supplementary trace structure through which the ethical comes into appearance. Consequently, the "emotional conduct" revealed in the face of the photographed child comprises an imaginary structure that does not originate in the child himself but in the irruption of the photographed image or trace that has been captured by an other whose relation to the child is that of a murderous sovereignty, the "truth" of the state.

By means of such a transcendental irruption of the photograph, the victim is projected beyond the finitude of being, if not to say, the ipseity of childhood. Moreover, the victim is projected beyond the

familiar historical understanding of the figure as that self-identical construction which embodies or objectifies immanent conditions of being, appearance, and also action. In contrast to the figure or image considered as a complete but unusual circumstance that solicits direct identification for didactic purposes, the photo of the Warsaw child enters history as if it could stand for a self-conscious agency capable of maturely bestowing or comprising those responsibilities that, properly speaking, lie beyond its grasp or its existential horizons. In other words, the image's appearance is intuited in an imaginative horizon that manifests itself beyond the ipseity of the image per se. To use Merleau-Ponty's words, we find ourselves "beneath the relation of the knowing subject to the known object." The composition of the child's image elicits correspondences that break with those horizons of existential and circumstantial unification that the photograph in its usual mimetic exemplary sense would suggest. It is, then, the correspondences between an imaginary ethical relation and the world that would take the place of a fixed relation between a knowing subject and a known object. If Merleau-Ponty remarks that with respect to the child "we [have] to do with a primordial operation by which the child organizes the imaginary, just as he organizes the perceived," I would like to suggest that in the photograph of the Warsaw child such an organization depends on the exemplary irruption of a representation eluding ipseity, in which a child's imagination is transcendentally constituted from beyond the being of the child. As such, the figure of the child is itself *otherwise-than-any-truth* that could determine the photograph as artful example.

ை

In *Totality and Infinity*, Lévinas writes that "the relations of transcendence lead to the other, whose mode the idea of Infinity has enabled us to specify."[3] Lévinas's work takes into account how it is we can objectify transcendental relationships that are characterized by the ways in which doing, labor, and thinking imply a relation with that other in whose shadow the determinacy of the subject is exceeded and an infinity of possible relations are opened up, an infinity in terms of

3. Emmanuel Lévinas, *Totality and Infinity: An Essay on Exteriority*, trans. Alphonso Lingis (Pittsburgh: Duquesne, 1969), p. 109.

which the subject disappears as that which is merely self-identical. For
Lévinas the broaching of the infinite yields a solitude beyond the rep-
resentable that is the effect of the subject's exceeding its existence as
existent. Lévinas argues that the solitude of the subject's transcen-
dence cannot be thematically recovered within a totality of relation-
ships in which the merely finite is expressed. The subject, therefore,
cannot thematically present itself as an example for others in the fa-
miliar moral sense. For Lévinas there are no saints. "The movement
from me to the other could not present itself as a theme to an objec-
tive gaze freed from the confrontation of the other, to a reflection."[4]
For this reason, the photograph we are considering would not be
thematically recoverable, because its ethical relations cannot be lo-
calized or exemplified in terms of finite subjects. Indeed, "experience,
the idea of infinity, occurs in the relationship with the other. The idea
of infinity is the social relationship."[5] Yet, this relationship is not iden-
tifiable as the moral sort of exemplary relationships outlined by some-
one such as Polonious in *Hamlet* or Cephalus in the *Republic,* two
figures who presuppose their self-certainty in a determinate totality of
social and political relationships.

Lévinas's invocation of the infinite has the political aim of resisting
the totality of the State and its apparatuses of representation, which,
in the photograph we are considering, places emphasis on exemplary
ipseity, finitude, truth, or totality. Certainly the photograph, as Nazi
document, reflects a hostile perspective maintained by an other that
regards the child through a pitiless gaze wherein the impossibility of
any relation except that to death or the finitely inert can be estab-
lished. Clearly, the camera has been used obscenely to document not
only the child's destruction but also the gazer's pleasure, which ema-
nates in part from the secure sovereignty of the viewer, a sovereignty
we are being tempted to share, especially when photographs of the
Shoah disclose themselves as voyeuristic glances into the freakish and
the grotesque. Such imaginary constructions attempt to suggest other-
ness through a deprecation that draws on a theatrical or cinematic
banality, one that accedes to the hideously supernatural or other-
worldly. Without doubt one could say that this is a hollow metaphysi-

4. Ibid., p. 121.
5. Emmanuel Lévinas, "Philosophy and the Idea of Infinity," in *Collected Philosophical Papers* (Dordrecht: Martinus Nijhoff, 1987), p. 54.

cal gesture whose effect is to reduce the other to what is ineluctably finite and degradable, that is, to *an example* that is comprehensible in terms of total domination and determination. That this repeats what Lévinas views as always already inherent in art—the reduction of the other to finitude, representation, closure—is what requires us to ensure that we see such a photograph as precisely that which is alien to art.

That is, we must repudiate what Lévinas would see as the self-certainty of the image that is achieved through the mimetic deprivation of an other's ability to survive. For the Nazis, the promotion of a hollow metaphysics of death is meant to falsify the historical by estranging and suspending the image to such a degree that it is no longer capable of being thought as something that could be real for us, even as the camera validates the exemplary truth that pictures tell. In *Difficile Liberté*, Lévinas calls this the pagan: a culture that searches for the closure that makes possible an abandonment of the face of the other. Indeed, the photograph we are considering was taken for the purposes of documenting the liquidation. Yet, the photograph could also be said to represent an aspect of Nazi photodocumentation that, not unlike photojournalism, searches for exemplary closure in the irony that from the gazer's remote and safe position the unthinkable is shown to be real. It is only when a filmmaker such as Ingmar Bergman uses the photograph of the Warsaw child in *Persona,* in a film language that resists such photojournalistic closure, that we begin to glimpse the moral objectionability of representational logocentrism.

Yet, even in a National Socialist image we can perceive a heteronomy of imaginary relays that are nevertheless embedded or entangled in the scene of exemplification. For example, the finitude of the Nazi gaze is ruptured by what Julia Kristeva has called a psychology of abjection wherein the infinite is linked to a construction of an abject object in terms of the death drive and its various political articulations. Here the gaze, so desirous of validating the destruction of the abject object, facilitates the impulse to kill, to destroy the figure it is so anxious to keep before it. As Kristeva summarizes the Nazi position, "The Jew: a conjunction of waste and object of desire, of corpse and life, fecality and pleasure . . . *Abjection itself.*"[6] In terms of the

6. Julia Kristeva, *Powers of Horror* (New York: Columbia University Press, 1982), p. 185.

Shoah the construction of the abject relates to the puzzling ways in which the Nazis meticulously documented and, at the same time, expunged traces of the Shoah. That such imaginary relays are chiastically bound, even as they resist the totalization of the glance of consciousness, underscores a latent heteronomy of the imaginary of the photograph. Certainly we could map other heteronomous aspects of the photographic imaginary, such as our own glance, the child's glance, the camera's eye, the omniscient historical witness, or the other child figures. To consider this photograph fully one would have to entertain the imaginary comportments of these gazes and to interrelate them along the lines set forth by not only Lévinas but also Merleau-Ponty in *The Visible and the Invisible*, wherein the Kantian assumption of a "unity of apperception" is undermined by vigorously putting into question a stable distance and self-identity of the gaze that would validate "that central vision that joins the scattered visions . . . that *I think* that must be able to accompany all our experiences."[7]

In the photograph of the Warsaw child, the figure of the boy, which we can now begin provisionally to understand as opening on to a manifold of imaginary constructions that resist totalization, is exemplary insofar as it stands for a being or existent that "cannot be integrated into the identity of the same," a condition underscored by the boy's standing apart from the other hostages as if he alone were answerable. Lévinas writes, "The exteriority of the infinite being is manifested in the absolute resistance which by its apparition, its epiphany, it opposes to all my powers. Its epiphany is not simply the apparition of a form in the light, sensible or intelligible, but already this *no* cast to powers; its logos is: 'You shall not kill.'"[8] This quotation leads me to wonder whether the photograph of the child is not a trace through which we imagine an ethical epiphany or law, a persistent showing that iconoclastically interdicts a unification of gazes. Could the photograph not be understood as an epiphany or baring of the face that prohibits the gaze from becoming a totalizing and unifying agency of

7. Maurice Merleau-Ponty, *The Visible and the Invisible* (Evanston, Ill.: Northwestern University Press, 1968), p. 145. The Kantian "unity of apperception" is discussed by Kant in *The Critique of Pure Reason* (B 181) with respect to identifying images with a concept by means of a transcendental schema that brings the sensible and the intelligible into correspondence. For Kant the mental processes of representation depend on "synthesis" and "unity of apperception."

8. Lévinas, "Philosophy and the Idea of Infinity," p. 55.

apprehension? And as such does the epiphanic not serve as the phe-
nomenological horizon that brings into correspondence the emo-
tional, the imaginary, the perceptible, the ethical, and the exemplary?
The photograph of the child, then, would mark the tracing of a struc-
ture that facilitates a coming into appearance of such an epiphany.
Because it is not epiphantic, the photograph, unlike a work of art, can
be seen as the residue of an epiphany that has come to appear. As
such it points to where the epiphantic has come to pass as that which
brings correspondences or attunements to consciousness.

That our gaze may not be reducible to a finite apprehension is
interdicted not merely by the resistance of epiphanic disclosure to
totalization but also by the historical given that a perception of the
child's face cannot ignore its numberless likenesses in the faces of
those children who perished. Yet the paradox from a Lévinasian posi-
tion is that, even if it is exemplary of the liquidation of countless
other Jewish children, the image, which cannot be divorced from its
being perceived, is too heteronomous to function as a mere example
or cultural cliché. In the coming to appearance of this face to con-
sciousness, a power makes itself known that escapes the exercise of
brutality: the power not of the individual to survive catastrophe or to
meet his or her fate with honor, but of the ethical to persist in its
exceeding the life of the individual wherein it appears as only a mo-
mentary epiphany, as nothing more than the appearance of a face
before an other, of what Lévinas calls the "*me voici.*" And this "*me
voici,*" of course, suggests itself through the figure's isolation from the
group, its coming to pass as a vulnerable and unprotected appearance
that incipiently acknowledges the annihilating capacity of the other.
That an ethical truth may live on at the cost of an individual's own
sacrifice is commonplace enough. But in the photograph the child's
image does not actively sacrifice itself in such an exemplary manner;
rather, it passively stands forth in its isolation, perplexity, anguish,
and incomprehension. Given the photograph's compositional struc-
ture, the figure of the child is so ambiguous that to some extent it
situates itself outside of an exercise of power and only passively dis-
closes itself in its infinitude to the extent that its nudity and destitu-
tion are not strategically placed before an enemy for the sake of en-
gaging him in a struggle in which a principle is put at stake; rather,
the disclosure of the figure escapes and exceeds thought even as it

manifests itself as the coming to appearance of a meaningful image. This establishes the figure in terms of what Merleau-Ponty calls the imaginary. However, unlike a Bachelardian notion of imagination, this transcendent imagination as a showing of the child's face and hands is not, strictly speaking, thematizable, and what it tells us of an emotional disposition certainly cannot be reducible to a determined notion of subjectivity or childhood. The figure of the child, then, as a transcendentally constituted imagination, is that trace of the infinite wherein ethics is constituted and persists even in the murderous gaze of an Other.

৯

In *L'Au-delà du verset* (*Beyond the verse*) Lévinas states that "the revelation of the [holy] name is not solely the corollary of the unity of a being; it carries us much further. Perhaps to the beyond of being."[9] Because no word is proper to God alone, the Talmudic tradition considers names capable of functioning as signs that refer to the holiness of God. These proper names for God are said to be heteronomous because they signify from the beyond of being. They cannot be thought in terms of essence and therefore "trace themselves as a modality of transcendence."[10] Elsewhere, Lévinas speaks of the appearance of the face in terms of a visitation of the Other, and one ought to be struck by the parallels this suggests in terms of that name which is not the corollary of the unity of being, but which carries us further, to the beyond of existence or being. For the appearance of the face is similarly not reducible to any one proper name but signifies from beyond the name even as its appearance shines forth as self-identical and capable of disclosing an ethical manifold of relationships in its becoming unconcealed before others. Indeed, the photograph of the Warsaw child meets the condition of a bearing of the face as a trace structure surviving the passing of the face, what is its destitution or death. Yet, the disclosure of the face, a disclosure transpiring in the absence of the name, brings before us questions of responsibility, obligation, and justice. "The presence of a face thus signifies an irrecusable order, a command, which puts a stop to the availability of con-

9. Emmanuel Lévinas, *L'Au-delà du verset* (Paris: Minuit, 1982), p. 148.
10. Ibid.

sciousness."[11] That is, in the bearing of the face a certain "law" is revealed instead of an interiorized psychology of individual will or resistance. This is why Lévinas insists that "the 'absolutely other' is not reflected in consciousness."[12]

Similarly, Merleau-Ponty's notion of "emotional conduct" transcends notions of interiorized consciousness and also suggests the possibility of an imaginary disclosure of the absolutely other by means of a residual coming to appearance. Such an appearance occurs not merely in a photograph but also through the photograph as trace structure, and it is this coming to appearance of the trace that is indicative of the name signing for that which is beyond being. The "emotional conduct," as we have noticed, transpires in the coming to appearance of the face, although it is an appearance that comes from beyond the bearing of the face itself. Of significance is not merely that a religious ethical command or law can inhere in a politically suspect representation, but that this command or law has been disclosed by the face of the Warsaw child from a position exterior to itself which consciousness is obliged to imagine. That consciousness is obliged to imagine that this is possible only because "the face, still a thing among things, breaks through the form that nevertheless delimits it."[13] Lévinas continues,

> The nudity of a face is a bareness without any cultural ornament, an absolution, a detachment from its form in the midst of the production of its form. A face *enters* into our world from an absolutely foreign sphere, that is, precisely from an absolute, that which in fact is the very name for ultimate strangeness. The signifyingness of a face in its abstractness is in the literal sense of the term extraordinary, outside of every order, every world. How is such a production possible? How can the coming of the other, the visitation of a face, the absolute not be—in any way—converted into a revelation, not even a symbolism or a suggestion? How is a face not simply a *true representation* in which the other renounces his alterity? The answer, we will have to study the exceptional signifyingness of a trace and the personal "order" in which such a signifyingness is possible.[14]

11. Emmanuel Lévinas, "Meaning and Sense," in *Collected Philosophical Papers*, p. 97.
12. Ibid.
13. Lévinas, *Totality and Infinity*, p. 198.
14. Lévinas, "Meaning and Sense," p. 96.

Not the face itself, but its nudity or coming to appearance before consciousness as that which is vulnerable, establishes an ethical horizon that resists exemplary objectification. The face as "emotional conduct" is ultimately strange and unassimilable within the context of what Husserl has called the "natural attitude" even as it obliges us to remember what has come to pass concretely in history. Because for Lévinas consciousness concerns consciousness of the sacred, a photograph, such as the one we are considering, can be understood as a coming to perception of a trace that signs for alterity, not unlike a sacred name that is not "proper." Indeed, if such a historical trace of the Shoah signs for the approach of a face, it still has a residual exemplary and representational function: to announce the otherwise than being. Such an appearance to consciousness of the otherwise than being "is a non-synchronizable diachrony, which representation and thematization dissimulate by transforming the trace into a *sign* of a departure, and then reducing the ambiguity of the face either to a play of physiognomy or to the indicating of a signified. But thus opens the dangerous way in which a pious thought, or one concerned with order, hastily deduces the existence of God."[15] These remarks in *Otherwise than Being; or, Beyond Essence* remind us that one must not assume congruity or identity between the image as trace and the alterity for whose approach it can be said to sign or name. Hence we must not simply conclude that God reveals himself in the face of a victim. This, of course, is representative of how profound the differences are between Judaic and Christian traditions, the latter being predicated on precisely the epiphanic disclosure of God in the face of the crucified. Rather, for Lévinas the trace merely signs for a being that cannot be said, but in whose very momentary posture an ethical comportment or law asserts itself in the bringing into correspondence of what Husserl called the "intentional correlates" of consciousness, that is, the noema.[16]

What interested Lévinas already in his early work on Husserl, *The Theory of Intuition in Husserl's Phenomenology*, is the difference be-

15. Emmanuel Lévinas, *Otherwise than Being; or, Beyond Essence* (The Hague: Martinus Nijhoff, 1981), p. 93.
16. On noesis and noema, see Edmund Husserl, *Ideas I* (The Hague: Martinus Nijhoff, 1983), pp. 210–35.

tween phenomenological signification that only points to an object and intuition that, in fact, reaches or possesses an object. Intuition, however, concerns the grasping of objects that are "merely thought," objects that are given to intuition as part of a perceptual experience through which the object is actually constituted by means of being faced. Intuition, then, concerns "an intentionality whose intrinsic meaning consists in reaching its object and facing it as existing."[17] In Lévinas's later work the question of facing becomes key to an intuition of the holy that depends on an understanding of ethics (rather than a privileging of ontology) as a bringing into correspondence of intentional correlates in terms of their intuitive significance. But if such an intuition grasps its object, it does not do so by making thought adequate to things, that is, by establishing identity or resemblances.[18] Rather, the "object" is grasped only insofar as it is phenomenologically experienced or faced by perception as a manifold of correspondences that cannot be homogeneously "resolved into relations." In a very important statement, given the studies that followed decades later, Lévinas wrote, "The *existence* of the world cannot be reduced to the categories which form its essence but lies in the fact of being, so to speak, met by consciousness."[19] Lévinas hints that given the irreducibility of the existence of the world to categories, its being faced by a consciousness aware of this irreducibility is already an occasion for the transcendence of Western ontology and an intuitive grasping of the otherwise-than-being.

The intuition of the photograph of the Warsaw child is, of course, subject to a similar stricture: that even as example the child is not reducible to ontological categories of resemblance or exemplarity. A consequence of this would be that the photograph of the child would not be comprehensible in terms of what Aristotle calls "practical wisdom."[20] Christian morality, of course, has always relied on the Ancient Greek assumption of parallel illumination and the revelation of moral universals, and these depend on ontological categories that allow for substitutability, resemblance, and identification. That is, the question

17. Emmanuel Lévinas, *The Theory of Intuition in Husserl's Phenomenology* (Evanston, Ill.: Northwestern University Press, 1973), p. 84.
18. Ibid., p. 85.
19. Ibid., p. 93.
20. See in particular Aristotle's *Magna Moralia*.

of moral exemplarity is directly tied to notions of imitation and iden-
tification which presume the universality of the human subject. Hence
in Dante's *Divine Comedy*, we are not surprised to discover that Dante
the pilgrim is, as universal moral subject, potentially capable of being
in the position of any one of the souls he meets in the afterworld.
Similarly, in the medieval play *Everyman* the protagonist is a moral
agency whose exemplary force depends on philosophical assumptions
concerning substitutability, resemblance, and identification. Lévinas's
intuitive phenomenology, however, undercuts such ontological and
moral assumptions. Indeed, a Renaissance figure such as Montaigne
already criticized Christian understanding of the moral example when
in the "Apology for Raymond Sebond" he wrote: "The participation
that we have in the knowledge of truth, whatever it may be, has not
been acquired by our own powers. God has taught us that clearly
enough by the witnesses that he has chosen from the common people,
simple and ignorant, to instruct us in his admirable secrets."[21] By
wryly recalling the commonly held assumption that we directly learn
what God wants us to know through commonplace examples rather
than through abstract philosophical or theological reflection, Mon-
taigne points to the strangeness of moral examples and their non-
synchronizable alterity, hinting that they require reflective reconcilia-
tion.

Lévinas, of course, would not want to suggest that the exemplary
bearing of the face is simply perplexing and in need of reflective rec-
onciliation, although he would want to convey the idea that an ethical
grasp cannot be embodied in a conceptual system that strongly valor-
izes the rules of a practical wisdom which derive from mimetic exam-
ples (ethics as *veritas*, *rectitudo*). For Lévinas the Judaic notion of the
law is an anti-mimetic or iconoclastic imperative. Yet, even in a mo-
ment such as the breaking of the tablets in *Exodus*, something con-
crete comes to appearance in history albeit from the otherwise-than-
being.

The concrete is defined by Lévinas as the "*il y a*," the terrifying
coming to pass of an event that is not reducible to ontology but that
nevertheless leaves traces of its immanence in the wake of its having

21. Michel de Montaigne, *The Complete Essays*, trans. Donald M. Frame (Stanford: Stan-
ford University Press, 1957), p. 369.

happened. The "*il y a*," then, is not strictly something that can be interiorized and held fast as personal conscious experience, although it can be phenonenologically intuited. In *Existence and Existents*, "The rustling of the *il y a* . . . is horror. We have noted the way it insinuates itself in the night, as an undetermined menace of space itself disengaged from its function as receptacle for objects, as a means of access to beings."[22] Here, as elsewhere, the "*il y a*" is radically estranged from those conditions out of which a world could be made up. The horror of the "*il y a*" is the coming to pass of an ethical catastrophe whose moments are countless and whose participants are themselves put in the position of having to make moral decisions in the midst of what appear as anonymous crowds or faces: people without proper names. In short, the "*il y a*" is the most concrete and agonizing perception of what our moral duty is in conditions that violently and sadistically militate against our human limitations and capacity to obey the laws of God. "[Such] horror is somehow a movement which will strip consciousness of its very 'subjectivity.'"[23] That is, the "*il y a*" transpires beyond the realm of subjective experience, beyond the humanly thinkable. The "*il y a*," if one had to find a name for it in *Existence and Existents*, could be signed for by the word Shoah in its most concrete senses. At the same time, Lévinas is arguing that in the horror of the "*il y a*" we are not released from our obligation to stand in proximity to the Jewish law that points to the otherwise-than-being as divine alterity. If the "*il y a*" marks the exposure of existence as an event of liquidating existence, it nevertheless marks in the most concrete terms the having come to pass of a law from on high, a law that survives a catastrophe that was intended to liquidate that law itself. Needless to say, there is no cause for rejoicing which might justify the horrors that were endured. Rather, there is only the perception that if we are to talk about representation and exemplification, it has to be in terms of the "*il y a*," through which mankind comes into a terrifying and murderous correspondence with the law, an "*il y a*" marked by horrific traces that approach the condition of those names that are not the corollary of the unity of being.

22. Emmanuel Lévinas, *Existence and Existents* (The Hague: Martinus Nijhoff, 1978), p. 60.

23. Ibid.

৯৹

In *Difficult Freedom* Lévinas writes that "ethics is an optics."[24] And in *The Book of Questions: Aely* by Edmond Jabès we are told that "within the word *œil*, eye, there is the word *loi*, law. Every look contains the law."[25] In the photograph of the Warsaw child the law comes to appearance as the face, and yet, as Lévinas specifies, the face has already withdrawn to that which is beyond our worldly order of being. It appears before us only as trace, the "*il y a*" of the coming to pass of a being from the beyond of being. As this "*il y a*," the face persists as vestige of an ethical encounter that we are obliged to acknowledge as exemplary insofar as we are obliged to understand and follow divine law. This is not to say that the photograph incarnates a divine manifestation of the law, but that it reveals those conditions under which we can intuit the coming to pass of an ethical order, what Lévinas calls the otherwise-than-being. When we say that the ethical encounter is something we must take as exemplary, we are, however, still breaking radically with the classical and Christian traditions that persist in those sections of Martin Heidegger's *Being and Time* that Lévinas rejects.[26]

We recall that in *Being and Time* Heidegger writes, "Dasein can thus gain an experience of death, all the more so because Dasein is essentially Being with Others. In that case, the fact that death has been thus 'Objectively' given must make possible an ontological delimitation of Dasein's totality."[27] Although Heidegger is questioning the notion of Dasein's finitude or totality by suggesting that in Dasein's proximity to the Other's death the categories of being are disrupted and hence refuse Dasein its existential closure, there is still the insistence that "*Here* one Dasein can and must, within certain 'limits' *be* another Dasein."[28] In other words, one Dasein can be substituted by another, and, as Heidegger notes, it is by means of such exemplary

24. Emmanuel Lévinas, *Difficile Liberté* (Paris: Albin Michel, 1976), p. 33.

25. Edmond Jabès, *The Book of Questions: Yaël, Elya, Aely* (Middletown, Conn.: Wesleyan University Press, 1983), p. 215.

26. See, for example, Lévinas, *Totality and Infinity*, p. 109. "In contradistinction to the philosophers of existence we will not found the relation with the existent respected in its being, and in this sense absolutely exterior, that is, metaphysical, on being in the world, the care and doing characteristic of the Heideggerian Dasein."

27. Martin Heidegger, *Being and Time* (New York: Harper and Row, 1962), p. 281.

28. Ibid., p. 284.

substitution that the existential category of concern or care emerges. Lévinas's philosophy is aggressively and self-consciously reacting against precisely these passages in *Being and Time*, because Lévinas believes that Heidegger is subordinating ethics to a mimetic notion of exemplification wherein one's relation to an other is ontologically determined. Instead of privileging what Judaic tradition views as the law, Heidegger privileges ontological difference and derives from it existential and moral notions such as care or being-with-others. In *La Dette impensée* (*The unthought debt*) Marlène Zarader, in comparing Heidegger to Lévinas, points out that "insofar as philosophy is defined as ontology . . . it ceaselessly looks for the Other without ever being able to reach it, since it never quits the field of being which is the field of the Same." And ontological difference, of course, would be the law that ensures a return to the same in which the other is not akin to what Lévinas calls the "Tout-Autre." For Lévinas, then, it is in proximity with the "absolutely other" that Dasein loses its finitude and the mimetic structures of identification through which we come to know ourselves in the examples of others. As Zarader points out, this surpassing of finitude is marked by Lévinas in terms of the "pure expression" of the face that reveals the infinite beyond any system of totalized relationships. Moreover, she rightly argues that this visage or "trace of the infinite" cannot be introjected within Western thought but concerns the Hebraic law that is defined in terms of those obligatory conditions laid down to those who fall under the shadow of an other's coming to appearance from the otherwise-than-being.[29]

Near the outset of this chapter, I was asking what Merleau-Ponty's notion of the imaginary might possibly be, given what he writes about the child and its emotional conduct, and I suggested, at one point, that the imaginary is phenomenologically posed exterior to the cogito, which is to say, from beyond the existential horizons of the subject's exemplary presence. The imaginary, I contended, is not reducible to an interiorized consciousness but must be considered in terms of ethical relations that come to pass in the coming to appearance of the

29. Marlène Zarader, *La Dette impensée* (Paris: Seuil, 1990), pp. 153, 154. On the face, see also Susan Handelman, *Fragments of Redemption* (Bloomington: Indiana University Press, 1991), pp. 208–11. Handelman reminds us that the Hebrew word for face is *panim* whose root is *panah*, to turn. Extrapolating from Handelman's analysis, which is centered on Rosenzweig, the face in Lévinas is a revision of the Heideggerian turn from being to Being.

trace. Furthermore, only through such a coming to appearance can we speak of a phenomenon that brings to consciousness a souvenir of what once was, that is, the Shoah. Of course, in our attempt to remember or commemorate this past we have been required to reflect on a photograph, and in so doing we have intuited a moral responsibility toward an other which is given from outside an ontological network of conceptual relations which presupposes the ability of one Dasein to "*be* another Dasein" within "certain limits." That is, in taking distance from a figure such as Heidegger, we have, with the guidance of Lévinas, come to understand a law that comes to appearance not because we perceive ourselves to be inherently identical to others, but because of our hard-won failure to imagine this identification. This leads to the surprising consequence that in not being able to comprehend the identity between an other and myself a certain ethical law comes to the fore.

This point can be better clarified if we turn to Merleau-Ponty's *Phenomenology of Perception*, in which the argument is made that perception is grounded not in identification but in the persistence of what is seen "as an unequal distribution of influences." Merleau-Ponty specifies that one's body experiences disequilibrium to the extent that it is incapable of projecting its visual existence into that which is apprehended. In a chapter on the cogito, Merleau-Ponty states that the "'I' is a field, an experiencing." And he insists that the "I" never occupies a fixed position in terms of which identifications are established but is always subject to being reinscribed within a new "possibility of situations."[30] Samuel B. Mallin summarizes Merleau-Ponty's position as follows:

> My body experiences a disequilibrium because it cannot implant its visual existence fully in its [the object's] milieu. It cannot clearly encompass the otherness that faces it by means of one of its structures, and thus it cannot bring it to its maximum visibility. The object side of this situation can be described as the unequal distribution of influences, because otherness is unable to precisely trigger and specify the one structure that would have accommodated it had it been proximal.[31]

30. Maurice Merleau-Ponty, *Phénoménologie de la perception* (Paris: Gallimard, 1945), pp. 465–66.

31. Samuel B. Mallin, *Merleau-Ponty's Philosophy* (New Haven: Yale University Press, 1979), p. 125.

Yet, if we experience disequilibrium, it is coupled, according to Mer-
leau-Ponty, with the perception that the object persists as something
constant. What is constant, however, is neither the identification of
subject with object nor the identification of the object with itself as
such. What remains constant is the object's persistence as a coming to
appearance that resists such identifications. What persists, in other
words, is that which "resides in exteriority" and is given to perception
by the other as that which can never be encompassed by the me.

If we were to speak of the imaginary conditions of the photograph
of the Warsaw child, it would have to be in terms of this non-
reciprocity in which, from Lévinas's perspective, the law is given in its
radical alterity. Indeed, Merleau-Ponty's phenomenology of percep-
tion contributes to an understanding of the imaginary appearing of
the face as an effect of the ethical constancy or persistence of the law,
a Talmudic law or truth other-than-truth in the Western tradition that
hails us from the depths of an exemplarity that resists identification
and conceptual closure. To put it in this way is to postulate that a
photograph such as that of the Warsaw child can be considered to be
like a Talmudic redaction—the providing of a historical example that
serves as the occasion for interpreting the law, in which the emotional
comportment of a child is imaginatively given exterior to both our
identification with him or his self-identification. His face speaks to us
from beyond the finitude of its appearance and from the beyond of its
being. And what speaks to us, then, is sacred insofar as what comes to
appearance from beyond is the persistence of a law that says "you
shall not kill." In an interview with Richard Kearney, Lévinas ad-
dresses this disclosure of the face as follows: "The face is not in front
of me [*en face de moi*] but above me; it is the other before death,
looking through and exposing death. Secondly, the face is the other
who asks me not to let him die alone, as if to do so were to become
an accomplice in his death. Thus the face says to me: you shall not
kill."[32] In the persistence of this disclosure one is required, therefore,
to consider the coming to pass of an Other whom we cannot know or
represent as such, even as we are obliged to heed him under the dic-
tates of an irrecusable order. For Lévinas the epiphany of the other's
approach "reveals as it were *horizontally*, on the basis of the historical
world to which it belongs. According to the phenomenological ex-

32. "Ethics of the Infinite," in Richard Kearney, *Dialogues with Contemporary Continen-
tal Thinkers* (Manchester: Manchester University Press, 1984), pp. 59–60.

pression, it reveals the horizons of this world. But this mundane signification is found to be disturbed and shaken by another presence, abstract, not integrated into the world. His presence consists in coming unto us, making an entry. This can be stated in this way: the phenomenon which is the apparition of the other is also a *face*."[33]

Of this world, the photographed face is perceived retroactively in the traces preserved by its annihilators, as if it were destined to survive and signify from beyond the time of its arrest in this world. The face therefore transcends the being of the subject and has to be apprehended as a presencing whose Otherness is not integratable into this world. To perceive the world in a worldly manner and still recognize that perception must consider the otherwise-than-being is, for Lévinas, a most basic phenemonological condition on which our capacity to remember and commemorate the past depends. Certainly, such perception is entirely congruent with the main outlines of Merleau-Ponty's phenomenological investigations. But Lévinas's position suggests that only in the transcendence of the artful moral example can there come about an intuition of the law mediated by a phenomenology of perception that imaginatively recollects an emotional comportment speaking to us undecidably from within and without the limits of presentation and exemplification. It is on account of the irremissible being of existence that the appearance of the child's face exceeds the truth of the artful image as an existent that would reduce his expression to the fate or punctum of an existence forever suspended in a concentrated space where liquidation is as yet to come. Even if the photograph is not art per se, it nevertheless stages certain artistic assumptions that contribute to an immorality that the disclosure of the face puts into question. The irony is that on account of this gross perversion of what one might call the truth in art, the Nazi photograph discloses a truth or law in spite of itself. That a restitution of this sort occurs in what many would consider a most inappropriate place does not mean that the image or act of making it has been morally redeemed; rather, it means that Alterity has come to pass where we least expected it. That God may not have abandoned the boy at the nadir of his predicament is a guiding thought for some of these speculations.

33. Emmanuel Lévinas, "The Trace of the Other," in *Deconstruction in Context*, ed. Mark C. Taylor (Chicago: University of Chicago Press, 1986), p. 351.

Index